TERRACOTTA ARMY

LEGACY OF THE FIRST EMPEROR OF CHINA

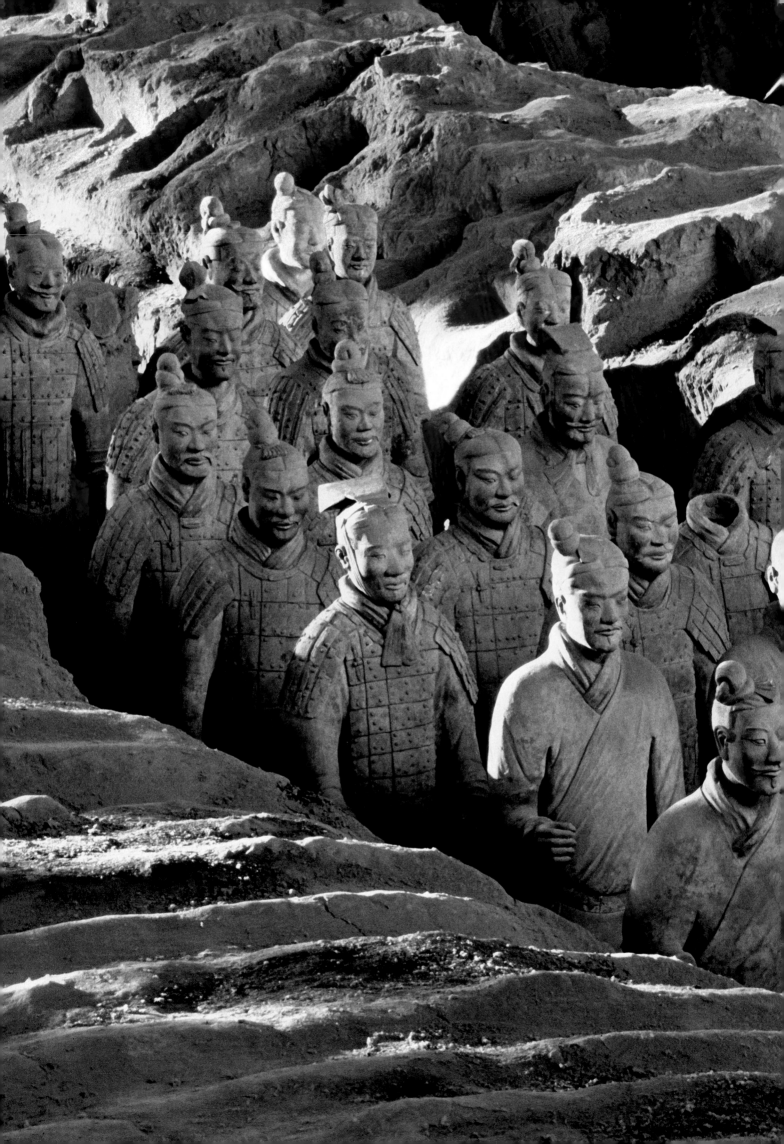

TERRACOTTA ARMY

LEGACY OF THE FIRST EMPEROR OF CHINA

Li Jian and Hou-mei Sung

with an essay by Zhang Weixing
and contributions by William Neer

Virginia Museum of Fine Arts | Cincinnati Art Museum

DISTRIBUTED BY Yale University Press, New Haven and London

This catalogue accompanies the exhibition *Terracotta Army: Legacy of the First Emperor of China*, organized by the Virginia Museum of Fine Arts and the Cincinnati Art Museum, in partnership with Shaanxi Provincial Cultural Relics Bureau, Shaanxi History Museum (Shaanxi Cultural Heritage Promotion Center), and Emperor Qin Shihuang's Mausoleum Site Museum of the People's Republic of China.

Exhibition Dates:
Virginia Museum of Fine Arts | November 18, 2017–March 11, 2018
Cincinnati Art Museum | April 20–August 12, 2018

ISBN 978-0-300-23056-7
Printed in the United States of America

Library of Congress Cataloging-in-Publication Data

Names: Li, Jian | Sung, Hou-mei. | Zhang, Weixing | Virginia Museum of Fine Arts, organizer, host institution. | Cincinnati Art Museum, host institution.
Title: Terracotta army : legacy of the first emperor of China / Li Jian and Hou-mei Sung ; with an essay by Zhang Weixing and contributions by William Neer.
Description: Richmond : Virginia Museum of Fine Arts, 2017. | Includes bibliographical references and index.
Identifiers: LCCN 2017044984 | ISBN 9780300230567 (hardback)
Subjects: LCSH: Qin shi huang, Emperor of China, 259 B.C.–210 B.C.—Tomb—Exhibitions. | Terra-cotta sculpture, Chinese—Qin-Han dynasties, 221 B.C.–220 A.D.—Exhibitions. | Excavations (Archaeology)—China—Shaanxi Sheng—Exhibitions. | Shaanxi Sheng (China)—Antiquities—Exhibitions. | BISAC: HISTORY / Asia / China. | SOCIAL SCIENCE / Archaeology. | ART / Asian. | ART / Collections, Catalogs, Exhibitions / General.
Classification: LCC DS747.9.Q254 T45 2017 | DDC 931/.04—dc23 LC record available at https://lccn.loc.gov/2017044984

Produced by the Department of Publications
Virginia Museum of Fine Arts
200 N. Boulevard
Richmond, VA 23220
VMFA.museum

Lucy Keshishian Grey, Project Editor
John Hoar, Graphic Designer
Frances Bowles, Indexer
Rosalie West, Editor in Chief
Sarah Lavicka, Chief Graphic Designer

Distributed by
Yale University Press
302 Temple Street
P.O. Box 209040
New Haven, CT 06520-9040
yalebooks.com/art

Composed and typeset in Minion Pro and ITC Tiepolo by the designer
Printed on Sappi McCoy Silk text by
Worth Higgins and Associates, Richmond, Virginia

Terracotta Army
Legacy of the First Emperor of China

Presented at the Virginia Museum of Fine Arts by

 Altria | E. Rhodes and Leona B. Carpenter Foundation

The Julia Louise Reynolds Fund

The Anne Carter and Walter R. Robins, Jr. Foundation

Virginia H. Spratley Charitable Fund II

Dr. Donald S. and Beejay Brown Endowment
The Community Foundation *Serving Richmond & Central Virginia*
Mrs. Frances Massey Dulaney
Jeanann Gray Dunlap Foundation
Dr. and Mrs. Steven E. Epstein
Frank Qiu and Ting Xu of Evergreen Enterprises
Norfolk Southern Corporation
Richard S. Reynolds Foundation
Stauer
Mr. and Mrs. Fred T. Tattersall
Ellen Bayard Weedon Foundation
YHB | CPAs & Consultants

Presented at the Cincinnati Art Museum by

The Harold C. Schott Foundation
CFM International
The John and Dorothy Hermanies Fund
E. Rhodes and Leona B. Carpenter Foundation
Christie's
Elizabeth Tu Hoffman Huddleston
The Jeanann Gray Dunlap Foundation

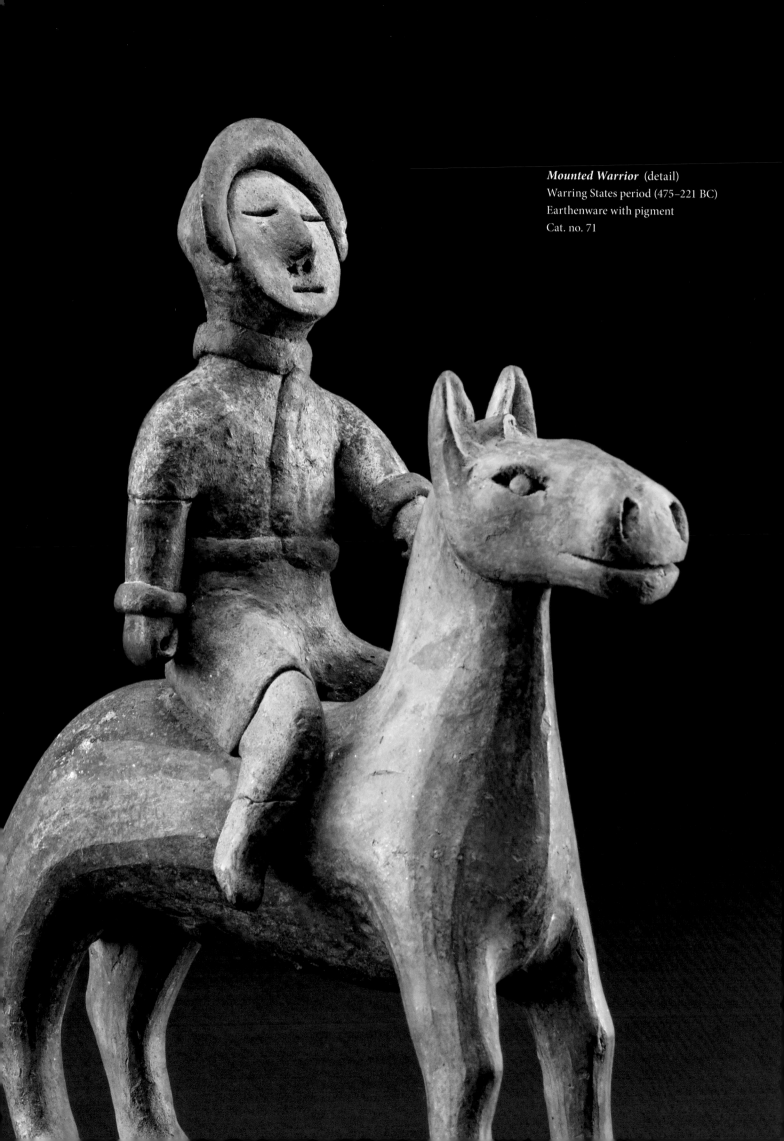

Mounted Warrior (detail)
Warring States period (475–221 BC)
Earthenware with pigment
Cat. no. 71

CONTENTS

Foreword

Shaanxi Province has been a cradle of human activity since ancient times. The Qin people began as a tribe, herding horses for the king of Zhou in their early settlement in today's eastern Gansu Province. They later developed into a fiefdom and, over the following six hundred years, thrived and expanded their territory. After Shang Yang's reforms in 356 BC during the Warring States period, the Qin developed at a rapid pace. In 221 BC, King Ying Zheng of Qin unified six states and established the first unified empire in Chinese history—the Qin dynasty. He was proclaimed the "First Emperor," and for the first time in history, the Qin abolished the inheritance system and established a centralized government, characterized by three lords, nine ministers, and many commanderies. The Qin also standardized language and script, currency, and measurements, and enacted the construction of a national highway network. This series of political, economic, and cultural innovations paved the way for the success of the following empire—the Han dynasty. The imperial system created by the Qin lasted for more than two thousand years in China. The Qin people made their mark on history with remarkable accomplishments.

In 1974, near Qin Shihuang's mausoleum in Lintong County, Shaanxi Province, farmers digging a well accidentally found pottery fragments that led to the discovery of the First Emperor's terracotta army pits. In the following years, archaeologists discovered additional related remains and cultural relics, making the terracotta army one of the greatest archaeological discoveries of the 20th century, and one of the most astonishing cultural inheritances in human history. It is considered by many to be the eighth wonder of the world. In 1987, the First Emperor's mausoleum and the terracotta army pits were listed by UNESCO as World Heritage Sites. Archaeological excavation of the terracotta figures continues to today. Due to the rich relics unearthed, the study of Qin culture has become an area of international scholarly focus and captivated the interest of the general public.

Shaanxi Provincial Cultural Relics Bureau, Shaanxi Cultural Heritage Promotion Center, and Emperor Qin Shihuang's Mausoleum Site Museum joined together with the Virginia Museum of Fine Arts to begin planning this exhibition in 2009, later joined by the Cincinnati Art Museum in 2015. Parties from both China and the United States have worked together to develop, through diplomacy and cooperation, a growing understanding of each other and mutual trust. Finally, we welcome the opening of *Terracotta Army: Legacy of the First Emperor of China*. Organized in three sections—the First Emperor and unification of China, birth of the Qin empire, and the First Emperor's quest for immortality—this exhibition showcases masterpieces of Qin history and culture, including works of art from fourteen museums and archaeological institutes throughout Shaanxi Province. Objects excavated from the First Emperor's mausoleum complex include terracotta figures of a general, cavalryman, and standing archer, as well as bronze birds and swords, highlighting the rich and glorious history of Qin's material culture.

I believe this exhibition will provide a great opportunity for American audiences to understand the daily life of Qin people and the visual culture of the empire over two thousand years ago. This exhibition actively promotes cultural exchange between China and the United States, and increases understanding and friendship between peoples of both nations. I would like to sincerely thank staff from all related institutions, in both China and the United States, for their dedication. I wish *Terracotta Army: Legacy of the First Emperor of China* great success.

Zhao Rong, PhD
Director, Shaanxi Provincial Cultural Relics Bureau

中國陝西地區自古以來就有大量人類活動遺跡。秦人早期在中國甘肅的隴東地區給周天子牧馬，後逐漸發展為一個西陲小邦。之後六百餘年間，不斷奮發圖強，積極進取，開疆拓土，特別是在戰國時期公元前356年的商鞅變法後，秦國逐漸發展壯大。公元前221年，秦王嬴政一統六國，建立了中國歷史上第一個統一的王朝—秦朝。他本人被稱作"始皇帝，"是中國歷史上第一位皇帝。秦王朝開創性地廢除了世襲制度，建立了三公九卿制和郡縣制為特點的中央集權制，統一了文字、貨幣和度量衡，修建了國家級的高速公路網"馳道"。這一系列的政治、經濟和文化創新，最終將中國社會推向了中國歷史上第一個發展高峰—漢代。秦所創建的封建制度在中國沿用兩千餘年。秦人的發展歷史，就是一部波瀾壯闊、蕩氣迴腸的民族自強不息、奮發圖強的歷史。

1974年在中國陝西臨潼縣秦始皇帝陵附近，被幾位農民在打井時偶爾發現的秦始皇兵馬俑坑，以及之後陸續發現的其他相關遺址和文物，是20世紀最偉大的考古發現之一，也是最震撼人心的人類文化遺產之一，被稱為"世界第八大奇蹟"。1987年秦始皇帝陵及其兵馬俑坑被聯合國教科文組織列入世界文化遺產保護名錄。自1974年秦兵馬俑正式考古發掘至今，考古發掘工作一直在持續進行中，秦文化的研究也因豐富的出土文物而成為學界乃至世界的熱點和公眾關心的焦點。

陝西省文物局、陝西省文物交流中心及秦始皇帝陵博物院，同美國弗吉尼亞美術館，早在2009年起就開始一起積極籌劃本次展覽。之後2015年辛辛那提藝術博物館參與投入。中美雙方共同努力，密切合作，彼此之間充分理解和信任。現在，終於迎來了《輝煌大秦—兵馬俑》展覽的成功舉辦。本次展覽，按照"大秦之崛起，""天下一統"和"千年永恆"三個主題，展出了陝西省14家文博單位收藏的眾多關於秦人歷史文化的文物精品，特別是秦始皇帝陵遺址區出土的將軍俑、騎兵俑、立射俑、青銅鴻雁、青銅長劍等文物，凸顯了秦代豐富多彩、熠熠生輝的物質文化史。

我相信，本次展覽一定會為廣大美國觀眾提供一個了解兩千多年前秦人真實生活和宏偉帝國面貌的極好機會，對於促進中美兩國文化交流，增進兩國之間的理解和友誼，必將產生十分積極的作用。在此，謹向雙方相關單位中為本次展覽成功舉辦付出艱辛努力的工作人員表示誠摯的感謝，並祝《輝煌大秦—兵馬俑》展覽圓滿成功!

趙 榮 博士
陝西省文物局 局長

Foreword

Terracotta Army: Legacy of the First Emperor of China represents the culmination of decades of archaeological discovery and curatorial scholarship in one spectacular exhibition and catalogue. An exhibition of this scope and caliber requires years of highly skilled diplomacy, resulting in a lifelong relationship between nations that only certain museums are ever able to achieve. The fascinating terracotta warriors are the cornerstone of this remarkable study of Ying Zheng (259–210 BC), who became China's first emperor. The exhibition and this catalogue showcase more than 130 artworks, drawn from the collections of fourteen art museums and archaeological institutes across Shaanxi Province in China. They tell the story of the Qin state and its expansion under the leadership of Ying Zheng, who unified China and declared himself Qin Shihuang, or First Emperor of Qin, in 221 BC. The exhibition also explores the First Emperor's quest for immortality and the life-size funerary sculptures discovered in 1974. Carefully selected objects reveal the First Emperor's political and cultural innovation and his legacy, providing a better understanding of ancient Chinese cultural history as part of world civilization.

This catalogue and the exhibition contribute new scholarship to the field of ancient Chinese art and include information gleaned from recent excavations of Qin Shihuang's mausoleum complex. The catalogue was written by Li Jian, E. Rhodes and Leona B. Carpenter Curator of East Asian Art at the Virginia Museum of Fine Arts, and Hou-mei Sung, Curator of Asian Art at the Cincinnati Art Museum. Zhang Weixing, a leading archaeologist from Emperor Qin Shihuang's Mausoleum Site Museum, also contributed an illuminating essay that brings new research to the field of Chinese art history and archaeology. Li Jian and Hou-mei Sung were assisted by William Neer, VMFA's Curatorial Assistant for East Asian Art.

The exhibition is organized by the Virginia Museum of Fine Arts and the Cincinnati Art Museum, in partnership with Shaanxi Provincial Cultural Relics Bureau, Shaanxi Cultural Heritage Promotion Center, and Emperor Qin Shihuang's Mausoleum Site Museum of the People's Republic of China. It has been a pleasure working in partnership with Cameron Kitchin, the Louis and Louise Dieterle Nippert Director of the Cincinnati Art Museum, where the exhibition will travel after VMFA. The exhibition would not have been possible without the considerable effort and congeniality of our colleagues at the Shaanxi Provincial Cultural Relics Bureau: Zhao Rong, Director; Luo Wenli, Deputy Director; and Zhang Tong, Director of the Division of Cultural Promotion & Cooperation; and Qiang Yue, Director of the Shaanxi Cultural Heritage Promotion Center. VMFA is also greatly indebted to the many generous lenders to the exhibition, among them being the Emperor Qin Shihuang's Mausoleum Site Museum, the Shaanxi Provincial Institute of Archaeology, and the Shaanxi History Museum. Last, and most important, I would like to thank Guan Qiang and Duan Yong of China's State Administration of Cultural Heritage in Beijing and our dear friend and counsel, Li Hong, Minister Counselor for Cultural Affairs, from the Embassy of the People's Republic of China in Washington, DC.

At the Virginia Museum of Fine Arts gratitude is extended to Li Jian, the brilliant E. Rhodes and Leona B. Carpenter Curator of East Asian Art. I have been working with her for nearly three decades—first at the Dayton Art Institute and now at VMFA. She is not only the curator of this stunning exhibition but also the architect of a strong partnership with our colleagues across China.

Since 1998, Li Jian and I have been responsible for four exhibitions that traveled from China to the US. In planning this exhibition, Li Jian was ably supported by VMFA's excellent staff, including Dr. Michael Taylor, Chief Curator and Deputy Director for Art and Education, who provided curatorial guidance and oversaw exhibition and education programs; Courtney Freeman, Director of Exhibitions Planning, and Courtney Burkhardt, Manager of Exhibitions, who provided great assistance with the intricate details of the exhibition; Stephen Bonadies, Senior Deputy Director for Collections and Chief Conservator, as well as his excellent team of conservators, registrars, and art preparators; and Jan Hatchette, Deputy Director for Communications, and her talented and dedicated team.

This exhibition would not have been possible without the generous support of our sponsors. *Terracotta Army: Legacy of the First Emperor of China* is presented by Altria Group and the E. Rhodes and Leona B. Carpenter Foundation. Other contributing sponsors include the Julia Louise Reynolds Fund, the Anne Carter and Walter R. Robins, Jr. Foundation, Virginia H. Spratley Charitable Fund II, Dr. Donald S. and Beejay Brown Endowment, The Community Foundation *Serving Richmond & Central Virginia*, Mrs. Frances Massey Dulaney, Jeanann Gray Dunlap Foundation, Dr. and Mrs. Steven E. Epstein, Frank Qiu and Ting Xu of Evergreen Enterprises, Norfolk Southern Corporation, Richard S. Reynolds Foundation, Stauer, Mr. and Mrs. Fred T. Tattersall, Ellen Bayard Weedon Foundation, and YHB | CPAs & Consultants. My sincerest thanks to all of the sponsors for their close work with our dedicated Advancement staff and for their generous support of this landmark exhibition.

Finally, thank you to all of the staff, volunteers, and supporters of the Virginia Museum of Fine Arts for their exceptional work on this catalogue and the accompanying exhibition. On behalf of everyone who has had a hand in this collaborative endeavor, please enjoy this publication, which brings to light new scholarship related to one of the world's most important archaeological discoveries of the 20th century.

Alex Nyerges
Director, Virginia Museum of Fine Arts

Foreword

Nearly twenty-three centuries ago, a young king embarked on an ambitious quest, eventually establishing himself as First Emperor of China. His reign of audacious accomplishments, both political and artistic, began with the aspirations of a young man still in his teenage years. Yet even the early years were marked with prescience. His eventual tomb, now a remarkable archeological site and museum, is evidence of a desire for eternal life.

The Cincinnati Art Museum and the Virginia Museum of Fine Arts are proud to join with our esteemed colleagues and curators at the Shaanxi Province museums to tell the story of the Qin dynasty through the people, artifacts, and cultural production of one of the most powerful and far-reaching societies yet known to historians. Alex Nyerges, Li Jian, Hou-mei Sung, and I journeyed to China in 2015 to forge an expanded relationship among our museums and between our nations, built on decades of successful exchange and the deepest respect. Our coterie of two American museum directors and two talented curators met with wonderfully generous museum officials in Xi'an and beyond. We remain immensely grateful for the partnership and the invitation for the Cincinnati Art Museum to collaborate to bring the splendor of China to our museums and visitors.

As much as has been discovered about the Qin period and the terracotta army, continual research is bringing new insights each year. It is my hope that this catalogue and accompanying exhibition contribute substantially to this endeavor. The depth of inquiry into the First Emperor and the focus of over 130 treasures assembled across more than a dozen Shaanxi museums represent exciting new scholarship. I am particularly pleased that Zhang Weixing of Emperor Qin Shihuang's Mausoleum Site Museum has honored us with his writing.

Thank you to our friends in China: Shaanxi Provincial Cultural Relics Bureau, Emperor Qin Shihuang's Mausoleum Site Museum, Shaanxi Provincial Cultural Heritage Bureau, Shaanxi Provincial Institute of Archaeology, Shaanxi History Museum, and Shaanxi Cultural Heritage Promotion Center. Our most sincere thanks to all of the cultural officials who guided us along the way and without whom this exchange would not have been possible: Beijing's State Administration of Cultural Heritage, the Embassy of the People's Republic of China, Li Hong, Guan Qiang, Duan Yong, Zhao Rong, Luo Wenli, Zhang Tong, Qiang Yue, and many others.

In Cincinnati, Susan Hudson, Kim Flora, Lauren Walker, Jenifer Linnenberg, David Linnenberg, Jill Dunne, Emily Holtrop, Serena Urry, Kirby Neumann, and Kristen Vincenty are just a few among the many talented and dedicated staff and volunteers responsible for bringing this project to fruition. In addition, Board of Trustees Chairman Jon Moeller's in-depth experience and learning in China offered an essential advantage to the project team, as did Board President Andrew DeWitt's leadership from our generous community.

In Cincinnati, the outpouring of support for *Terracotta Army: Legacy of the First Emperor of China* begins with the Harold C. Schott Foundation, supporting major rigorous exhibition projects at the museum. Key funding was also provided by CFM International, the John and Dorothy Hermanies Fund, the E. Rhodes and Leona B. Carpenter Foundation, Christie's, Elizabeth Tu Hoffman Huddleston, and the Jeanann Gray Dunlap Foundation. The exhibition and the catalogue in your hands are evidence and outcomes of their strategic giving. On behalf of the entire community and our trustees, I offer my sincerest thanks to all.

Cameron Kitchin
Director, Cincinnati Art Museum

Exhibition Lenders

寶雞青銅器博物館
Baoji Bronze Ware Museum

寶雞市陳倉區博物館
Baoji Municipal Chencang District Museum

寶雞市考古工作隊
Baoji Municipal Archaeological Team

寶雞周原博物館
Baoji Zhouyuan Museum

寶塔區文物管理所
Baota District Institute of Cultural Relics

秦始皇陵博物院
Emperor Qin Shihuang's Mausoleum Site Museum

扶風縣博物館
Fufeng County Museum

隴縣博物館
Longxian County Museum

洛川縣博物館
Luochuan County Museum

陝西歷史博物館
Shaanxi History Museum

陝西省考古研究院
Shaanxi Provincial Institute of Archaeology

西安博物院
Xi'an Museum

咸陽市文物考古研究所
Xianyang Municipal Institute of Cultural Relics and Archaeology

延安市文物研究所
Yan'an Municipal Institute of Cultural Relics

Assistance in planning the exhibition was provided by the following individuals at institutions in the People's Republic of China:

陝西省文物局	**Shaanxi Provincial Cultural Relics Bureau**	
趙榮	Zhao Rong	Director, Shaanxi Provincial Cultural Relics Bureau
羅文利	Luo Wenli	Deputy Director, Shaanxi Provincial Cultural Relics Bureau
張彤	Zhang Tong	Director, Division of Cultural Promotion & Cooperation
張陽	Zhang Yang	Assistant, Division of Cultural Promotion & Cooperation
劉嘉	Liu Jia	Assistant, Division of Cultural Promotion & Cooperation

陝西省文物交流中心	**Shaanxi Cultural Heritage Promotion Center**	
強躍	Qiang Yue	Director, Shaanxi Cultural Heritage Promotion Center
文軍	Wen Jun	Chief, Department of Cultural Relics Exchange
程俊	Cheng Jun	Manager, Office of Administration
許晨	Xu Chen	Assistant Manager, Office of Administration
張正	Zhang Zheng	Project Manager, Department of Cultural Relics Exchange
王春燕	Wang Chunyan	Project Assistant, Department of Cultural Relics Exchange
郭徽	Guo Hui	Project Assistant, Department of Cultural Relics Exchange
宋暘	Song Yang	Project Assistant, Department of Cultural Relics Exchange
田麗娜	Tian Lina	Project Assistant, Department of Cultural Relics Exchange
周永興	Zhou Yongxing	Staffer
孫強	Sun Qiang	Staffer
王巧英	Wang Qiaoying	Staffer
王向農	Wang Xiangnong	Staffer
倪元	Ni Yuan	Staffer
張蒙	Zhang Meng	Staffer
趙苗	Zhao Miao	Staffer
王濤	Wang Tao	Staffer

展覽籌展人	**Individuals who provided curatorial assistance with the exhibition**	
由更新	You Gengxin	Emperor Qin Shihuang's Mausoleum Site Museum
王望生	Wang Wangsheng	Shaanxi Provincial Institute of Archaeology
呼嘯	Hu Xiao	Shaanxi History Museum
伏海翔	Fu Haixiang	Xi'an Museum
張華	Zhang Hua	Yan'an Municipal Institute of Cultural Relics
胥小平	Xu Xiaoping	Baoji Municipal Cultural Relics & Tourism Bureau

Acknowledgments

The idea for a terracotta army exhibition was conceived in 2009 as the expansion of the Virginia Museum of Fine Arts was nearing completion. In 2014, after VMFA presented *Forbidden City: Imperial Treasures from the Palace Museum, Beijing*, we were able to turn our full attention to planning the current exhibition. The following year, we traveled with Alex Nyerges, Director of VMFA, and Cameron Kitchin, Director of the Cincinnati Art Museum, to Xi'an, where we visited numerous museums and partnered with the Shaanxi Provincial Cultural Heritage Promotion Center to organize this exhibition. In 2015–16, we traveled together to Tokyo and Taipei and then separately to Chicago to view the terracotta army exhibitions in those cities; in trips arranged by our Xi'an partner, Li Jian traveled from Xi'an to Longxian, Baoji, Fengxiang, and Xianyang, visiting museums and excavated sites in those locations.

We would like to extend our gratitude to the many individuals who inspired our work and assisted us with this project: from Shaanxi Provincial Cultural Heritage Promotion Center, Zhang Zheng, the project manager, and Guo Hui and Wang Chunyan, the project assistants, for communicating with all lenders and multilevel institutes and for their hospitality and support during each of our visits; from Longxian County Museum, Director Wang Quanjun, Zhang Zhiming, and Sun Xiaoli, for assisting with the selection of objects in storage; from Baoji Archaeological Institute, Deputy Director Wang Hao, for good conversation about regional excavations over a dinner; Director Yu Cailing of Fengxian County Museum, for her personal tour of the museum with her staff; Director Yao Yang of Xianyang Palace Site Museum, for his knowledge about the Xianyang capital and his tours of the gallery and palace remains; scholars Qin Zaoyuan and Shao Anding from Shaanxi Provincial Institute of Archaeology, for their support and for introducing Carol Mattusch to the Archaeology Forum project; from Shaanxi History Museum, Exhibition Manager Liu Wei, for his support in selecting objects; and archaeologist Zhang Weixing from Emperor Qin Shihuang's Mausoleum Site Museum, for contributing an essay to this catalogue. Thanks to curator Kawamura Yoshio, Tokyo National Museum; curator Tsai Ching-Liang, National Palace Museum; curator Zhixin Jason Sun, Metropolitan Museum of Art; and project manager Tom Skwerski, Field Museum, for giving insightful tours of their exhibitions. Thanks also to our colleague He Li, curator from the Asian Art Museum, San Francisco, for imparting her knowledge and making valuable suggestions after carefully reviewing this catalogue's manuscript.

At VMFA, William Neer and Wei Huang made invaluable contributions as curatorial assistants in the past two years; Courtney Burkhardt served as this exhibition's project manager, working closely with staff at VMFA and CAM and with our partners in Xi'an. We also extend our appreciation to the following at VMFA for contributing their expertise: registrar Kelly Burrow, conservator Sheila Payaqui, exhibition designer Trang Nguyen, and educator Lulan Yu. For their leadership and support at VMFA, we are grateful to Alex Nyerges, Director; Michael Taylor, Chief Curator and Deputy Director for Art and Education; and Lee Anne Chesterfield, Director of Museum Planning and Board Relations.

At CAM, this exhibition was made possible under the leadership of Cameron Kitchin, Director. We also express our appreciation to the following individuals for their dedication and expertise: Susan Hudson, Director of Collections and Exhibitions; exhibition designer Lauren Walker; Kim Flora and the whole team in Design and Installation; associate registrar Jenifer Linnenberg; Emily Holtrop, Director of Learning and Interpretation; and curatorial assistant Lynne Pearson. The catalogue also received generous support from Beth Huddleston, to whom we offer our heartfelt gratitude.

We are most grateful to editor Lucy Grey, for her careful attention to detail and her guidance in shaping content; graphic designer John Hoar for his talented work on every page, including the excellent maps and illustrations; and Sarah Lavicka, Chief Graphic Designer, and Rosalie West, Editor in Chief, for overseeing the publication of this catalogue.

Li Jian
E. Rhodes and Leona B. Carpenter Curator
of East Asian Art, Virginia Museum of Fine Arts

Hou-mei Sung
Curator of Asian Art, Cincinnati Art Museum

Qin Chronology

2100–1600 BC	**Xia dynasty**
1600–1046 BC	**Shang dynasty**
1046–256 BC	**Zhou dynasty**

Western Zhou dynasty (1046–771 BC)

Eastern Zhou dynasty (770–256 BC)

Spring and Autumn period (770–476 BC)

770 BC	Qin established as a vassal state of the Zhou dynasty at Qinyi
762 BC	Qin relocated the capital to Qianweizhihui
753 BC	Qin appointed court officials to record history
714 BC	Qin relocated its capital to Pingyang
677 BC	Capital relocated to Yongcheng
600 BC	Birth of Laozi, author of *The Way of Dao*
551 BC	Birth of Confucius
547 BC	Birth of Sunzi, author of *The Art of War*

Warring States period (475–221 BC)

386 BC	Seven states formed (Qi, Chu, Yan, Han, Zhao, Wei, and Qin)
356 BC	Military and Legalist reforms began under Shang Yang
350 BC	Qin capital relocated to Xianyang; second reforms began under Shang Yang
318 BC	Wei united with Qi, Chu, Yan, Zhao, and Han against Qin
259 BC	Birth of Ying Zheng (Qin Shihuang, First Emperor of Qin)
256 BC	Qin defeated Zhou dynasty
246 BC	King Ying Zheng of Qin enthroned
241 BC	Qin defended against attacks from Chu, Zhao Wei, Han, and Yan states
238 BC	Ying Zheng inaugurated at Yongcheng
230 BC	Qin defeated Han state
228 BC	Qin defeated Zhao state
227 BC	Jing Ke of Yan attempted assassination of Ying Zheng
226 BC	Qin seized Yan's capital in present-day Beijing
225 BC	Qin flooded Wei's capital of Daliang and defeated Wei state
223 BC	Qin seized Chu's capital
222 BC	Qin captured king of Yan and defeated Yan state

221–206 BC	**Qin dynasty**

221 BC	Qin defeated Qi; Ying Zheng unified China and proclaimed himself First Emperor
221 BC	Standardization of currency, measurement units, and script enacted
220 BC	Construction of a nationwide network of roads began
215 BC	Qin campaigned against Xiongnu
214 BC	Five-year construction of the Great Wall began; Ling Canal completed; Qin unified Baiyue
213 BC	Burning of books ordered by First Emperor
212 BC	Construction of Erpang Palace began; imperial highway (*zhidao*) built
210 BC	Death of First Emperor
209 BC	Huhai ascended the throne; Chen Sheng's rebellion took place
207 BC	Xiang Yu defeated Qin forces; Ziying ascended the throne following Huhai's death; Liu Bang defeated Qin forces
206 BC	Liu Bang seized Qin capital of Xianyang; Qin dynasty ended

206 BC–AD 220	**Han dynasty**

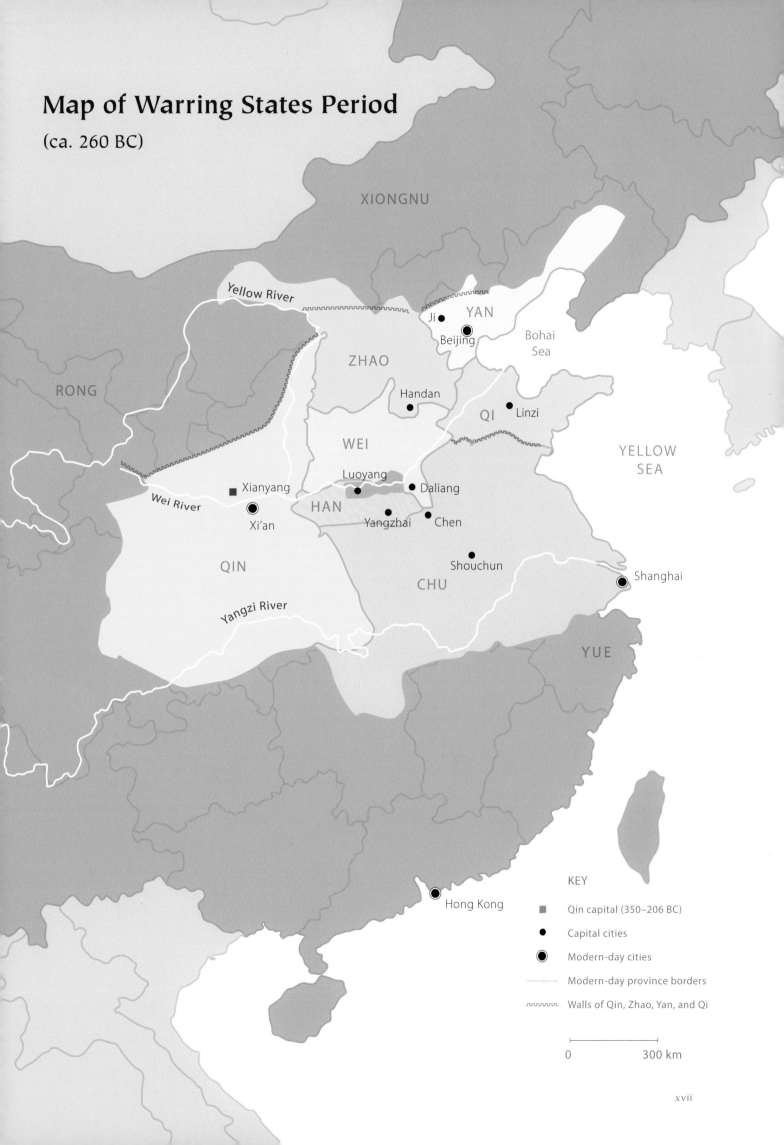

Map of Warring States Period

(ca. 260 BC)

XIONGNU

Yellow River

RONG

ZHAO

YAN

Ji •
• Beijing

Bohai
Sea

Handan •

WEI

QI
• Linzi

YELLOW
SEA

Luoyang •
Xianyang ■
Wei River
Xi'an ⊙

HAN

Daliang •

Yangzhai •
• Chen

QIN

Shouchun •

CHU

Shanghai ⊙

Yangzi River

YUE

KEY

Hong Kong ⊙

▪ Qin capital (350–206 BC)

• Capital cities

⊙ Modern-day cities

Modern-day province borders

〰〰〰 Walls of Qin, Zhao, Yan, and Qi

0 300 km

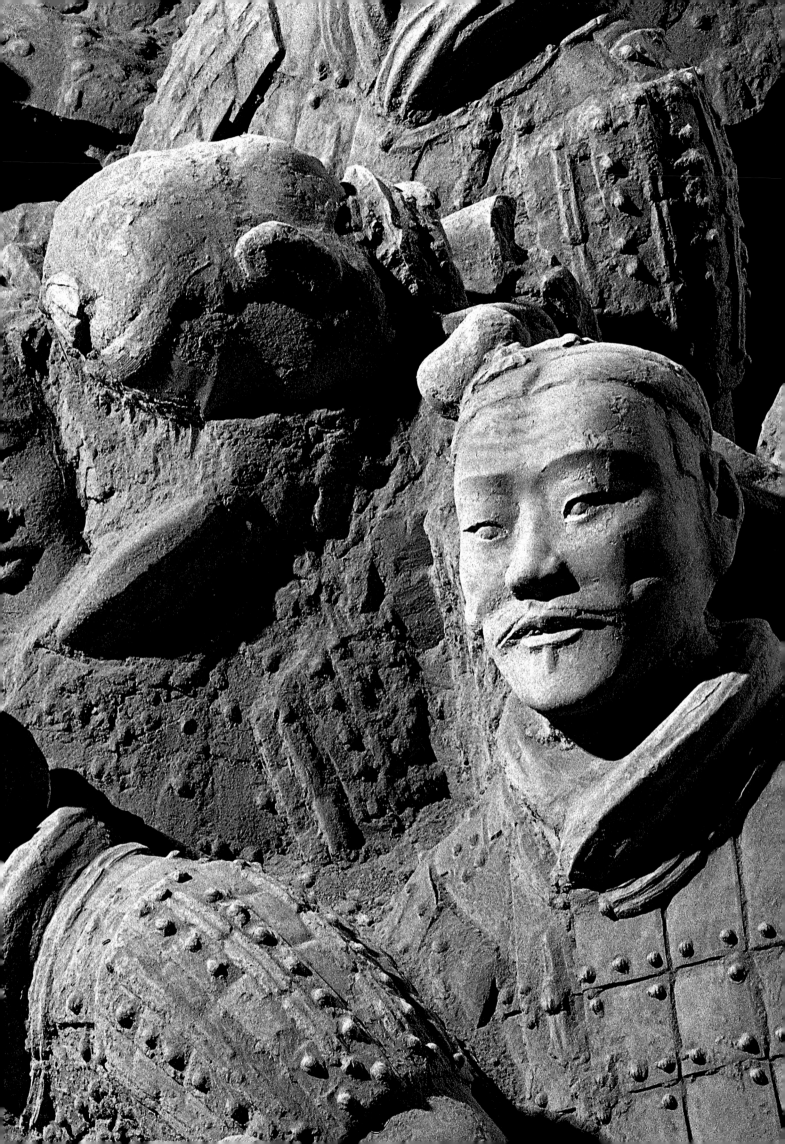

Terracotta Army
Legacy of the First Emperor of China

Li Jian

Produced in conjunction with the exhibition *Terracotta Army: Legacy of the First Emperor of China*, this catalogue presents archaeological discoveries that trace the history of the Qin people and Ying Zheng (259–210 BC), later known as the First Emperor of Qin, or Qin Shihuang. Once merely a tribe and then a vassal state of the Zhou dynasty, the Qin developed into a conquering power among rival states and ultimately an empire. As king of the Qin, Ying Zheng defeated the warring states, centralized authority, and declared himself First Emperor in 221 BC. His seminal reforms established a unified country, setting the course for China's cultural identity and an imperial system that continued for the next two thousand years. In addition to his political pursuits, the First Emperor's determined quest for immortality produced his other enduring legacy: nearly eight thousand life-size terracotta figures created for his afterlife. The First Emperor's "terracotta army," discovered in 1974, is known as one of the most astounding archaeological discoveries of the 20th century. Ongoing excavations in the First Emperor's grand mausoleum complex—which includes a double-walled area, the emperor's tomb mound, and various burial pits and tombs within and beyond its walls—have deepened our understanding of the history, myths, and burial customs of ancient China.

Selected from fourteen museums and archaeological institutes throughout Shaanxi Province, the more than 130 objects presented here date from the Zhou dynasty (1046–256 BC) through the Qin dynasty (221–206 BC). In addition to ten life-size terracotta figures, the catalogue features objects made of gold, jade, precious stones,

bronze, ceramics, and limestone, as well as weapons, armor, horse and chariot ornaments, jewelry, household objects, and architectural components. Organized in three sections, the catalogue provides a historical and cultural backdrop while examining the significance of archaeological discoveries and offering insights from the most recent scholarship on Qin material culture, illuminating our knowledge of not only Qin history but also the powerful influence of China's first emperor and his lasting impact on the nation.

Section I recounts the First Emperor's rise to power out of the Qin state and the changes he implemented, including political, economic, and cultural reforms that unified the country. Section II examines Qin's evolution over five hundred years from a vassal state to a powerful empire, Qin migration eastward from mountainous areas to fertile land, and the adoption of artistic styles and traditions from neighboring cultures. The objects represent major Qin capitals across Shaanxi Province—from Longxian and Baoji in the west, to Fengxian and Xianyang in the central province—as well as nomadic cultures in the north. They trace Qin footprints at different stages in its expansion and often reflect the styles of neighboring cultures. Section III presents the First Emperor's quest for immortality. By examining terracotta figures, bronze weapons, and architectural components, this section investigates the strength of the Qin military, royal burial customs, and ancient Chinese beliefs about the afterlife. Soon after the First Emperor's sudden death in 210 BC, the short-lived Qin dynasty collapsed. However, Qin culture and the First Emperor's influence shaped succeeding dynastic systems of governance in China for two thousand years.

Terracotta Warriors
in Pit 1 of the
mausoleum complex

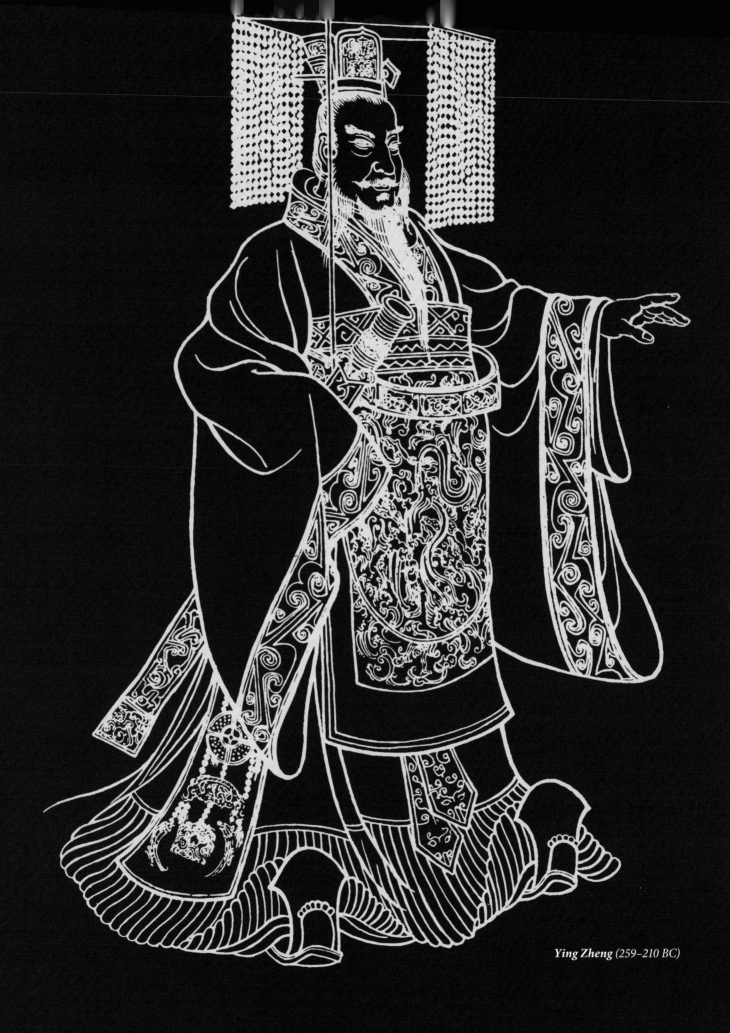

Ying Zheng (259–210 BC)

The First Emperor and Unification of China

Li Jian

One of seven competing states that formed a unified China, the Qin evolved from a small tribe to a vassal state and finally an empire after the Zhou dynasty (1046–256 BC). The future first emperor of China, Ying Zheng (259–210 BC), became king of the Qin state at the age of thirteen. Not until the age of twenty-two did he gain full control of the state following his formal coronation at the ancient Qin capital of Yongcheng in 238 BC. During King Ying Zheng's reign, the Qin outgrew the other six states politically, economically, and militarily. In a series of military campaigns, the Qin defeated the Han in 230 BC, seized the Zhao's capital in 228 BC, and swept the Wei in 225 BC. In 223 BC, the Qin defeated the southern state of Chu, paving the way for its final conquests of the Yan and Qi in 222 BC and 221 BC and ending the Warring States period after hundreds of years of turmoil. Ying Zheng, at the age of thirty-nine, unified the states to form one nation under the title "Qin Shihuang," meaning First Emperor of Qin (r. 221–210 BC).

The First Emperor ruled from the last capital of Qin, Xianyang, which was built in 350 BC as part of Chancellor Shang Yang's reforms. In Xianyang, the First Emperor implemented a series of political and economic reforms and transformed the state of Qin into a powerful empire, controlling all of ancient China. As one of his first tasks, the First Emperor turned to Chinese cosmology and the Five Elements (metal, wood, water, fire, and earth), selecting water and its corresponding color, black, to represent Qin dynastic identity and to ensure its success. He divided his empire into thirty-six commanderies and a thousand counties, which he ruled from a centralized government. To legitimize his control, he sent his men out in search of the bronze *ding* vessel used by the preceding Zhou court to symbolize the transfer of power. He also erected stone steles at Mount Tai to commemorate his political triumph as being aligned with the cosmic order.

The First Emperor ordered his officials to simplify the surviving writing style and create a universal system for writing, known as Qin script or small seal script. He revoked the currencies circulated in six of the seven former states and authorized the issuance of new national currency. He revised units for weights and measurements to promote trading across the empire, and he ordered the construction of a national network of roadways. Regarding defense, he called for the destruction of forts and barriers built between the borders by earlier individual states, and he linked their existing walls along the northern border into one wall, known today as the Great Wall, which over centuries since the Qin dynasty has been lengthened to 5,500 miles. In only ten years, the First Emperor unified China, invented centralized government, and established China's imperial system, greatly influencing Chinese culture not only during his historic reign but for the next two thousand years.

After unification of the country, the First Emperor amassed book collections from the six defeated states and summoned seventy court scholars and two thousand students to study and catalogue these collections. By 213 BC, the aristocracy of the six states wanted to revert from the new government and its policies. Facing such challenges, the First Emperor accepted Chancellor Li Si's advice and ordered the burning of former states' private collections of historical records and poetry, except those on medicine, divination, landscaping, and craftsmanship. The Qin court retained its own collection. While viewed by some scholars as ruthless, the order is regarded by others as a protective measure that preserved ideological integrity and cultural identity. In 212 BC, necromancers (*fangshi*) and intellectuals were accused of abusing their court standing and wasting state funds in attempts to acquire immortal medicine. When faced with criticism, they either attempted to escape or publically disparaged the First Emperor, who then allegedly ordered their execution.

1 秦始皇帝陵1號銅車馬複製品

***Chariot No. 1 with Horses* (replica)**

Qin dynasty (221–206 BC)

Bronze, pigment

H. 152 cm (59.9 in.), L. 225 cm (88.6 in.), W. 179 cm (70.5 in.)

Excavated from Bronze Chariots Pit, Qin Shihuang's Mausoleum, 1980

Emperor Qin Shihuang's Mausoleum Site Museum, MMYL007

Shortly after the discovery of the terracotta army, two painted bronze chariots, each drawn by four bronze horses, were excavated from a small pit immediately west of the central burial mound. Produced in half the scale of the wooden chariots and horses found alongside the terracotta figures, the pair of bronze chariots most likely represents the First Emperor's royal convoy that traveled across China following unification.

The original bronze chariots have never before left China. This chariot, the "standing chariot," would have led the second one, the covered "sedan chariot," in processions. This chariot features a rectangular carriage on two wheels drawn by four barebacked horses. An unarmored charioteer with a sheathed long sword stands holding the reins of the horses underneath an open parasol. The carriage is intricately cast, both its interior and exterior decorated in clouds and geometric designs, and the parasol's handle is inlaid with gold and silver. A shield, crossbow, and quiver are mounted onto the carriage walls, and its four white horses are adorned with gold, silver, and bronze bridle components. (WN)

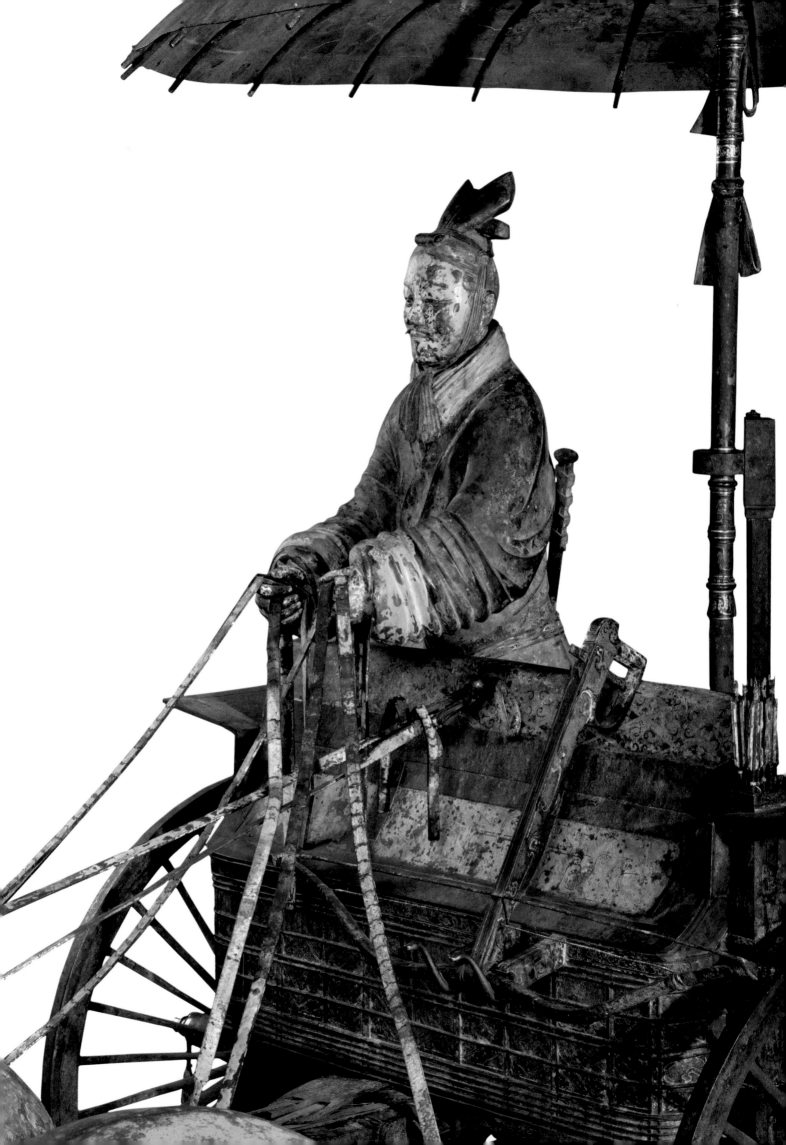

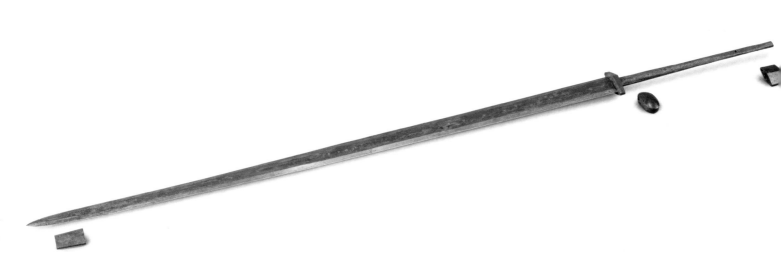

2 秦 青銅長劍 秦始皇帝陵兵馬俑1號坑

Long Sword

Qin dynasty (221–206 BC)

Bronze

L. 93.5 cm (37.2 in.)
Excavated from Pit 1, Qin Shihuang's Mausoleum, 1990
Emperor Qin Shihuang's Mausoleum Site Museum, 002522

The Qin military considered swords, which were more structurally complex than other weaponry, to be status symbols and issued them only to high-ranking military officials. This long bronze sword is one of only a few examples found in the terracotta army pits. It is composed of a precise copper-tin alloy, making its blade slender and elastic. Its handle and body were formed in a single cast then polished and treated with chromium oxide. The Qin's ancient chromium coating process prevented corrosion and strengthened weaponry, and it predates modern usages of oxidized chrome by more than two thousand years.

The blade's point and edges are still sharp, and the narrow, grayish-yellow blade features three raised ridges on either side. A guard, pommel, and cord-wrapped grip were attached to the double-handed hilt afterward, and the sword was then stored in a sheath made of wood, linen, and silk. Bronze fittings were placed over the bottom and side of the sheath, stopping the blade from piercing through and allowing the weapon to be suspended and worn. (WN)

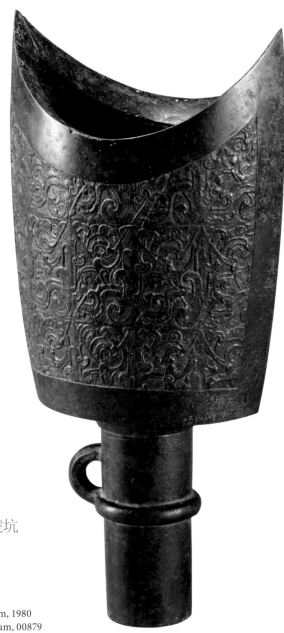

3 秦 青銅鐃 秦始皇帝陵兵馬俑1號坑

Battle Bell
Qin dynasty (221–206 BC)
Bronze
Overall H. 25.9 cm (10.2 in.)
Excavated from Pit 1, Qin Shihuang's Mausoleum, 1980
Emperor Qin Shihuang's Mausoleum Site Museum, 00879

The Qin military utilized bells and drums on the battlefield to signal commands and formations. This bronze battle bell (*nao* or *zheng*), excavated from Pit 1 amid chariot remains and wooden mallets, features an arching lip, rounded sides, and a small loop on its stem. Originally the bell would have been suspended from a wire or mounted upside down on a wooden shaft. Its surface is divided into a grid of fifteen squares with ornate, dragon-like scroll designs on each one. Since every striking point produced a distinct tone, where and how many times the bell was struck conveyed commands to pause, retreat, or cease fire. (WN)

Horse Ornaments

The horse played a significant role in the early development of Qin society. Like their Eurasian Steppe neighbors, the Qin people embraced horse domestication, including herding and training. When the horse became the Qin's primary means of transportation during the Spring and Autumn period (770–476 BC), it transformed society by speeding up travel, making long-distance trade feasible, and intensifying warfare.

Excavations of early Qin tombs at the Bianjiazhuang cemetery in Longxian and at Qin Shihuang's mausoleum have yielded rich archaeological evidence such as bridle fittings, sacrificial horse remains, and decomposed wooden chariots. The bridle is comprised of a snaffle bit, a halter, and the reins. The halter consists of a headband, brow piece, noseband, cheek pieces, and throatlatch, as well as rosettes and joints. The reins fastened at the bit rings extend backward to the rider, and those affixed to the wooden yoke connect to the carriage and the axle. Over time, all leather pieces decomposed, and only harnesses survived. (LJ)

4 秦 金當盧 秦始皇陵銅車馬陪葬坑

Brow Piece
Qin dynasty (221–206 BC)
Gold

H. 9.6 cm (3.8 in.), W. 4.7 cm (1.8 in.)
Excavated from Bronze Chariots Pit, Qin Shihuang's Mausoleum, 1980
Emperor Qin Shihuang's Mausoleum Site Museum, 004492

This finely crafted leaf-shaped gold plate ornamented a horse's brow. A horizontal loop is soldered underneath for attaching the halter strap to prevent it from slipping back over the horse's ears or down its neck. Embossed with a cicada motif, which symbolized rebirth and immortality, this brow piece was found on the head of a bronze horse in the pit of bronze chariots, located west of the First Emperor's burial mound and between the inner and outer walls of the mausoleum. (LJ)

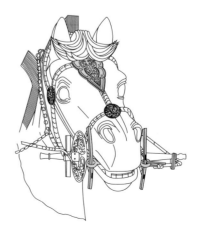

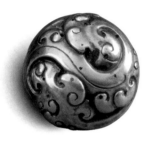

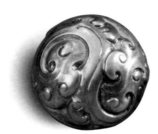

5, 6, 7 秦 金銀圓泡形節約 秦始皇陵銅車馬陪葬坑

Three Rosettes

Qin dynasty (221–206 BC)

Gold, silver

Dia. 2.44–2.48 cm (1 in.)
Excavated from Bronze Chariots Pit, Qin Shihuang's
Mausoleum, 1980
Emperor Qin Shihuang's Mausoleum Site Museum, 004477,
004505, 004500

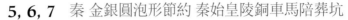

Miniscule yet lavish, these gold and silver rosettes display stylized serpent designs amid swirling cloud motifs in high relief. The flat back of each ornament includes two to four vertical and horizontal loops used for fastening bridle straps. The bronze horse excavated near the mausoleum complex features one brow piece (cat. no. 4), two gold rosettes, and three silver rosettes. The gold brow piece is placed upon the forehead, the two gold rosettes on each cheek, one silver rosette on the nose, and the other silver rosette on the upper cheek. (LJ)

Qin Goldwork

Gold products entered the territory of Northern China during the Shang dynasty (1600–1046 BC) through interaction and trade with people of the Eurasian Steppe, a vast region to the north that stretched from the Black Sea to Mongolia. In the following centuries, the Western Zhou court produced their first group of gold ornaments after Steppe examples. The Qin further developed gold craftsmanship and became the leader among the vassal states in both the quantity and quality of their gold production, which required high temperatures and sophisticated techniques. By the mid-to-late Warring States period (475–221 BC), the Qin court had established its own workshops to manage the production and distribution of gold. Silver production required even more complex techniques of processing and refining because its minerals contained more impurities. Archaeological examples of the remarkable workmanship of Qin goldsmiths include personal accessories, weapons, and horse ornaments. (LJ)

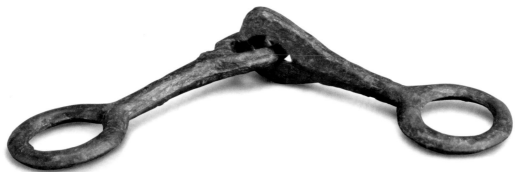

8 春秋 青銅馬銜 隴縣邊家莊

Snaffle Bit, 8th century BC
Spring and Autumn period (770–476 BC)
Bronze

L. 24 cm (9.4 in.)
Excavated from Bianjiazhuang, Longxian, 1986
Longxian County Museum, 2010L3406

The snaffle bit enables a rider to control the direction
and speed of a horse with the aid of the reins.
Archaeological evidence found in tombs shows that
the snaffle bit dates back in China to the Shang dynasty
(1600–1046 BC). At the Bianjiazhuang cemetery, one
or two snaffle bits were found in the mouth of a horse's
skull, surrounded by various other bronze bridle fittings.

This jointed snaffle bit would have been placed across
the tongue of a horse, setting the rings at the outer corners
of the horse's mouth. The reins would have passed through
the bit rings to be handled by a rider. (LJ)

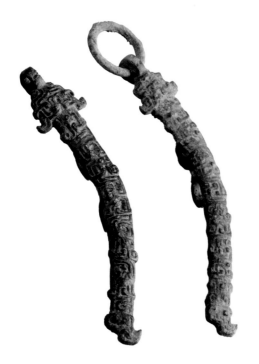

9.1–2 春秋 青銅馬鑣 隴縣邊家莊

Pair of Cheek Pieces
Spring and Autumn period (770–476 BC)
Bronze

L. 12.7–15 cm (5–5.9 in.)
Excavated from Bianjiazhuang, Longxian, 1987
Longxian County Museum, 2010L3621, 2010L3210

Each of these cheek pieces is cast with an animal
head at its end and serpent motifs along its surface.
A cheek piece would pass through the fixed ring on
a snaffle bit (cat. no. 8) and rest at the corner of the
horse's mouth. The flat backside of the cheek piece
features two vertical loops used to fasten the cheek
straps onto a horse.

These devices gave the rider more control and
prevented bridle straps or reins from sliding across the
horse's mouth. The slightly curved shape of the cheek
piece reduced pressure on the horse's mouth and better
conveyed the rider's commands to the horse. (LJ)

Horse Chariots

As they expanded eastward, the Qin people embraced the traditions of nomadic cultures and the preceding Shang and Zhou dynasties, becoming proficient in chariot production themselves. Archaeological data reveals that a Qin chariot drawn by two or four horses would have featured two wheels with wooden spokes, a carriage, and a single shaft with a horizontal drawbar. While all wooden components decayed over time, bronze fittings and bridle ornaments survived to offer evidence of the chariot's role in Qin society.

According to ancient Chinese texts, the first horse-drawn chariot used for daily activities, hunting, and combat was developed during the Xia dynasty (2100–1600 BC) by Xi Zhong, a native of the state of Lu in today's Shandong Province. However, the earliest archaeological evidence dates the chariot to the 12th century BC during the Shang dynasty (1600–1046 BC). Chariots with horse implements were excavated in 1936 from a site in Yinxu, Anyang, Henan Province, and a two-wheel chariot track, dating to the 14th century BC, was discovered

in 1996 at Yanshi Shang city, Henan Province. In the areas ruled by the Western Zhou dynasty (1046–771 BC), chariots were a highly developed means of transportation used both in daily life and on the battlefield.

Privileged members of Qin society rode in wheeled horse-drawn chariots, while commoners traveled in carts pulled by donkeys, mules, or oxen. Luxurious chariots, which belonged exclusively to nobles and members of the royal family, were drawn by four horses and decorated with metal and paint. (LJ)

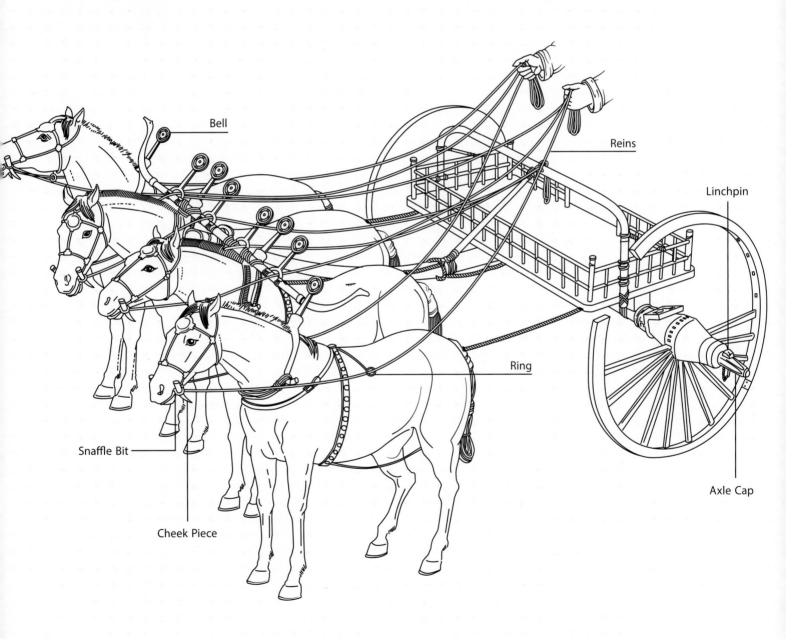

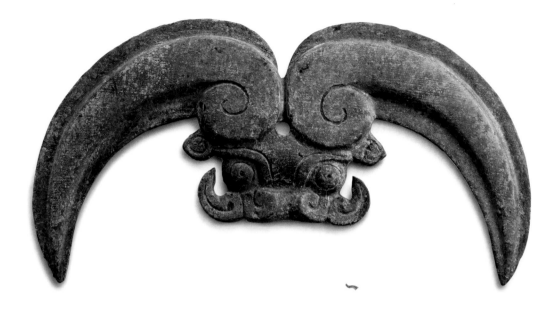

10 春秋 獸面鉤形銅飾 隴縣邊家莊9號墓

Mythical Animal Mask, 8th–7th century BC
Spring and Autumn period (770–476 BC)
Bronze

L. 16.5 cm (6.5 in.), W. 6.7 cm (2.6 in.)
Excavated from Tomb 9, Bianjiazhuang, Longxian, 1986
Longxian County Museum, 86L1017

Fashioned like a mythical animal, this mask features a
pair of large horns set above dramatically smaller ears
and bulging eyes. The mythical animal represents not
only the valiant nature of a horse but also the heroic
status of its owner.

The mask may have been used as a head guard placed
on the horse's forehead as protection during travel or
combat. Small holes pierced in the middle of the mask
indicate that it was sewn to backing material made
of leather or fabric, providing the horse comfort and
protection. Similar pieces were excavated in 1932–33
from Xincun, Xunxian, Henan Province, and from Pit 2
at Zhangjiapo, Shaanxi Province. (LJ)

11, 12 春秋 青銅節約 隴縣邊家莊

Two Bridle Joints, 8th–7th century BC
Spring and Autumn period (770–476 BC)
Bronze

H. 3.2–3.4 cm (1.2–1.3 in.)
Excavated from Bianjiazhuang, Longxian, 1987
Longxian County Museum, 2010L3542, 2010L3624

These small tubular pieces served as bridle joints
to connect various straps and reins when they
overlapped. Shaped like the letters "I" or "X," each
piece bears a motif signifying the mythological
animal known as *taotie*, which wards off evil spirits.
The reverse features a tiny hole for attachments.
In addition to bridle joints, other buried items
recovered at the Bianjiazhuang tombs include horse
skeletons, decayed wooden chariots, and bronze
bridle fittings such as snaffle bits, rosettes, and
bridle rings. (LJ)

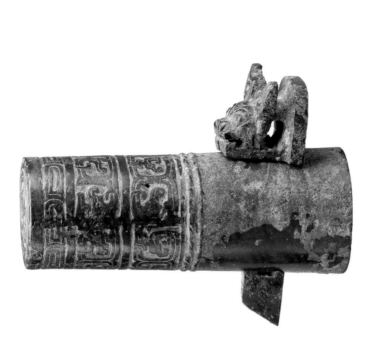

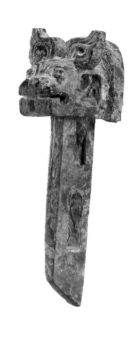

13 春秋 青銅重環紋虎頭車轄軎
隴縣邊家莊11號墓

Axle Cap with a Tiger-Head Linchpin
Spring and Autumn period (770–476 BC)
Bronze

L. (cap) 10 cm (4 in.), L. (linchpin), 10.2 cm (4 in.)
Excavated from Tomb 11, Bianjiazhuang, Longxian, 1986
Longxian County Museum, 2010L3465

This axle cap's tapered cylinder shape features a double-loop design and solid tiger-head linchpin. A protector against misfortune and evil spirits, the tiger symbolized victory in battle. Upon excavation, the heavy device was found capping the end of a nine-foot-wide axle on a decayed wooden chariot wheel. Archaeological evidence shows that the bronze axle cap first appeared in China with the development of wooden chariots during the Shang dynasty (1600–1046 BC).

The cap was intended to protect the wooden axle, which supported the carriage and wheels. A linchpin was inserted into a rectangular socket on the axle cap to fasten the wheels in place. A leather strap would pass through the tiny hole at the lower end of the pin to prevent it from spinning out. (LJ)

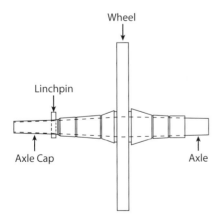

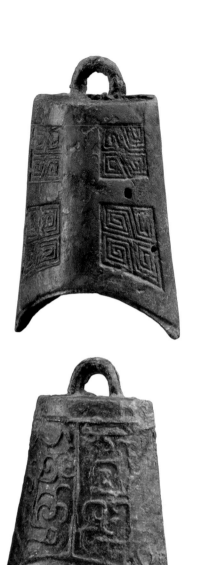

14.1–4 春秋 小銅鈴 隴縣邊家莊12號墓

Four Small Bells
Spring and Autumn period (770–476 BC)
Bronze

H. 8–8.4 cm (3.1–3.3 in.)
Excavated from Tomb 12, Bianjiazhuang, Longxian, 1987
Longxian County Museum, 2010L3209, L3476

The bells are uniformly shaped with arching rims and small loops used for hanging rattles. The ridges on both sides of the bells display joint marks, indicating they were cast as multiple pieces. Five ritual bronze vessels unearthed from the same tomb suggest the tomb occupant held an official title of counselor (*dafu*).

Similar bells have been excavated at Sunjianantou cemetery, which was located near an early Qin capital. They were discovered mostly around the remains of sacrificial horses and dogs, indicating their use as bridle and collar ornaments. Other examples were affixed to chariot drawbars and yokes where they rang their musical tones upon movement. At another tomb site, two bells were found at the corners of an outer coffin, indicating they were perhaps fastened onto a coffin's coverlet to expel evil spirits. (LJ)

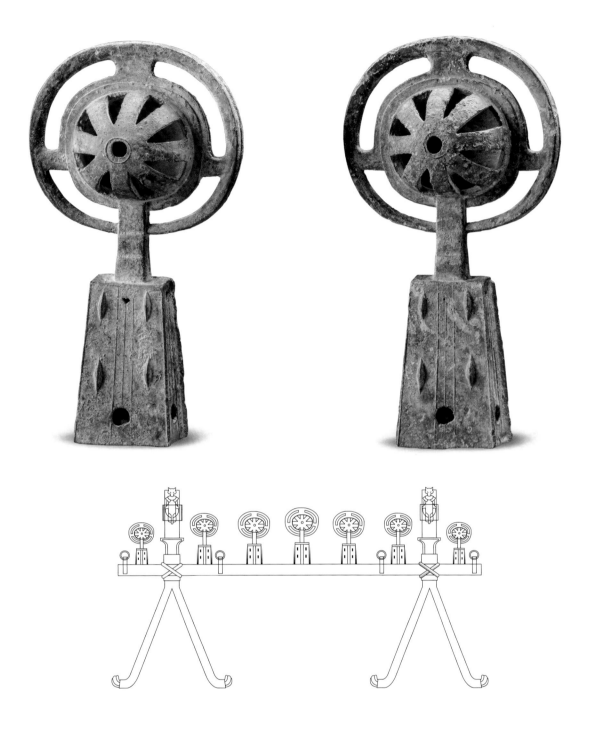

15, 16 西周 鑾鈴 扶風縣黃堆村1號墓

Chariot Bells, ca. 8th century BC
Western Zhou dynasty (1046–771 BC)
Bronze with turquoise inlay

H. 18.1 cm (7 in.)
Excavated from Tomb 1, Huangduixiang, Fufengxian, 1980
Baoji Zhouyuan Museum, 1316, 1317

These two bells with openwork decorations belong to a set of six bells unearthed from an aristocrat's tomb at Huangduixiang, ten miles north of Fufeng County. Each bell consists of an openwork design on the top and a trapezoid-shaped stand, a style inspired by the Rong nomads. During the Western Zhou dynasty, such bells, which were attached to a drawbar or a yoke on a horse-drawn chariot, indicated the passenger's social status when displayed in sets of two, four, six, or eight bells. The percussive sounds made by the loose metal balls of chariot bells were different than the sounds of ritual bells and reflected the pursuits of Zhou elites during that new era. The use of this type of chariot bell spread from the Western Zhou in today's Shaanxi Province eastward in the centuries that followed and declined by the end of the Warring States period (475–221 BC). (LJ)

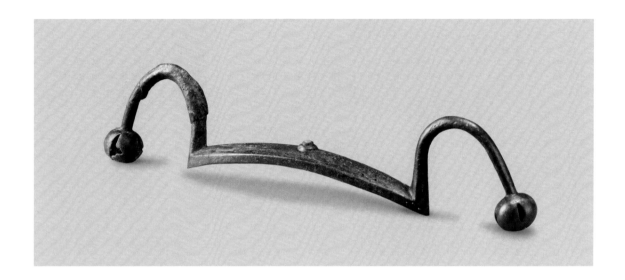

17 西周 青銅綠松石鑲嵌蟬紋弓形器

Bow-Shaped Object
Western Zhou dynasty (1046–771 BC)
Bronze with turquoise inlay
L. 36.5 cm (14.3 in.), W. 3.6 cm (1.4 in.)
Baoji Zhouyuan Museum, 3015

The name and function of this object, which lacks any mention in historical records, is uncertain. Its excavation alongside weapons suggests it was an archery accessory used to protect the bow. Others speculate that it may have been attached to a banner pole and used to summon hunters or warriors. Most recent interpretations assert that a charioteer might have worn such an implement on the right side of his waist, tying it to the reins to free his hands for other tasks.

This example has two cicada motifs on its long shaft, a piece of turquoise encrusted in the center, and two small rattles on the ends, which sounded when the chariot moved forward. A similar variety has been found along with chariots, weapons, and whips from Shang and Zhou aristocrats' tombs, dating between the 12th and 8th centuries BC. (LJ)

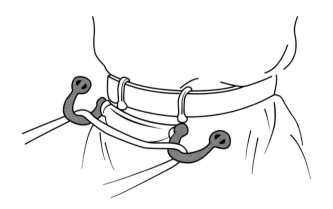

Xianyang: Qin Capital (350–206 BC)

The last capital of Qin, Xianyang, whose construction began in 350 BC, quickly became the largest city in China and was renowned for its extravagant palaces. After he was enthroned, the First Emperor launched ambitious construction projects ranging from palaces and shrines to his mausoleum complex and the Great Wall. One million people, one-tenth of the population, labored on these projects, which remain unmatched in Chinese history in terms of scale, quantity, and forced labor.

Although the city burned down in a rebellion led by Xiang Yu in 206 BC, Xianyang and its grandeur were documented by Han-dynasty historian Sima Qian (ca. 145–86 BC) in *Records of the Grand Historian (Shiji)*:

> On the banks of the Wei River are the palaces modeled after the architectural styles of the six defeated states. There are 145 palaces and 270 palace halls, connected by a network on the ground and elevated paths, forming a glorious metropolis.

Xianyang Palace No. 1 (see p. 99), a political center and royal residence, hosted court assemblies, celebratory functions, and state banquets. The palace was constructed in the reign of King Zhaoxiang (r. 306–251 BC). An archaeological survey determined it was 170 feet high, 1,770 feet wide, and 450 feet deep. Today an 18-foot-high terrace in ruins provides a grand and once-advantageous view of the landscape, with the Wei River to the south and the distant mountains to the north. (LJ)

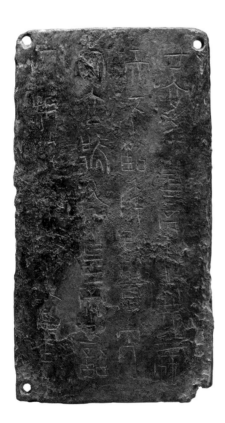

18 秦 銅詔版 蔣宗彝捐

Imperial Edict on Plaque, 221 BC
Qin dynasty (221–206 BC)
Bronze
H. 12.2 cm (4.8 in.), W. 6.6 cm (2.6 in.)
Gift of Jiang Zongyi, 1957
Shaanxi History Museum, 57.176

When the unification of China brought centuries of turmoil to an end, the First Emperor set in motion a series of economic, political, and cultural reforms. The imperial court issued an edict to standardize units of weights and measures, and it required that all Qin measuring devices bear the text of that edict. Either cast or chiseled onto weights, measures, or plates, the edict was issued across the country in 221 BC.

The text on this plaque is chiseled in small seal script, vertically from right to left. Like most Qin edicts, the uneven size and strokes of the characters show the spontaneous style of the artisan who inscribed it. (LJ)

Inscription: 二十六年，皇帝盡並兼天下諸侯，黔首大安，立號為皇帝，乃詔丞相狀綰，法度量則，不壹歉疑者，皆明壹之 (In the 26th year [221 BC], the Emperor unified all vassal states under heaven and the people are in great peace. The title of Emperor is established and the edict is issued to chancellors [Wei] Zhuang and [Wang] Wan to regulate standardized measures and weights, clarifying the incoherent, missing, and confusing, and transforming variety into oneness.)

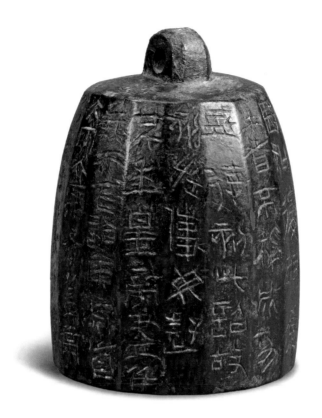

19 秦 兩詔銅權 秦始皇帝陵飤官遗址
Weight Inscribed with Two Edicts, 209 BC
Qin dynasty (221–206 BC)
Bronze
H. 7.3 cm (2.9 in.), Dia. 5.4 cm (2.1 in.)
Excavated from the Administrative Site, Qin Shihuang's Mausoleum, 1975
Emperor Qin Shihuang's Mausoleum Site Museum, 2787

Following the First Emperor's regulation of systems of measurements, his successor, Huhai (r. 209–207 BC), ordered that bell-shaped weights be cast to serve as standardized units for measuring. This example is one of three excavated from a site of offices and housing for administrative officials, situated between the western inner and outer walls of the mausoleum complex. Chiseled onto the exterior of this hollow, seventeen-facet weight are two sets of official edicts: a forty-character edict issued in 221 BC by the First Emperor, and a sixty-character edict issued in 209 BC by Huhai. (LJ)

Inscriptions, chiseled with Emperor Qin Shihuang's edict issued in 221 BC (cat. no. 18); and Huhai's edict issued in 209 BC: 元年制詔丞相斯, 去疾, 法度量, 盡始皇帝為之, 皆有刻辭, 今襲號, 而刻辭不稱始皇帝, 其於久遠也, 如后嗣為之者, 不稱成功盛德, 刻此詔, 故刻左, 使毋疑. (In the first year of the reign [209 BC], this edict is issued to chancellors [Li] Si and [Feng] Quji to enforce standardized measures and weights. Those initiated by the First Emperor are all inscribed with the edict. This year, Ershi succeeded the title. If the edict is inscribed without noting the First Emperor's accomplishments and great virtues, his edict would be mistakenly attributed to his descendants as time goes on. Therefore, this edict is written to its left to avoid any confusion.)

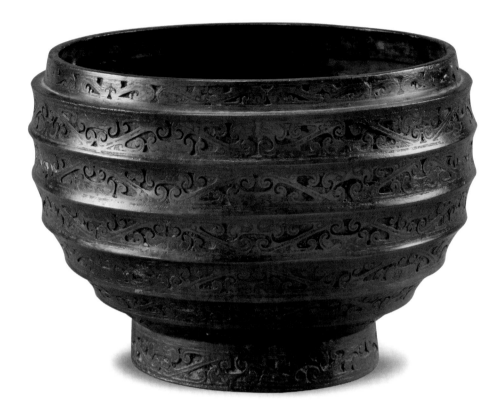

20 戰國 秦二十五年銘文青銅盨
Tureen with Inscription, 3rd century BC
Warring States period (475–221 BC)
Bronze
H. 15 cm (5.9 in.), Dia. 25 cm (9.8 in.)
Acquired in 1956
Shaanxi History Museum, 59.256

According to the *Rites of Zhou (Zhouli)*, a ritual bowl of this type was used for offering food and grain to ancestors. Originally inlaid with turquoise and capped with a lid, this large tureen is cast with six horizontal ridges and adorned with incised cloud motifs. An inscription on the underside indicates that the tureen was produced in the 25th year (282 BC) during the reign of King Zhaoxiang of Qin (r. 306–251 BC), who played a pivotal role in the Qin's success in the 3rd century BC.

Other scholars believe the Qin captured this bowl from the Yan when they seized the Yan capital near present-day Beijing in 222 BC, the 25th year of Ying Zheng (r. 246–210 BC). To celebrate their victory, the Qin inscribed "the 25th year" and measured and recorded the volume of the bowl on its base. (LJ)

Inscription, chiseled on underside of the vessel: 二十五年 *ershiwu nian* (25th year), 造攻（工）*zaogong*, 一升八斗 *yisheng badou* (3800 ml).

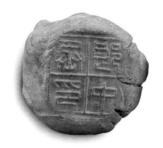

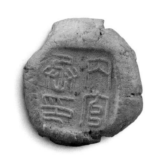

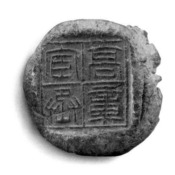

21, 22, 23 秦 "郎中丞印" 封泥 西安未央區相家巷村
*Seal Clay with Seal of Associate Official
of Court Security*

秦 "内官丞印" 封泥 西安未央區相家巷村
*Seal Clay with Seal of Associate Official
of Inner Court*

秦 "高章宦丞" 封泥 西安未央區相家巷村
*Seal Clay with Seal of Associate Eunuch
of Gaozhang Palace*
Qin dynasty (221–206 BC)
Clay

H. 2.9 cm (1.1 in.)
Excavated from Xiangjiaxiangcun, Weiyang, Xi'an, 2000
Xi'an Museum, H25:3.11, 2000.1, H3:3/9:27

Seal clay was used by government officials to secure
confidential documents. Before the advent of paper,
text was written on bamboo or wooden strips that were
rolled and tied with a cord. The cord's knot was covered
with seal clay, into which the sender's insignia was
pressed. To open the document, the recipient would cut
the cord and remove the clay with its impressed seal to
archive it. Seal clays were first used during the Eastern
Zhou dynasty (770–256 BC), and they remained
popular in the Qin dynasty (221–206 BC).

Here each clay is divided with a cross and
filled with four characters in small seal script, the
standardized Qin form of calligraphy. The seal
impressed with "Gaozhang" discloses the name of
a Qin palace. There are no prior discoveries of any
historical texts that record the existence of this palace.

In 1995 more than three thousand seal clays were
unearthed on the southern bank of the Wei River
near Xi'an. They are impressed with the titles of
Qin officials, government departments, and names
of palaces and gardens, representing the hierarchy
of Qin government that was established after the
unification of China. Recent interpretations suggest
the site was an ancestral temple dedicated by Huhai
to his father, the First Emperor. (LJ)

Inscriptions: 郎中丞印 *langzhong cheng yin* (seal of
associate official of court security), 内官丞印 *neigong
cheng yin* (seal of associate official of inner court),
高章宦丞 *Gaozhang huancheng* (associate eunuch of
the Gaozhang palace)

24 秦 "榮祿" 銅印 秦始皇帝陵上焦村陪葬墓

Seal of Ronglu

Qin dynasty (221–206 BC)

Bronze

H. 1.1 cm (0.4 in.), W. 1.45 cm (0.6 in.)
Excavated from Shangjiaocun, Qin Shihuang's Mausoleum, 1976
Emperor Qin Shihuang's Mausoleum Site Museum, 003478

A Qin-dynasty individualized seal was carried by its owner as personal identification. This seal is one of two seals and a total of two hundred objects excavated from a tomb complex east of the First Emperor's mausoleum. The complex contained seventeen tombs, of which eight were excavated between October 1976 and January 1977. The excavation revealed a pathway and double coffins that contain the remains of five males and two females in their twenties and thirties. The disturbed remains suggest that these people did not die naturally. A silver frog also excavated from this site is inscribed with "Shaofu," the name of the imperial workshop, indicating that the tomb complex belonged to a royal family.

Carved into this square seal is "Ronglu," the combination of two characters that mean "honor" and "prosperity" and perhaps the given name of a prince. After the death of the First Emperor, his youngest son, Huhai (r. 209–207 BC), ascended the throne and had all of his siblings murdered and entombed half a mile from the First Emperor's burial mound. The names of these princes and princesses remained a mystery until the 20th century. Evidence of their violent deaths include an arrowhead embedded in a young man's skull and the remains of young women adorned with royal jewelry. (LJ)

Inscription, cast in small seal script: 榮祿 (Ronglu)

25.1–2 戰國 青銅方形印章 西安臨潼新豐
Square Seal with Relief Characters
Warring States period (475–221 BC)

Bronze

H. 1.1 cm (0.5 in.)
Excavated at Xinfeng, Lintong, Xi'an, 2007
Shaanxi Provincial Institute of Archaeology, M624:8

戰國 青銅半通印章 西安臨潼新豐
Rectangular Seal with Incised Characters
Warring States period (475–221 BC)

Bronze

H. 1.4 cm (0.6 in.)
Excavated at Xinfeng, Lintong, Xi'an, 2007
Shaanxi Provincial Institute of Archaeology, M630:8

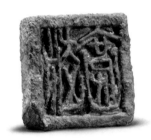

Excavated at a Qin cemetery near the First Emperor's mausoleum, these two seals with looped handles are fine examples of the art of Qin bronze seals from the 4th and 3rd centuries BC. The square example has a slanting base, and its face is cast with two relief characters in rounded, balanced forms framed by heavy lines. The rectangular seal features a three-tiered base. Its face is divided into two parts and filled with engraved characters with a more pictographic appearance. Technically, it would be more time consuming to craft a relief script than an intaglio graph on the seal's underside. The characters are inscribed in Qin's official language, known as small seal script, a form modified from the large seal script found on Zhou bronzes. Although often depicted in irregular, hard-to-read forms, the archaic and elegant appearance of small seal script inspired painters, calligraphers, and seal engravers for thousands of years.

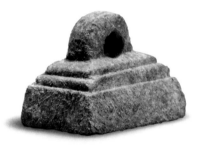

With the rapid development of social, economic, and political relationships, the seal became the symbol of authority and personal identification by the late Warring States period. These two examples, identified as personal seals, would have been pressed onto clay, silk, or bamboo. Qin elites would have carried seals like these along with jade pendants as symbols of social status. Seals were entombed with their owners for the afterlife. (LJ)

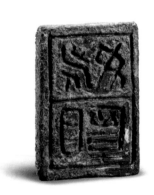

Standard Currency

The First Emperor imposed many nationalistic reforms, including the standardization of currency. Before unification, gold, silver, tortoise shells, cowries, and even textiles were used as currency, but cast bronze was the most widely used material. Bronze coins, minted in different regions during the Warring States period (475–221 BC), came in three shapes: spade, knife, and round. Round coins had square or round cut-out centers. Coins in the shapes of spades and knives were derived from the ancient custom of trading agricultural and hunting tools.

In 221 BC, after the unification of the seven states and the founding of the empire, the First Emperor imposed a law to standardize currency using the Qin *banliang* coin as the legal currency for the entire empire. However, both gold and bronze coins were in circulation, with gold as the high-grade currency. In addition to promoting economic convenience and efficiency, a unified currency was also an essential and effective measure for the First Emperor to centralize power. (HMS)

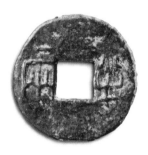

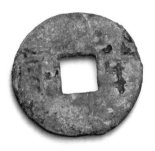

26, 27 戰國-秦 秦國 半兩銅幣 秦始皇陵園魚池遺址 陳尊祥捐

Coins from Qin Inscribed with "Banliang"
Warring States period (475–221 BC)–Qin dynasty
(221–206 BC)
Bronze
Dia. 2.8–3.7 cm (1.1–1.4 in.)
Excavated at Yuchi site, Qin Shihuang's Mausoleum, 1978
Gift of Chen Zunxiang, 1981
Emperor Qin Shihuang's Mausoleum Site Museum, 005529
Shaanxi History Museum, 81.149(2)

The standardized Qin coin, known as *banliang,* or half *liang* (five grams), began to circulate in 336 BC under Duke Huiwen of Qin. Banliang, which was a round coin with a square hole in the center, was easier to produce and carry. The round shape and hole were likely derived from the archaic ritual jade known as *bi.* The round shape symbolizes heaven, and the square in the middle symbolizes earth following the traditional cosmological concept. The two Chinese characters, "banliang," inscribed in small seal script on the coin were written by Li Si, the Qin chancellor. The design of these Qin coins continued to dominate Chinese currency until the 19th century. (HMS)

28 戰國 趙 蘭布幣

Spade-Shaped Coin from Zhao
Inscribed with "Lan"

Warring States period (475–221 BC)

Bronze

L. 4.2 cm (1.6 in.), W. 2.9 cm (1.1 in.)
Acquired in Xi'an, 1957
Shaanxi History Museum, 58.16

The inscription on this spade-shaped bronze coin
from the state of Zhao during the Warring States
period reads "lan," referring to the Lan district in
present-day western Shanxi Province. (HMS)

29 戰國 魏 安邑二釿布幣

Spade-Shaped Coin from Wei
Inscribed with "Anyi Erjin"

Warring States period (475–221 BC)

Bronze

L. 6.5 cm (2.6 in.), W. 4.2 cm (1.6 in.)
Shaanxi History Museum, 72.73

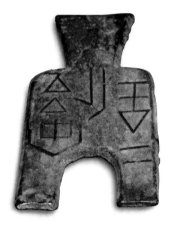

The inscription on this spade-shaped coin from
the state of Wei reads "Anyi erjin." Anyi refers to
the Wei capital during the early-to-mid Warring
States period in modern-day southwestern Shanxi
Province. The word *jin* refers to a unit in weight
measure, and the word "erjin" specifies the monetary
value of this coin. (HMS)

30 戰國 韓 梁邑布幣 陳尊祥捐

Spade-Shaped Coin from Han
Inscribed with "Liangyi"

Warring States period (475–221 BC)

Bronze

L. 4.5 cm (1.8 in.), W. 2.9 cm (1.1 in.)
Gift of Chen Zunxiang, 1981
Shaanxi History Museum, 81.146

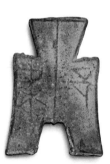

This spade-shaped bronze coin from the state of
Han has squared ends and an inscription that reads
"liangyi" in seal script on its front surface. Liangyi
refers to the Han state capital in modern-day
Kaifeng, Henan Province. (HMS)

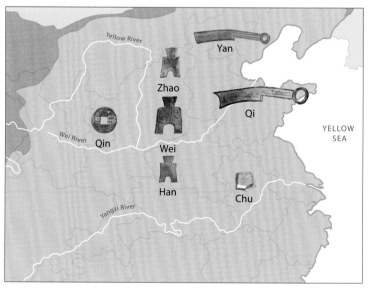

During the Warring States period, a variety of currency circulated
throughout the seven states. The First Emperor abolished them all
except for the Qin coin, known as banliang.

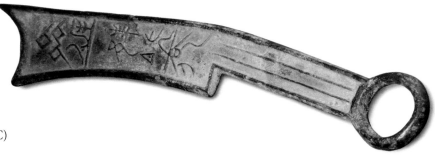

31 戰國 齊 刀幣
Knife-Shaped Coin from Qi
Warring States period (475–221 BC)
Bronze

L. 17.5 cm (6.9 in.), W. 3.1 cm (1.2 in.)
Shaanxi History Museum, 65.211

Gracefully designed and skillfully cast, knife-shaped bronze coins, which were modeled after hunting tools, circulated in the northeastern states of Qi and Yan during the Warring States period.

This larger knife-shaped coin is known as "the large knife of Qi" (*qidadao*) because it was first minted in the reign of Qi's King Wei (r. 356–320 BC). It soon became that state's most widely circulated currency, particularly

in the Shandong area and the eastern coastal regions along the Yi and Shu Rivers. This coin was minted in 386 BC when the House of Tian fully replaced the House of Jiang as the official ruler of Qi. (HMS)

Inscription: 齊造邦長法化 (*Qi zao bang chang fa hua* or "The inaugural long knife coin of the Qi state")

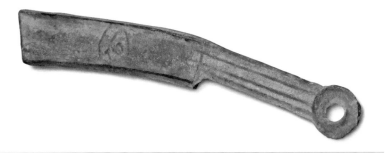

32 戰國 燕 明刀幣
Knife-Shaped Coin from Yan Inscribed with "Ming"
Warring States period (475–221 BC)
Bronze

L. 13.7 cm (5.4 in.), W. 2 cm (0.8 in.)
Shaanxi History Museum, 99.1/1

Like the state of Qi, Yan also used knife-shaped currency. Smaller than the Qi coins and possessing a straight tip blade, this Yan coin, nicknamed *ming*, takes its name from the character inscribed in relief on the knife's face. Judging from the fact that most

inscribed coins from the Warring States period were named after the geographic locations in which they circulated, the ming character likely refers to the coin's place of origin. (HMS)

33 戰國 楚 郢爰金版 安徽省博物館調撥
Gold Coin from Chu Inscribed with "Yingyuan"
Warring States period (475–221 BC)
Gold

L. 1.7 cm (0.7 in.), W. 1.8 cm (0.7 in.), D. 0.4 cm (0.2 in.)
Transferred from Anhui Provincial Museum, 1972
Shaanxi History Museum, 72.31

An example of the earliest gold currency in China, this gold coin, known as *yingyuan*, was the currency of the Chu state during the Warring States period. The coins were cut from larger blocks of gold and shaped into small cube-like pieces. The inscription

on the coin is "yingyuan." Ying refers to the Chu capital and *yuan* was the weight unit. The mark thus signifies that the currency was officially weighed and certified by the Chu state. (HMS)

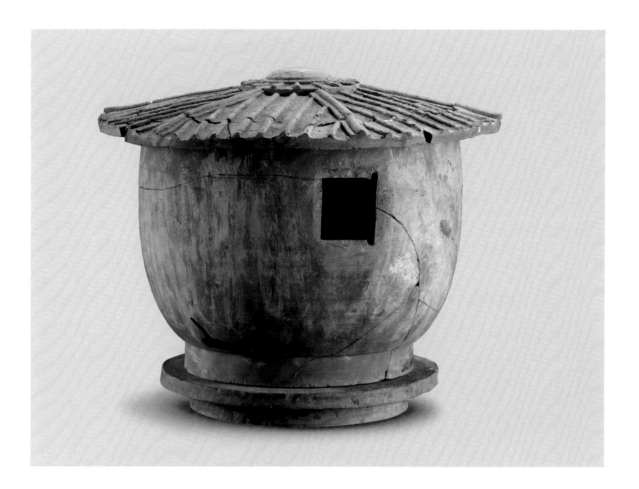

34 戰國 彩繪陶囷 西安雁塔區潘家莊
Model of a Granary
Warring States period (475–221 BC)
Earthenware with pigment
H. 30.2 cm (11.9 in.), Dia. 38.4 cm (15.1 in.)
Excavated from Panjiazhuang, Yantaqu, Xi'an, 2003
Xi'an Museum, SjxcM185:22

Granary models were first used as funerary objects for the afterlife during the Spring and Autumn period (770–476 BC). Their style evolved from simple to sophisticated with the addition of functional architectural details that reflected the Qin's growing emphasis on agricultural development and private land ownership. By 408 BC, official edicts had been issued by the Qin government to allow commoners to purchase land, with the state collecting property tax accordingly.

Promotion of agriculture ensured the seasonal harvest and resulted in the increased production of granary models. This example takes the shape of a tapered barrel atop a round platform. The circular roof has six raised ridges radiating from a small dome in the center. The tiles on the roof and the small window on the side likely mimic a farmhouse of the region near Xianyang, the last Qin capital. (LJ)

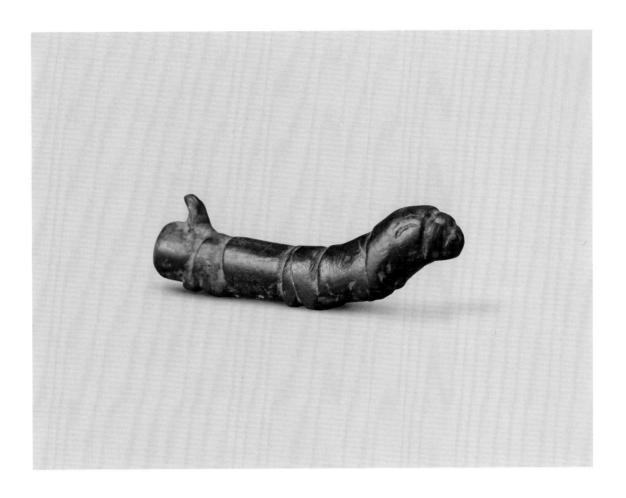

35 秦－漢 青銅蠶
Silkworm
Qin dynasty (221–206 BC)–Han dynasty (206 BC–AD 220)
Bronze
H. 5.1 cm (2 in.)
Acquired in 1974
Xi'an Museum, 3gtD8

The Chinese were the first to produce silk. According to the earliest Chinese historical document, *Book of Documents (Shangshu)*, silk production dates to about 2700 BC. Archaeological records also point to silk cultivation in China as early as 5000–3000 BC as part of the Yangshao culture. A fragment of silk excavated from Henan Province dates to 3650 BC. By the Qin dynasty, sericulture was considered as important as agriculture.

Silkworms were depicted in stone and pottery beginning in the Neolithic period. Finely carved jade silkworms were also found in Shang and Zhou burial sites. This bronze object realistically models a silkworm with its segmented body, rounded head, tail horn, and small legs. With eyes half open, the silkworm lifts its head. A closely comparable gilt bronze silkworm, excavated in 1984 from Sichuan County, Shaanxi Province, can be found in the collection of the Shaanxi History Museum. (HMS)

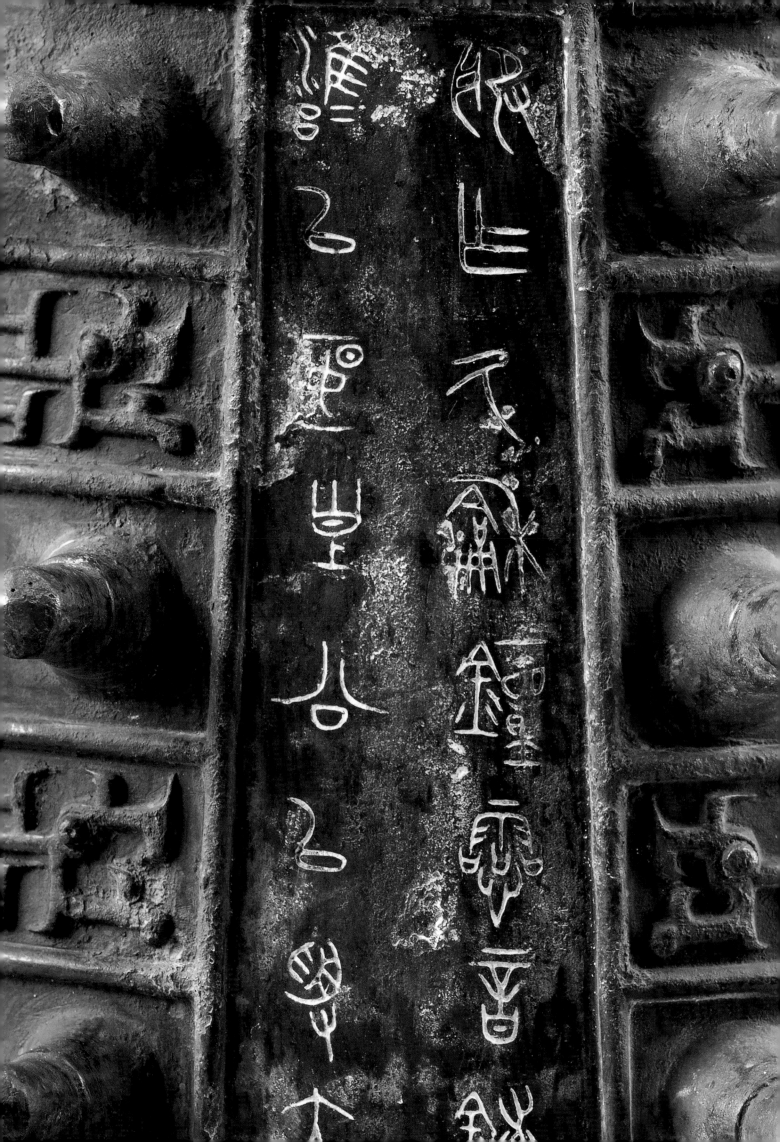

Birth of the Qin Empire

Li Jian

Legend and historical texts tell us that the Qin tribe first settled on the western frontier of the Zhou dynasty, where they made a living in herding and breeding horses and making salt. When King Xiao of Zhou recognized that tribal chief Feizi (d. 858 BC) possessed excellent skills in horse training and breeding, he rewarded Feizi with a small fief, known as Qinyi, located perhaps in present-day Qingshui, Gansu Province. In 770 BC, Duke Xiang of Qin was awarded a noble title and given land around Qishan, in western Shaanxi Province, because he escorted King Ping of Zhou to the new capital at Luoyi, Henan Province, where the king was safe from attacks by Rong nomads. Land and a noble title established Qin as a vassal state under the Zhou dynasty, making Duke Xiang the first Qin ruler.

In the centuries that followed, the Qin grew in power and influence, both politically and economically. They expanded their territory eastward from rugged mountainous areas to fertile land with river access, facilitating irrigation, farming, and transportation. Yongcheng became the most important Qin capital in a succession of capital cities that ended with Xianyang. Founded in 677 BC, Yongcheng emerged as a political, economic, and cultural center where nineteen Qin kings ruled for over three hundred years. Archaeological surveys and excavations have revealed the city's layout and architecture. Surrounded by city walls, the capital boasted imperial palaces and ritual temples as well as residential areas, markets, and workshops. A 2016 excavation uncovered the earliest, largest, and most complete Qin ritual structures at Xuechi, a precinct of Yongcheng. These discoveries, which include Qin altars, more than two thousand jade objects, and horse and chariot ornaments, represent state rituals in the Qin and Han dynasties.

Qin's political and economic reforms, enacted by Duke Xiao in 350 BC, began with the support of his chancellor, Shang Yang (d. 338 BC). As part of his reforms, Duke Xiao moved the capital to Xianyang. A native of Wei state, Shang Yang implemented a series of reforms involving land allocation, taxation, and immigration. His policies and measures resulted in increased trade and economic growth for the Qin state, which in turn led to its dominance and paved the way for King Ying Zheng of Qin to unify the states and declare himself emperor.

During the Zhou dynasty (1046–256 BC), the Qin people lived in close proximity to the Rong and Di nomads, who inhabited land in present-day Gansu, Ningxia, northern Shaanxi, and Inner Mongolia. From these nomads, the Qin people learned about horses, archery, hunting, and combat. The Qin, Rong, and Di also engaged in frequent conflicts over land. Archaeological discoveries of diverse artworks and artifacts provide evidence of dynamic interaction and exchange among these cultures.

Archaeological findings presented in this section shed light on the lives of Qin royalty, aristocrats, commoners, and neighboring nomads and span more than five hundred years of Chinese history, most dating from the Spring and Autumn period (770–476 BC) to the Warring States period (475–221 BC). Excavated from areas far west and across Shaanxi Province, these works offer evidence of Qin migration eastward and the stylistic influences of surrounding feudal states and nomadic peoples along the way.

Ritual Bell with a Looped Handle (detail), 7th century BC
Bronze
Cat. no. 42

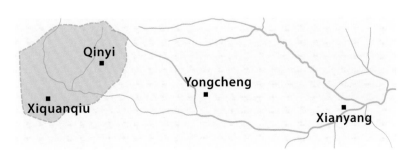

Shown here are four of the most important Qin capital cities, illustrating Qin migration eastward over the course of five hundred years, from Xiquanqiu, to Xianyang, the last Qin capital.

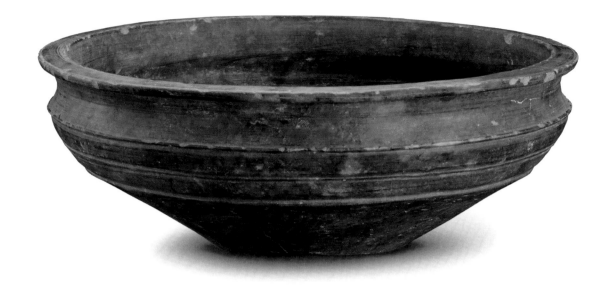

36, 37 春秋 陶盉 隴縣邊家莊

Basin

Spring and Autumn period (770–476 BC)

Earthenware

H. 9.4 cm (3.7 in.), Dia. 26.8 cm (10.5 in.)
Excavated from Bianjiazhuang, Longxian, 1987
Longxian County Museum, 2010L3181

秦 陶拍 秦始皇帝陵園

Anvil

Qin dynasty (221–206 BC)

Earthenware

H. 9.6 cm (3.8 in.), Dia. 9.9 cm (3.9 in.)
Excavated from Pit 1, Qin Shihuang's Mausoleum, 1979
Emperor Qin Shihuang's Mausoleum Site Museum, 001904

Following farmers' reports of tomb objects found in the village of Bianjiazhuang, archaeologists undertook a series of surveys and excavations in 1986 and 1987. Recovered earthenware, bronzes, weapons, and horse fittings from more than twenty tombs in the village offer a glimpse of Qin life in western Shaanxi during eastward migration in the early Spring and Autumn period.

The pottery vessel known as *yu* (above) takes a tapered form and curves inward below the mouth rim. Used for washing or making wine, it represents a fine example of gray utilitarian ceramics made by Qin inhabitants. Artisans would have used tools such as a wooden paddle and an anvil (left), which was placed inside the vessel as a support to flatten out the surface and compress the walls. This anvil, excavated at a workshop near the First Emperor's mausoleum, demonstrates that such tools continued to be used by the Qin people for centuries. (LJ)

38 春秋 彩繪花耳陶壺 隴縣邊家莊

Vessel with Ornate Handles

Spring and Autumn period (770–476 BC)

Earthenware with traces of pigment

H. 35.5 cm (14 in.), Body Dia. 13 cm (5.1 in.)
Excavated from Bianjiazhuang, Longxian, 1992
Longxian County Museum, 10L3003

Bianjiazhuang, a village in the south of Longxian County in western Shaanxi, was the frontier for Qin's early settlers, who made a living in farming and herding. The two distinct types of earthenware produced in the region were gray clay vessels, similar in shape and motif to classical bronzes, and painted ceramics, with alternative forms and designs inspired by bronze vessels.

Modified after a bronze container for wine, this vessel features two dangling masklike handles designed as mythological creatures (*taotie*). Royals, ranking officials, and the elites used bronze vessels for ritual and ceremonial events. Commoners used less expensive painted earthenware, like this example, for rituals or as funerary objects. (LJ)

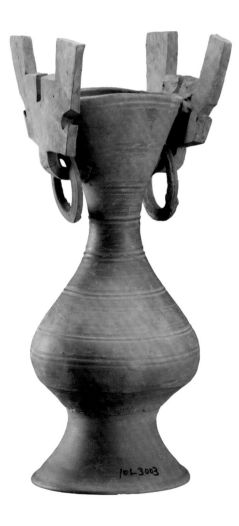

39 戰國 彩繪陶蓋壺 隴縣店子村

Vessel with a Lid

Warring States period (475–221 BC)

Earthenware with pigments

H. 27.5 cm (10.8 in)
Unearthed from Dianzicun, Longxian, 1992
Longxian County Museum, 2010L3016

Dianzicun, a village located two miles northwest of Longxian County in western Shaanxi Province, is known for having the largest undisturbed cemetery for Qin commoners. Archaeological surveys and excavations have revealed 224 Qin tombs, dating from the 8th to 3rd centuries BC. Found among the ceramics unearthed in the cemetery, this gourd-shaped vessel features two looped handles and painted geometric designs. Its form and design simulate bronze vessels. Lack of bronze vessels in this area reflects constant warfare in the Qin territory and declined wealth that made bronze increasingly difficult to acquire.

Scholars believe that the Dianzicun cemetery is a resting place for many Qin veterans, as bronze weapons were also found in the same tombs along with pottery vessels and granary models. According to *Records of the Grand Historian (Shiji)*, written by Sima Qian (ca. 145–86 BC), Qin's ruler awarded lands to esteemed veterans for their military accomplishments. (LJ)

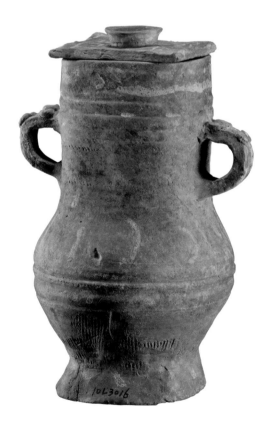

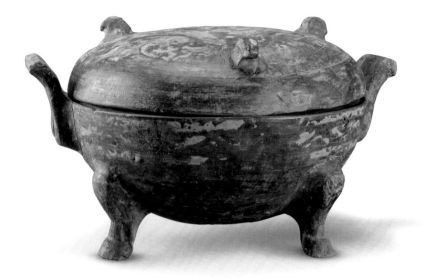

40 戰國 陶胎漆鼎 蒲城縣永豐村5號墓
Tripod, 4th century BC
Warring States period (475–221 BC)
Earthenware with lacquer, pigment

H. 14 cm (5.5 in.), Dia. 25 cm (9.8 in.)
Excavated from Tomb 5, Yongfengcun, Puchengxian, 2011
Shaanxi Provincial Institute of Archaeology, M5:5

Modeled after the classical form of a bronze *ding* vessel, this vessel's rounded body, which rests on three short legs, is painted in red with textile designs of swirling clouds against a black lacquered surface. Made of earthenware but mimicking bronze forms, this vessel represents changing burial customs in the mid–Warring States period, when painted ceramics began to replace bronze ware for funerary rituals.

Pucheng, now located in northeastern Shaanxi Province, was a Qin frontier bordering the Wei state during the Warring States period. Similar ceramic vessels with lacquered designs have been unearthed at Luonan in southern Shaanxi, indicating social interaction and trade activity among the Qin, Wei, and Chu states around the 4th century BC. (LJ)

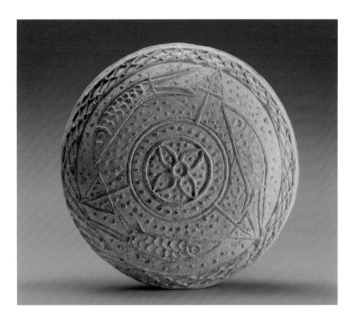

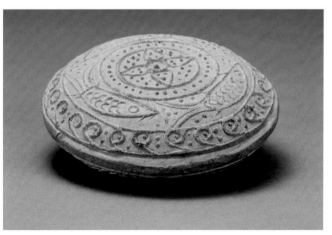

41 戰國 陶響鈴 西安臨潼新豐
Bell
Warring States period (475–221 BC)
Earthenware

Dia. 8.8 cm (3.5 in.), D. 3.3 cm (1.3 in.)
Excavated from Xinfeng, Lintong, 2007
Shaanxi Provincial Institute of Archaeology, M403:7

This round earthenware bell, probably a toy rattle, is a rare and interesting object excavated from Lintong in Xi'an. A similar bell with the tiger and boar design was found in the Qin palace precinct in Xianyang. These bells were assembled by inserting a small stone between two halves of molded clay joined together.

This bell illustrates three carp swimming in between concentric circles with a four-petal flower at the center. The carp are separated by three arrow-like symbols. With a wave pattern on the rim and small round dots scattered evenly throughout, the whole design appears to be a vivid depiction of the aquatic world of fish swimming in a pond. The toy rattle is also an indication of Qin prosperity during this time. (HMS)

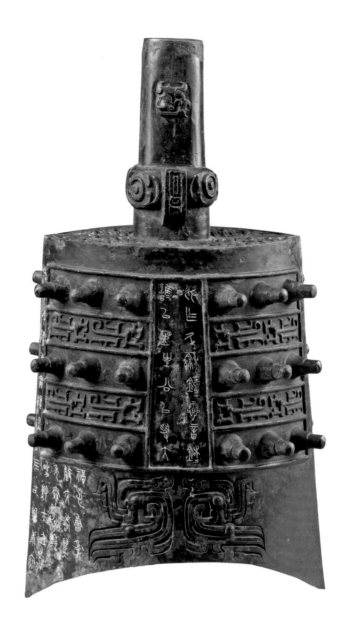

42 春秋 秦武公鐘 寶雞陳倉區太公廟村
Ritual Bell with a Looped Handle, 7th century BC
Spring and Autumn period (770–476 BC)
Bronze
H. 45 cm (17.7 in), Weight 21.5 kg (47.4 lbs)
Excavated from Taigongmiaocun, Chencang, Baoji, 1978
Baoji Bronze Ware Museum, IA5.7 (02758)

Known as a *yongzhong*, this ritual bell with a
looped handle was cast with primary motifs
of dragons, serpents, and phoenixes. Played at
ceremonial court events, it is one of eight bronze
percussion instruments excavated from a royal
hoard near the early Qin capital at Pingyang. The
inscriptions chiseled on the bells record early Qin
history and note the accomplishments of Qin rulers,
suggesting the bells were made during the reign of
Duke Wu (r. 697–678 BC) and housed in a royal
palace or an ancestral temple.

This yongzhong produces distinct tones when
struck with a wooden mallet in two areas: the middle
and lower-right areas of the rim. The bell's interior
height and thickness determine its volume and
correspond to its pitch. In ancient China, where
a sophisticated musical culture was developing,
a full set of bells formed the core of a conventional
ensemble. This discovery is significant as these bells
have provided invaluable information on the study
of Qin rituals, musical history, writing script, and
bronze casting during the 7th century BC. (LJ)

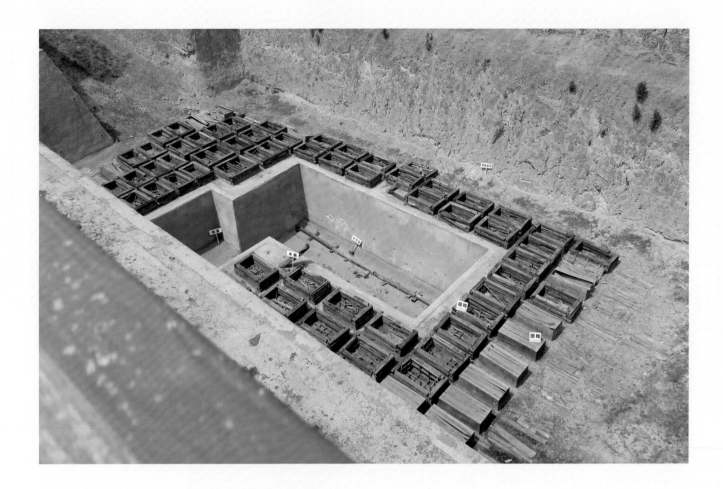

Tomb of Duke Jing of Qin

Duke Jing (r. 576–537 BC), the thirteenth ruler of Qin, reigned for forty years at the capital of Yongcheng and was buried at the mausoleum complex located in the southern suburb of the city. Starting in 1976, archaeologists undertook a ten-year excavation project that uncovered an underground tomb constructed as a three-tiered inverted pyramid. The tomb is 985 feet long and 80 feet deep with an area of more than 53,800 square feet, making it the largest vertical earthen tomb ever excavated in China. The prestigious wooden burial chamber exceeds Zhou-court standards for a ruler of a vassal state, reflecting the Qin ruler's political and personal ambitions.

During excavation, archaeologists identified 247 holes on the tomb's first landing and more than ten holes in the burial chamber, evidence of continual looting that occurred from the Han dynasty (206 BC–AD 220) into the 20th century. Despite centuries of looting, archaeologists still managed to unearth more than 3,500 objects, including gold and jade ornaments, bronze vessels, and stone musical instruments. The remains of 186 sacrificed humans were found in the tomb along with the remains of the duke's favorite dog in the burial chamber. (LJ)

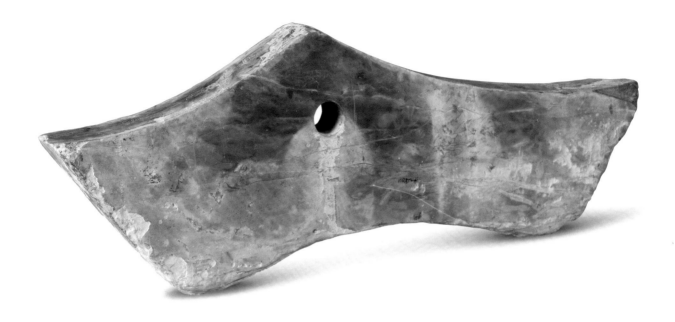

43 春秋 石磬 鳳翔縣秦景公大墓
Stone Chime, ca. 573 BC
Spring and Autumn period, Duke Jing reign (576–537 BC)
Limestone

L. 37.5 cm (14.8 in.)
Excavated from Tomb of Duke Jing, Fengxiangxian, 1985
Emperor Qin Shihuang's Mausoleum Site Museum, 004778

This stone chime is among thirty-four chimes and more than a hundred fragments unearthed from Duke Jing's tomb near Yongcheng. An ancient Chinese percussion instrument, stone chimes were played with a set of bronze bells (cat. no. 42) at state banquets and ritual events. Inscriptions engraved into the edges reveal that these chimes were part of a court ensemble, played for a king of Zhou at a state banquet hosted by Duke Jing in 573 BC.

When struck with one or two mallets, chimes such as this produced different musical tones according to varying dimensions and thickness. Most likely these chimes were suspended on a one- or two-tiered rack at a performance and stored in wooden crates thereafter. (LJ)

Inscription, carved on thirty-four chimes with more than 188 characters in large seal script, including: 百樂咸奏…天子郾喜, 龔桓是嗣, 高陽又靈, 四方以鼎平 (Hundreds of musical instruments are playing at the banquet in honor of the Zhou king, held by the successor of Dukes Gong and Huan. With the blessings of the spirit of ancestor Gao Yang, the Qin embraces the peace.)

Royal Hoard at Yimencun

Yimencun is a village situated south of Baoji on the path toward Bashu, Sichuan Province. In 1992 Chinese archaeologists excavated a treasure hoard, known as Tomb 2, where they discovered more than two hundred objects such as weapons, harnesses, garment accessories, and jewelry. Made from gold, jade, and iron, these luxury objects represent a variety of cultures, including the Rong and the Chu, but most belong to the Qin culture. In this atypical tomb, no human or animal remains were found.

Since the discovery, the hoard of hidden treasures has been a topic of debate for scholars and archaeologists, in their efforts to identify the purpose and ownership of the hoards and their contents. The variety of gemstone ornaments, including nephrite, turquoise, and agate, indicates the noble status of the tomb owner. Did they belong to an aristocratic chief, a king of Rong or Qin, or a high-ranking official? (LJ)

44, 45 春秋 金圓泡 寶雞益門村2號墓
Two Round Rosettes, 6th century BC
Spring and Autumn period (770–476 BC)
Dia. 2–2.3 cm (0.8–0.9 in.)
Gold
Excavated from Tomb 2, Yimencun, Baoji, 1992
Baoji Municipal Archaeological Team, BYM2:52, BYM2:70

These two objects were among fifty-six gold rosettes excavated from Tomb 2 at Yimencun. Found in the head compartment between the inner and outer coffins that contained horse harnesses, each rosette has a convex surface and a loop on the back, indicating they may have been attached to bridle straps.

Similar rosettes decorated the cheek straps of bronze horses (cat. no. 1) excavated near the First Emperor's tomb mound in 1980. Other examples, found scattered around the remains of Duke Huan of Rui (act. ca. 750–710 BC) at Liangdaicun, demonstrate the use of gold rosettes to adorn a belt or garment. All these findings reveal that this type of horse ornament was popular among royals and cultural elites for centuries. (LJ)

46, 47 春秋 鴨首金帶扣 寶雞益門村2號墓

Duck-Shaped Hook Buckle, 6th century BC
Spring and Autumn period (770–476 BC)
L. 1.9 cm (0.7 in.)
Gold

Excavated from Tomb 2, Yimencun, Baoji, 1992
Baoji Municipal Archaeological Team, BYM2:33, BYM2:34

Two of seven excavated from Tomb 2 at Yimencun, these gold buckles, used on a horse's bridle straps, represent the earliest hook buckles produced in China. Each of the ring-shaped buckles presented here is ornamented with a duck's head and beak and incised S-shaped motifs. A similar gold duck-shaped garment hook was excavated from the tomb of Duke Jing (r. 576–537 BC), indicating that these Yimencun examples may have also been created in the 6th century BC.

The hook buckle, a Central Asian invention, was used first as a horse ornament and later as a fashionable accessory for nomads inhabiting northwestern China. In the 6th century BC, the buckles were transformed from horse bridle components to men's garment accessories. Buckles eventually replaced local Chinese garment hooks (cat. nos. 68, 69) by the Han dynasty (206 BC–AD 220). (LJ)

48 春秋 素面金環 寶雞益門村2號墓

Harness Ring, 6th century BC
Spring and Autumn period (770–476 BC)
Gold

Dia. 3.2 cm (1.3 in.)
Excavated from Tomb 2, Yimencun, Baoji, 1992
Baoji Municipal Archaeological Team, BYM2:45

This gold harness ring, one of six unearthed from Tomb 2, features a multifaceted surface with a hexagonal cross-section. A ring of this type would have been used by a chariot driver for securing leather reins. As described in an ancient text, a four-horse chariot would have eight reins. A charioteer would hold six reins in his hands, while the two innermost reins passed through rings such as this and connected to the chariot or its axle.

Similar rings made of bronze have been excavated from Pit 1 at the First Emperor's mausoleum near Xi'an. Most of the rings were located near the abdomens of terracotta sculptures of horses and decayed wooden chariots, suggesting they were movable rings used on the girth straps and reins. (LJ)

49 春秋 金絡飾 寶雞益門村2號墓
Horse Neck Chain, 6th century BC
Spring and Autumn period (770–476 BC)
Gold

Length (each tube): 1.7 cm (0.7 in.)
Excavated from Tomb 2, Yimencun, Baoji, 1992
Baoji Municipal Archaeological Team, BYM2:101

This chain was discovered alongside a group of harnesses in the head compartment of a double coffin. According to scholars and archaeologists, it may have decorated the neck of a ceremonial horse. Designed with sixty-five gold tubes, it resembles a necklace found in the bronze chariots pit at the First Emperor's mausoleum. That necklace, which contained eighty-four gold, gilt bronze, and silver pieces, was found on a half-scale bronze horse lying on the outside row of a four-horse chariot in the pit. (LJ)

50, 51 春秋 料珠鑲嵌獸面金方泡 寶雞益門村2號墓
Two Square Ornaments with Animal Masks, 6th century BC
Spring and Autumn period (770–476 BC)
Gold, faience

H. 3.5–3.9 cm (1.4–1.5 in.)
Excavated from Tomb 2, Yimencun, Baoji, 1992
Baoji Municipal Archaeological Team, BYM2:32, BYM2:29

Shaped like animal masks, these ornaments are among seven excavated along with other personal possessions in the center of the inner coffin from Tomb 2 at Yimencun. Each ornament features incised geometric designs and the small head of a bear-like animal at the bottom tip. Eight holes on one mask indicate it may have been inlaid with faience and perhaps semiprecious stones. The concave reverse side features a horizontal iron loop, either for a belt strap to pass through or for the ornament to be sewn onto a garment.

The earliest examples of faience appeared in Central China in the 14th century BC. Artisans used faience to emulate turquoise and other vibrant gemstones. Faience contains primarily silica, which provided bright colors and a hard, glassy coating after firing. (LJ)

52 春秋 金虎 寶雞鳳翔縣
Tiger
Spring and Autumn period (770–476 BC)
Gold

L. 4.8 cm (1.9 in.), H. 2.3 cm (0.9 in.)
Excavated from Fengxiangxian, Baoji, 1979
Xi'an Museum, D3Gj70

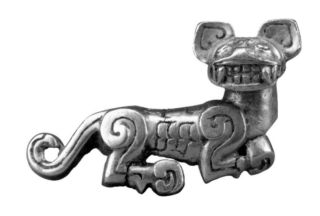

Prior to the Spring and Autumn period, jade and bronze were the materials most valued by Chinese aristocrats. After the nomadic people of the Eurasian Steppe introduced the Chinese to gold, its use for making luxury objects increased. Treasures from the Qin royal tombs illustrate gold's newfound popularity in Qin culture. A fine example is this small tiger-shaped gold ornament, which features a loop attached to its back for use on a horse's harness.

The tiger, native to China and revered for its fierceness as the "king of beasts," is depicted accordingly here. With sharp protruding teeth and tensed muscles, the tiger appears ready to pounce on its prey. The simple marking, similar to the character of 人 (*ren*), on its nose, body, and tail and the spiral pattern on its legs reveal the distinct design typical of this time. (HMS)

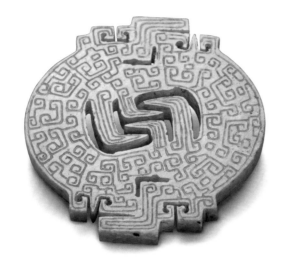

53 春秋 鏤空龍紋玉佩 鳳翔縣秦景公大墓
Dragon Pendant in Shape of Lantern
Spring and Autumn period, Duke Jing's reign
(r. 576–537 BC)
Nephrite

H. 5.1 cm (2 in.), W. 4.9 cm (1.9 in.)
Excavated from Tomb of Duke Jing, Fengxiangxian, 1986
Shaanxi Provincial Institute of Archaeology, 000924

This lantern-shaped pendant is made of nephrite, a
soft jade material mined locally in China—unlike
jadeite, which is a hard jade generally imported
from Myanmar. As seen here, the style of Qin
jade ornaments was innovative in terms of form
and design. The most distinctive Qin features are
the abstract dragon motifs in simple lines on the
pendant's surface. The L-shaped openwork illustrates
the dragons' claws, and the incised lines constitute
their bodies. Two sets of holes drilled through the
pendant's plain back provided a means by which to
affix the ornament to fabric or leather. (LJ)

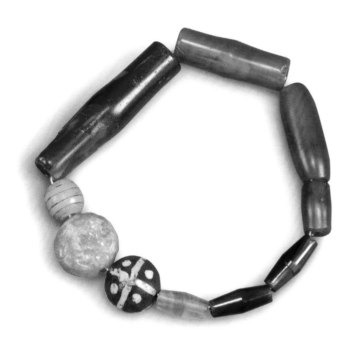

54 春秋 瑪瑙玉串飾 寶雞益門村2號墓
Bracelet, 6th century BC
Spring and Autumn period (770–476 BC)
Agate, nephrite

L. 9.4 cm (3.7 in.), W. 5.5 cm (2.2 in.)
Excavated from Tomb 2, Yimencun, Baoji, 1992
Baoji Municipal Archaeological Team, BYM2:211–220

This bracelet is one of three threaded with beads in
various shapes found in a royal hoard at Yimencun.
The bracelet holds seven agate tubes, two nephrite
beads, and one agate bead painted with dots and
short lines. The variety of colors and shapes in the
assemblage reveals the lavish lifestyle of its owner,
and the Central and South Asian influences.

Unlike green or white nephrite jade, agate was
favored for its vibrant red color, which was often
dyed and enhanced through a heating process.
In ancient China, agate beads or ornaments were
hammered into the desired shape, then polished
to produce flat ends and a glossy surface. To pierce
the bead for stringing, craftsmen drilled through to
the center from both ends to avoid damaging the
overall structure. Noticeable on this bracelet is one
translucent tubular bead, which is a fine example of
crystalized agate with circular red bands. (LJ)

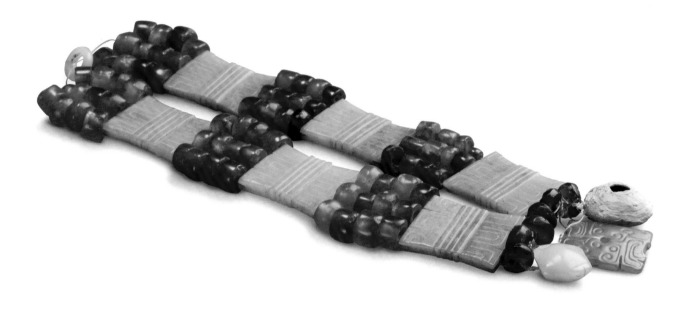

55 春秋 玉瑪瑙串飾 隴縣邊家莊9號墓

Necklace
Spring and Autumn period (770–476 BC)
Nephrite, agate, faience

L. 30 cm (11.8 in.)
Excavated from Tomb 9, Bianjiazhuang, Longxian, 1986
Longxian County Museum, 86LBM9:41

This necklace of red agate beads and white jade pendants represents the most characteristic jewelry fashion of Qin nobility. Jade and agate, used in combination, became the most favored materials for aristocrats in the Spring and Autumn period.

The necklace consists of a ring, six bowknot-shaped pendants, and a square plaque, all of nephrite jade; seventy-eight patterned agate beads strung together; one small shell-shaped pendant; and one faience bead. The contrast of the soft white luster of the nephrite pieces and the warm glow of red agate beads indeed creates a gracefulness and beauty befitting both male and female Qin nobles. (HMS)

Royal Tombs of Rui at Liangdaicun

Rui, an ancient vassal state, emerged in the 11th century BC and thrived until its capital was seized by Qin forces in 641 BC. In 2005 villagers in Liangdaicun, located on the west bank of the Yellow River, 135 miles northeast of Xi'an, reported looting activities, which led archaeologists to survey and excavate the area. During the next six years, they uncovered Liangdaicun cemetery with its 1,300 tombs, the largest tomb complex of the Western Zhou dynasty (1046–771 BC).

The inscription on a bronze vessel from Tomb 27 suggests that this cemetery is the resting place of Duke Huan of Rui (r. ca. 740–710 BC), his wife Rui Jiang, and another noblewoman in their household. It also indicates that the vessel was cast in honor of Duke Huan by order of Rui Jiang, who was buried just a few feet away in a separate tomb. Their tombs are numbered in the order they were found: M19, the tomb of a noblewoman; M26, the tomb of Rui Jiang; and M27, the tomb of Duke Huan. Buried with the Rui royals in their tombs were precious jewelry, gold ornaments, jade pendants, bronze vessels, weapons, and horse bridle components. Their shapes and designs were adopted by Qin craftsmen in examples of jewelry and horse ornaments excavated from Yimencun in present-day Baoji and the Qin capital of Yongcheng. The findings at Liangdaicun reveal the close tie between Rui royalty and the Qin, as well as the influence of the Eurasian Steppe peoples. (LJ)

56 春秋 玉韘 韓城梁帶村芮國27號墓
Thumb Ring, 8th century BC
Spring and Autumn period (770–476 BC)
Jade

L. 4.7 cm (1.8 in.), W. 3.4 cm (1.3 in.)
Excavated from Tomb 27, Liangdaicun, Hancheng, 2008
Shaanxi Provincial Institute of Archaeology, M27:229

Used in archery, a thumb ring protected and secured an archer's grip when drawing back a bowstring. This ring features an oval-shaped lip in the front and two holes at the rear. A small prong on the side is designed for securing the arrow shaft while the archer's index finger would stabilize it from the other side, preventing it from shifting away from the bowstring. A cord would pass through the tiny holes and affix the ring to the archer's wrist.

This prestigious ring was excavated along with two gold thumb rings from Duke Huan's tomb. The rings reveal not only the Rui ruler's hunting and combat activities but also his preference for both jade and gold, likely due to the cultural contributions of the Zhou and nomadic Steppe peoples. (LJ)

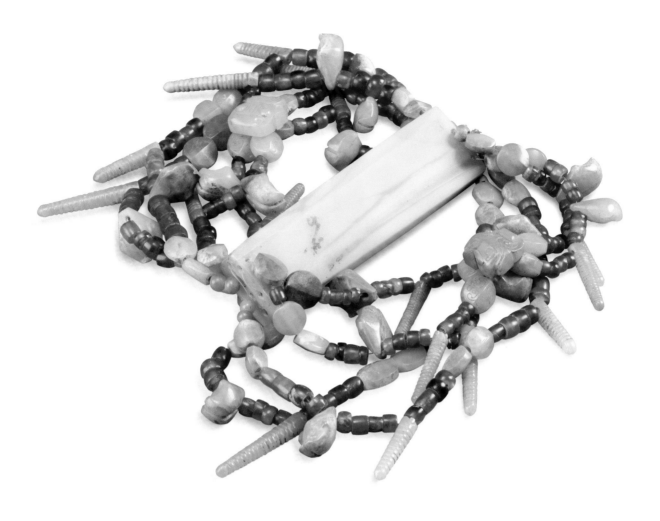

57 春秋 瑪瑙玉串珠手握 韓城梁帶村芮國26號墓
Bracelet, 8th century BC
Spring and Autumn period (770–476 BC)
Nephrite, agate, faience

L. 10.2 (4 in.), W. 2.5 cm (1 in.)
Excavated from Tomb 26, Liangdaicun, Hancheng, 2008
Shaanxi Provincial Institute of Archaeology, M26:267

Made as a funerary object, this bracelet consists of a central, rectangular jade bar and eight radiating strands adorned with agate beads and jade amulets, including silkworms, turtles, shells, and animal masks. Representing one of the most complicated assemblages in early Chinese jewelry making, this bracelet is one of a pair that belonged to Rui Jiang (act. ca. 750–700 BC), who was buried in Tomb 26. Following the death of her husband, Duke Huan of Rui, Rui Jiang ruled the state, expelling Rui Bowan, her son and Duke Huan's heir, to the Wei state.

However, Rui Bowan assumed his rightful position in 708 BC when the Qin escorted him back and onto the throne.

When Rui Jiang's tomb was excavated, this bracelet's jade bar and two strands of beads were found clasped in the remains of her right hand with the other strands placed over the back of her hand. The discovery of this bracelet, along with others from the same site, reveals a unique funeral rite performed by the Rui royals in the early 8th century BC. (LJ)

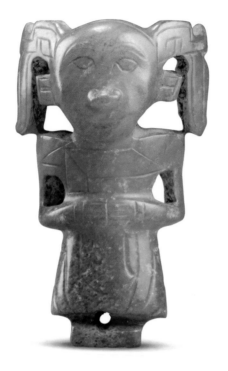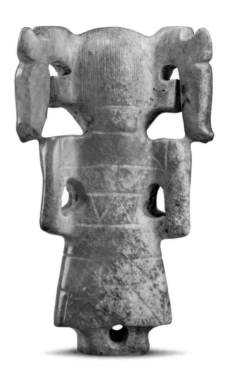

58 春秋 玉人 韓城梁帶村芮國26號墓
Standing Figure of Woman, 8th century BC
Western Zhou dynasty (1046–771 BC)
Nephrite
H. 5.6 (2.2 in.), W. 3.5 cm (1.4 in.)
Excavated from Tomb 26, Liangdaicun, Hancheng, 2008
Shaanxi Provincial Institute of Archaeology, M26:186

Carved in a three-dimensional round form, this jade figure depicts a female dressed in a long garment with her hands clasped at her waist. Carved into the jade are almond-shaped eyes, a closed mouth, thick eyebrows, and a patterned robe. The design of her hair, worn in pigtails, displays the work of sophisticated tools and the artisan's masterful carving skill.

The figure's dignified pose, cool gaze, and long garment imply that she is a mythical being. The shape of the bottom indicates that the figure could be attached to a peg and carried or worn to protect the wearer from misfortune. This object was found on the right side of a tomb occupant's waist. (LJ)

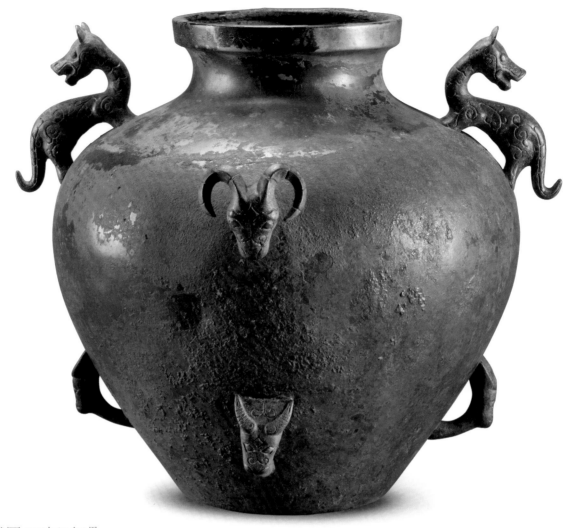

59 戰國 "工師" 銅罍

Wine Vessel with Inscription, 273 BC
Warring States period (475–221 BC)
Bronze
H. 27.5 cm (10.8 in.)
Shaanxi History Museum, 93.20

Known as *lei,* this round vessel for holding wine is adorned with two striding beasts and two ram heads on its shoulder, and four loops in the shape of ox heads around its lower section. Chiseled along the mouth rim is an inscription indicating the date, chief craftsman, maker, and weight and volume of the vessel. The inscription dates to the 34th year of King Zhaoxiang of Qin (273 BC). In this year, a joint force of the Zhao and Wei states attacked the Qin's neighboring state of Han, in whose defense King Zhaoxiang of Qin then launched a successful counterattack.

Authorities seized this jar in 1993 when it was illegally unearthed, reportedly from Xihexian, Gansu Province. The jar is most likely from the Yuandingshan cemetery near the Qin's early settlement at Xiquanqiu. A metallographic analysis reveals that different metal alloys were used for the vessel and the animal ornaments, suggesting the latter were added later. However, scholars disagree on whether or not the vessel was ever altered. Archaeological excavations at this site, from 1998 through 2000, recovered more than eighty bronze vessels, horse ornaments, jades, and other objects, dating from the Spring and Autumn period through the late Warring States period. This discovery indicates that even after Qin's eastward migration toward Xianyang, Xiquanqiu remained an important stronghold and a historic fortress. (LJ)

Inscription, chiseled along the exterior mouth rim: 卅四年工師文工安正十七斤十四兩四斗 (The 34th year, chief craftsman Wen, craftsman Anzheng, 17 *jin* and 14 *liang* [5.3 kg], 4 *dou* [7950 ml])

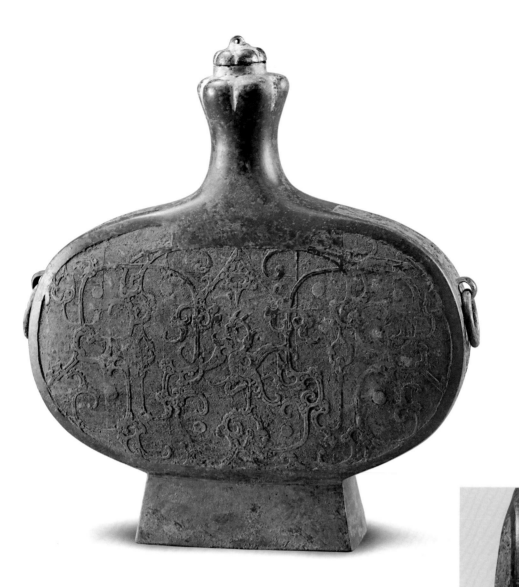

60 戰國 青銅蟠虺紋扁壺 乾縣
Flask with Serpent Design, 3rd century BC
Warring States period (475–221 BC)
Bronze with traces of gilding

H. 35 cm (13.8 in.)
Acquired from Qianxian, 1967
Shaanxi History Museum, 67.1

The oval shape and flat form of this flask were inspired by vessels made of animal hide, which nomadic people used for holding wine or water when riding, herding, and hunting. Found in Qianxian, located at the Qin northwestern frontier where cultures intermingled, the flask represents the social and economic exchanges that took place in the region, especially during the Warring States period. Containers such as this can be traced to an 8th century BC prototype from the early Qin settlement of Bianjiazhuang, Longxian.

This vessel is decorated with serpent designs on the body and geometric designs on the sides, where an animal mask (*pushou*) holds a ring. The innovative garlic-shaped mouth with its six sections represents a distinct Qin style. The mouth is covered by a lid with a tiny loop knob, which would have been connected by a cord to one of its ring handles. The gently curving shoulders and intricate decorations of serpents and clouds demonstrate multicultural influences, especially from the southern state of Chu, and masterful bronze casting employed during the 3rd century BC. (LJ)

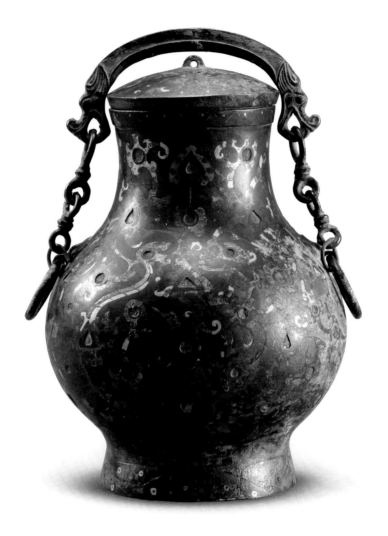

61 戰國 金銀鑲嵌青銅提梁壺 陳倉區石羊廟
Vessel with a Chain Handle
Warring States period (475–221 BC)
Bronze with gold and silver inlay

H. 21.5 cm (8.4 in.)
Excavated from Shiyangmiao, Chencang, 1973
Baoji Municipal Chencang District Museum, 015

This gourd-shaped wine container is a rare surviving example of a bronze vessel decorated with gold and silver inlay. The metal-inlay technique first appeared in ancient China during the late Spring and Autumn period (770–476 BC) and was fully developed in the Warring States period (475–221 BC). The inlay process involved chiseling small grooves into a metal surface and filling the grooves with soft pieces of gold and silver cut from thin sheets. The vessel was then polished to a glittering finish against a brownish-red background.

Scholars have debated whether the dragon-head chain handle on this vessel is original. A similar vessel that does not include a chain was found at Liujiatai, Baoji, leading some to believe the handle was added during the Han dynasty (206 BC–AD 220). Others argue that the dragon-head component was produced in the mid–Warring States period, concurrent with the vessel itself. (LJ)

62 秦 青銅鎏金虎鎮 西安灞河東岸

Tiger Weight
Qin dynasty (221–206 BC)
Gilded bronze

L. 20 cm (7.9 in.), H. 11.2 cm (4.4 in.)
Excavated from East Bank of Ba River, Baqiao, Xi'an, 1974
Xi'an Museum, 2gt17

During the Qin dynasty, people still sat on floor mats
and carpets rather than chairs. Weights such as this
were used for keeping household floor mats in place,
and for preventing their corners from curling. Mat
weights were frequently designed as a set of four in
animal motifs, such as bears, tigers, and deer, and
they sometimes took the shape of human figures.

This reclining tiger, with its hind legs tucked under
its body and front paws resting on the ground, is
realistically modeled with a slightly open mouth. The
Chinese consider the tiger "the king of beasts" and
greatly admire its fierceness. Despite its well-worn
features and flaking gold coating, this tiger still shows
its majestic spirit. Based on the inscription on the
bottom, this weight belonged to the Deng (鄧) family
and measures 2.5 kilograms (十斤). (HMS)

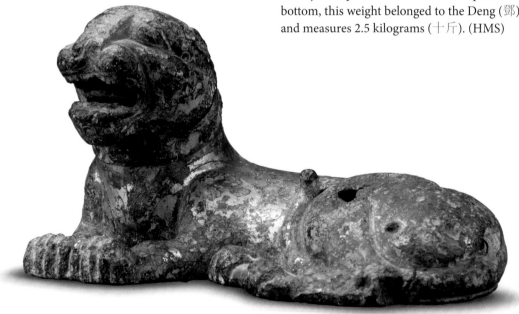

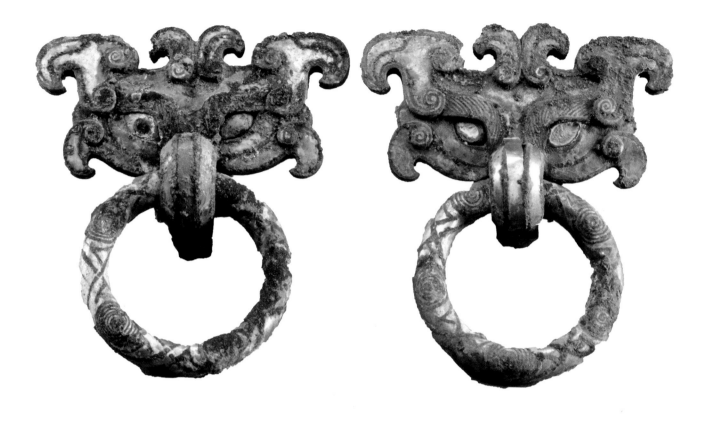

63, 64 戰國–秦 青銅錯銀鋪首 西安秦神禾塬陵園
Pair of Animal-Mask Handles
Warring States period (475–221 BC)–Qin dynasty (221–206 BC)
Bronze with silver inlay
L. 15 cm (5.9 in.), W. 12 cm (4.7 in.)
Excavated from Shenheyuan Mausoleum of Qin, Xi'an, 2005
Shaanxi Provincial Institute of Archaeology, H5:18–1, -2

Archaeologists excavated this pair of bronze ring handles in the form of animal masks (*pushou*) from the tomb in Shenheyuan, which researchers believe belonged to Queen Dowager Xia (d. 240 BC), the grandmother of the First Emperor. The Shenheyuan Mausoleum, located southwest of Xi'an, contains a large disturbed tomb and thirteen accompanying pits. In 2005 and 2007, archaeologists conducted surveys and excavations and unearthed gold and jade objects, horse and chariot ornaments, and ceramics.

Although many Qin gold and silver ornaments exhibit strong influences from the Eurasian Steppe, the principal design on these handles is clearly derived from the Shang and Zhou dynasties' *taotie* motif, the most striking zoomorphic mask motif of the early bronze period. In Chinese mythology, taotie, a powerful mythological animal, could gulp down the sun and the moon, as well as human beings, during eclipses. The taotie motif was used on buildings, utensils, and ornaments to ward off evil spirits.

The pushou handles, designed originally to serve as door knockers or as handles for coffins or bronze vessels, were soon applied to a variety of other containers. Made of bronze, this pair of handles may have once adorned a container or served as door rings. (HMS)

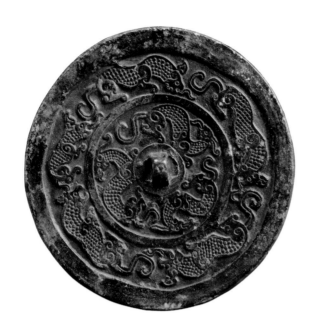

65 春秋 青銅獸紋鏡 隴縣店子村49號墓
Mirror with Animal Design
Spring and Autumn period (770–476 BC)
Bronze

Dia. 8.5 cm (3.3 in.)
Excavated from Tomb 49, Dianzicun, Longxian, 1991
Longxian County Museum, LD91M49:1

On the back of this mirror, eight mythical creatures—
spotted animals with S-shaped tails—are cast in a
design of concentric circles. In the inner circle, three
creatures turn their heads backward; and the five in
the outer circle chase each other.

This rare mirror is one of only three intact examples
excavated from 224 tombs at the Dianzicun cemetery.
Archaeological findings report that 80 percent of Qin
mirrors were intentionally damaged before they were
placed in tombs around the heads, elbows, and legs of
deceased individuals. This funeral practice appeared
in the early Qin settlement during migration eastward
from Gansu Province to Shaanxi Province. (LJ)

66 戰國 青銅連弧蟠螭紋鏡 西安臨潼區新豐
Mirror with Serpent Design
Warring States period (475–221 BC)
Bronze

Dia. 13 cm (5.1 in.)
Excavated at Xinfeng, Lintong, Xi'an, 2007
Shaanxi Provincial Institute of Archaeology, M430.6

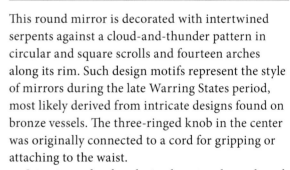

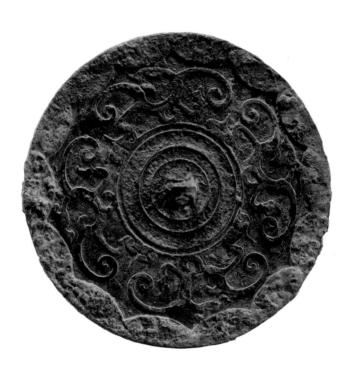

This round mirror is decorated with intertwined
serpents against a cloud-and-thunder pattern in
circular and square scrolls and fourteen arches
along its rim. Such design motifs represent the style
of mirrors during the late Warring States period,
most likely derived from intricate designs found on
bronze vessels. The three-ringed knob in the center
was originally connected to a cord for gripping or
attaching to the waist.

Scientists and archaeologists have jointly conducted
a metallographic study of twenty-three samples of
mirror fragments excavated from the Xinfeng cemetery,
four miles north of the First Emperor's mausoleum.
Results from the study reveal that mirrors from this
group contain an average of 25.1 percent tin and 7.8
percent lead. A high-tin alloy would enhance the
hardness of the metal, which made for easy polishing
but also made the object brittle. This may explain
why most mirrors are damaged upon excavation, in
addition to the intentional, ritual destruction discussed
in earlier archaeological studies. (LJ)

67 戰國 青銅鎏金琵琶形獸面紋帶鉤
Lute-Shaped Garment Hook
Warring States period (475–221 BC)
Gilt bronze

L. 9 cm (3.5 in.)
Acquired in 1990
Yan'an Municipal Institute of Cultural Relics, 345

68 戰國 青銅鎏金帶鉤 西安交通學校工地24號墓
Dragon-Head Garment Hook, 4th–3rd century BC
Warring States period (475–221 BC)
Gilt bronze

L. 19.6 cm (7.7 in.)
Unearthed from Tomb 24, Xi'an College of Transportation, 1998
Shaanxi Provincial Institute of Archaeology, 98M24:1

69 漢 青銅錯金銀帶鉤 西安浐灞生態園
Dragon-Head Garment Hook
Han dynasty (206 BC–AD 220)
Copper with gold and silver inlay

L. 13.5 cm (5.3 in.)
Unearthed from Chanba Ecology Park, Xi'an, 2004
Shaanxi Provincial Institute of Archaeology, 007280

These garment hooks exhibit various design motifs, such as scrolling clouds or swirling waves, with decorations of gold and silver inlay. In the inlay process, grooves were chiseled and then filled with gold and silver strips before the entire surface was polished. Cast in the shape of a lute or a cylindrical animal body, each hook features a stud underneath.

Archaeological evidence shows that such hooks first appeared in ancient China during the Western Zhou dynasty (1046–771 BC) and became popular during the Warring States period (475–221 BC). Some believe that garment hooks may have originated in Central Asia because the earliest examples were found in the Eurasian Steppe and even farther west. At excavations, examples of hooks have been found around the waist or shoulder remains of tomb occupants, indicating that they served as garment hooks or belt hooks from which swords and knives were hung. (LJ)

70 戰國 青銅燈 西安臨潼新豐

Lamp

Warring States period (475–221 BC)

Bronze

H. 15.4 cm (6 in.), Mouth Dia. 11.2 cm (4.4 in.)
Excavated from Tomb 391 at Xinfeng, Lintong, 2007
Shaanxi Provincial Institute of Archaeology, M391:30

This bronze household lamp was excavated from a late Warring States–era burial site north of Xi'an, which contains nearly six hundred individual Qin tombs. The lamp consists of three components: a plate, stem, and base. The stem tapers like a stalk of bamboo, and a corrugated bronze band around its center was perhaps used as a grip. With tapered stems and flared bases, the recognizable form of Qin lamps is thought to have been derived from a Zhou-dynasty food vessel on a stand, known as a *dou*.

The plate would have contained animal fat or vegetable oil, early fuel sources capable of burning for extended periods of time. As candles did not yet exist, the spike-like piece in the center of the plate would have had a wick affixed to it, likely made of hemp or a similar material and used to ignite the surrounding fuel. (WN)

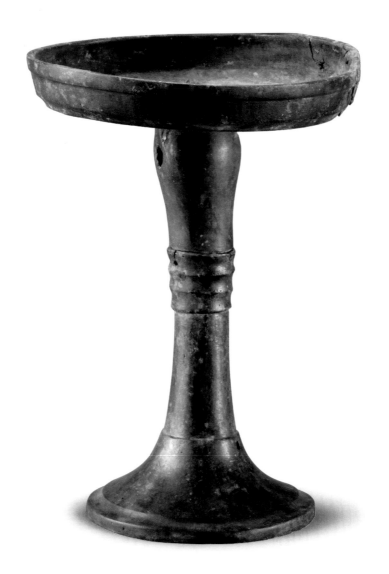

戰國 青銅燈 西安臨潼新豐

Western Rong Nomads

More than three thousand years ago, numerous nomadic groups inhabited the Eurasian Steppe, a vast region stretching from the Black Sea to Mongolia. The Rong, also referred to as the Western Rong, emerged as the strongest of these tribes and migrated eastward into the provinces of Gansu and Shaanxi. In 771 BC, the Rong launched an attack on the Western Zhou dynasty's capital, Fenghao (near today's Xi'an), and killed its king. As their power grew over centuries, they established extensive contacts and continually engaged in military conflicts along the Zhou frontier during the Warring States period. Qin forces finally defeated the Rong in 272 BC by carrying out a series of military campaigns. A branch of the Rong migrated northward to Mongolia and later developed into a multicultural empire known as Xiongnu.

The Rong nomads were skilled in horse riding and archery. They produced high-quality bronze weapons, horse fittings, and personal accessories that included bronze and gold ornaments. As a practice of shamanism, they performed rituals of horse and animal sacrifice and worshipped nature, including the spirits of mountains and rivers. Living closely with wildlife, Rong people strived to embody the strengths and abilities of animals and birds. (LJ)

Spring and Autumn Period
(7th century BC)

Northern Di Nomads

The Di people, also known as the Northern Di, resided on the Mongolian Plateau, north of China, raising livestock and hunting where today there is only desert. Since the Spring and Autumn period (770–476 BC), the Di migrated south into the Zhou's northern frontier where they had conflicts over land and natural resources with vassal states Qin, Zhao, Wei, and Yan, in present-day Shaanxi, Shanxi, Henan, and Hebei Provinces. They resided in northern Shaanxi, Inner Mongolia, and Ningxia in the Ordos Plateau, which was covered with hills, plains, and deserts. By the mid–Warring States period (475–221 BC), northern Shaanxi was occupied by the Wei state, whose people coexisted with Di nomads. In 297 BC, King Zhaoxiang of Qin (r. 306–251 BC) defeated Wei's primary forces and occupied the land.

Archaeological evidence shows that multicultural styles coexisted in northern Shaanxi during the Warring States period. The most notable characteristics of Ordos bronzes are animal and human forms and openwork designs, seen in household utensils, blades and knives, horse fittings, and accessories such as garment buckles and finials. (LJ)

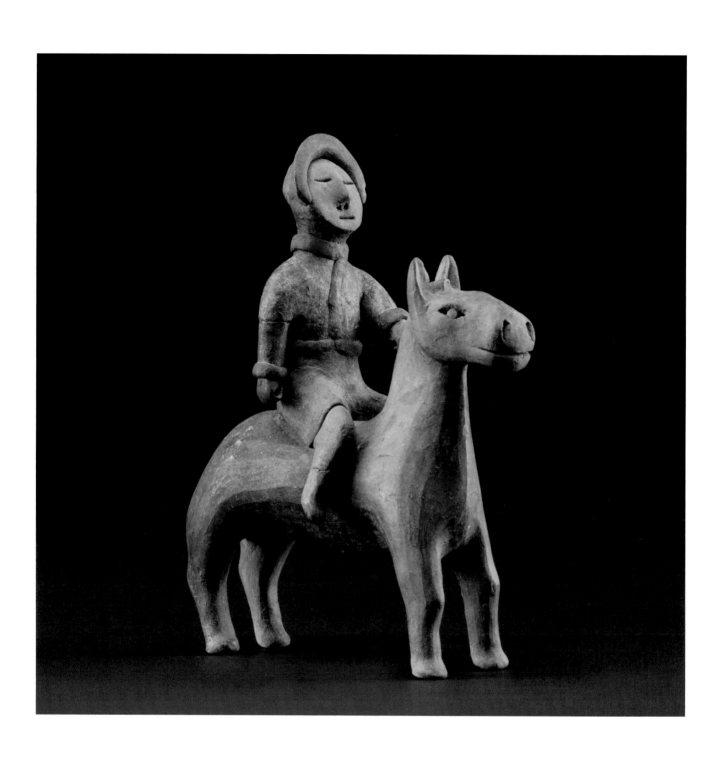

71 戰國 彩繪陶騎馬俑 咸陽鋼管廠2號墓

Mounted Warrior

Warring States period (475–221 BC)

Earthenware with pigment

H. 22 cm (8.7 in.), L. 18.4 cm (7.2 in.)
Excavated from Tomb 2, Steel Factory, Xianyang, 1995
Xianyang Municipal Institute of Cultural Relics and Archaeology, M28057:6

This warrior on horseback belongs to a pair of hand-molded earthenware sculptures excavated in 1995 from a tomb of the Qin state in Xianyang. Seated on a painted saddle, the figure extends his arm to hold reins, which are now missing. Thought to be the oldest known depiction of cavalrymen ever found in China, this mounted warrior displays many distinct features associated with neighboring nomads: a round face with a prominent nose, a tunic that folds toward the left (the garments of all Chinese terracotta warriors near the First Emperor's tomb fold toward the right), a close-fitting cap with a wide brim, and riding trousers and boots. Created nearly one hundred years prior to the First Emperor's terracotta army, this figure not only provides us with the earliest examples of burial cavalrymen found in China but also demonstrates the close relationship between the Qin state and neighboring regions. (HMS)

72 新石器 廟底溝文化 灰陶鏤空覆盆形面具
Mask with Openwork Design, ca. 3500 BC
Neolithic period, Miaodigou culture (4000–3000 BC)
Earthenware
H. 27 cm (10.6 in.), Dia. 26.5 cm (10.4 in.)
Acquired in 1997
Luochuan County Museum, 523

This rare bucket-shaped mask with an open mouth, cut-out eyes, and raised nose comes from the Luochuan County Museum, located about a hundred miles north of Xi'an. The mask's A-line shape suggests it was modeled after a wooden helmet, which an exorcist would have worn while performing shaman rituals to ward off evil spirits and misfortune. Due to insufficient information about its excavation, the date and origin of this mask remained uncertain until a later discovery at Yangguanzhai Village. There, from 2004 to 2008, on the banks of the Jing River outside

Xi'an in Gaoling County, archaeologists excavated the remains of a large settlement and unearthed a similar mask, along with painted ceramics and ritual stone *bi* and *cong* objects. Used for utilitarian purposes as well as for the worship of heaven and totems, the objects found at Yangguanzhai Village date to around 3500 BC. Recent excavations at a nearby cemetery and DNA testing identified some tomb occupants as Mongols, descendants of ancient Rong and Di people, who inhabited this area with multiple cultural groups during the Neolithic period. (LJ)

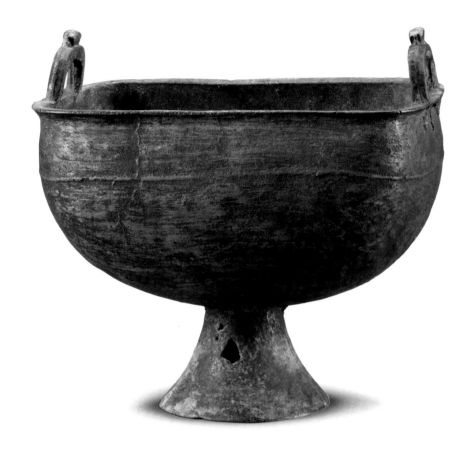

73 戰國 高圈足銅鍑 延安安塞縣高橋鄉
Square Container, 5th–4th century BC
Warring States period (475–221 BC)
Bronze

H. 22 cm (8.7 in.), W. 23.8 cm (9.4 in.)
Acquired from Gaoqiaoxiang, Ansai, Yan'an, 1983
Yan'an Municipal Institute of Cultural Relics, 212

Elegantly set on a flared base, this bronze vessel—with a high foot, round body, square rim, and looped handles with small knobs—reflects the nomadic style of objects from the Central Asian Steppe and northern Shaanxi. A single raised line below the rim decorates the vessel, which was used for holding food.

In the early to middle Warring States period, the Yan'an region was the frontier of the Wei state, where its people resided along with the Di nomads, sharing the southern border with Qin. Earthenware examples of this bronze, dating to the same period, have been unearthed from a tomb in Huanglingxian, also in northern Shaanxi. (LJ)

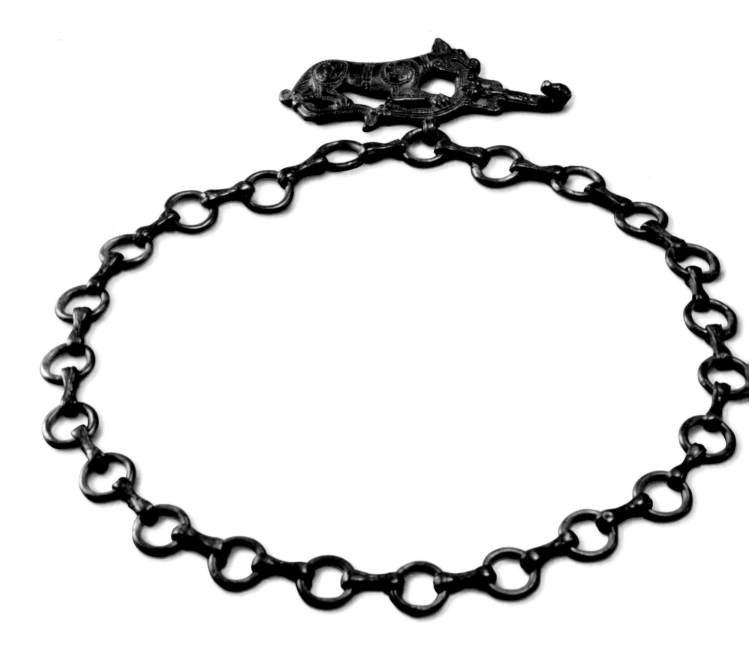

74 戰國 青銅虎噬蜥蜴帶鏈帶鉤 安塞縣謝屯村
Chained Garment Hook with Animals in Combat
Warring States period (475–221 BC)
Bronze

Hook L. 10 cm (4 in.), Chain L. 66 cm (26 in.)
Acquired at Xietuncun, Ansai, 1983
Yan'an Municipal Institute of Cultural Relics, 219

Discovered at Ansai in northern Shaanxi, this bronze garment ornament consists of an openwork plaque with a hook and a chain of rings. The plaque depicts animals in combat: a tiger and a lizard are attacking a snake as it grasps at another snake's tail. Fireball motifs decorate the tiger's body, and the lizard's curved tail forms the animal hook. Perhaps worn around the waist or on an upper garment, this ornament is one of the most complete of its type, featuring twenty-three rings linked by oblong joints.

The mountainous area of Ansai was an ancient battleground alternately occupied by Qin, other vassal states under Zhou control, and Rong and Di nomads during the Warring States period. To repel the advances of nomadic groups, King Zhaoxiang of Qin (r. 306–251 BC) ordered the construction of defensive walls along Ansai's mountainous northern borders, a structure later expanded by the First Emperor to form the Great Wall. (LJ)

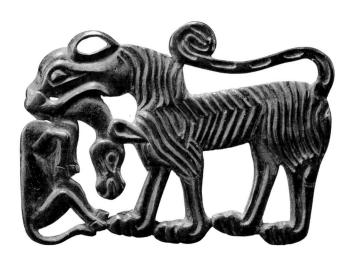

75 戰國 青銅虎銜驢紋飾件
Plaque with Tiger and Mule Design
Warring States period (475–221 BC)
Bronze

L. 9.3 cm (3.7 in.), W. 6.5 cm (2.6 in.)
Acquired in 1970
Xi'an Museum, 3gtD124

This openwork bronze plaque depicts a tiger walking off with a mule hanging from its mouth. Such spirited and vibrant depictions of wild animals are closely associated with the culture and art of the Eurasian Steppe, including the Ordos region in northern Shaanxi and Inner Mongolia. Beginning with the Warring States period, bronze belt plaques with representations of animals engaged in violent confrontations with one another became prominent. This plaque illustrates the Qin appropriation of art forms from their nomadic neighbors. (HMS)

76 戰國 青銅虎牛紋鏤空板飾
Plaque with Design of Tiger and Bull
Warring States period (475–221 BC)
Bronze
L. 11.9 cm (4.7 in.), W. 6.5 cm (2.6 in.)
Acquired in 1983
Xi'an Museum, 3gtD116

The scene on this bronze belt plaque depicts a tiger attacking a bull. Belt ornaments are the most distinctive artifacts associated with nomadic peoples from areas bordering the Qin region. In Tomb 34 at Beikang Village near Xi'an, archaeologists discovered clay molds from the 3rd century BC for manufacturing such belt plaques. Their findings further confirmed that the Qin adopted such art forms from neighboring regions. (HMS)

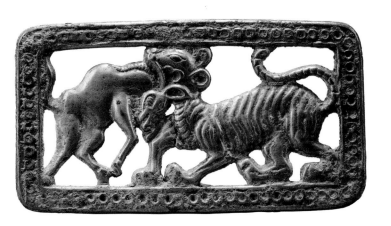

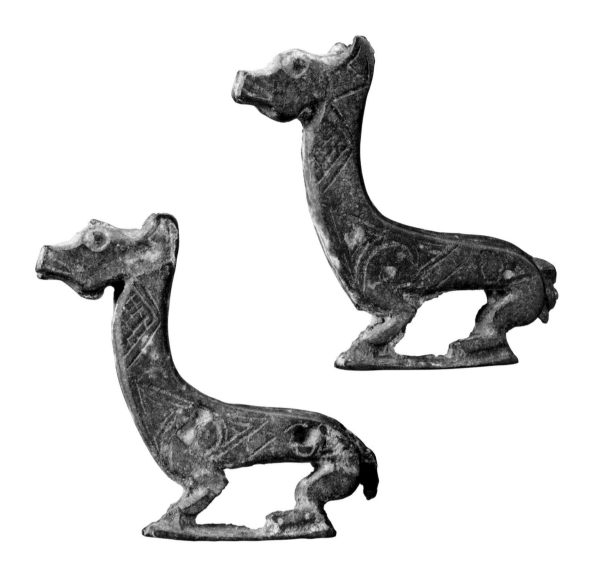

77, 78 戰國 青銅鹿飾件 安賽縣井溝村
Pair of Deer with Long Necks
Warring States period (475–221 BC)
Bronze
H. 9.5 cm (3.7 in.), L. 11 cm (4.3 in.)
Acquired from Jinggoucun, Ansai, 1983
Yan'an Municipal Institute of Cultural Relics, 214–2, 214–3

This pair of deer-shaped bronze ornaments from a set
of six came from the district of Ansai, an area known
for many important burial sites. Located on Qin's
northern frontier, about 230 miles north of Xi'an,
Ansai was influenced greatly by the nomadic Ordos
culture during the Warring States period.

The deer, with flattened bodies and curved tails, are
decorated with incised geometric patterns. The small
round sockets on the bodies suggest that they may
also have contained some inlays. (HMS)

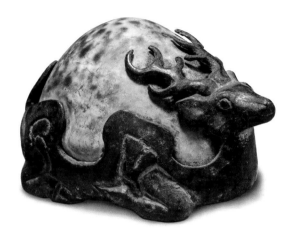

79, 80 戰國 青銅嵌貝鹿鎮
Pair of Deer with Shells
Warring States period (475–221 BC)
Bronze, tiger cowrie seashells
H. 4.7 cm (1.8 in.), L. 8.8 cm (3.5 in.)
Acquired in 2004
Baota Institute of Cultural Relics, 13–1, 13–2

This interesting pair of objects functioned as weights for the corners of floor mats. Most weights from this period were made of bronze and often shaped like bears, dragons, sheep, tortoises, or snakes. These weights, modeled as crouching deer and inset with large spotted seashells, must have been highly valued for their new and innovative designs. The style apparently continued in the Han dynasty (206 BC–AD 220) since quite a few sets of similar weights were excavated from tombs of the Western Han dynasty (206 BC–AD 9). (HMS)

Yongcheng: Qin Capital (677–350 BC)

Located in central Shaanxi Province on the north bank of the Yong River, Yongcheng was the capital of Qin for more than three centuries, between 677 and 350 BC. During that time, the Qin grew rapidly from a vassal state into a powerful kingdom. Yongcheng remained a sacred place to return for significant events such as state ceremonies. Ying Zheng (r. 246–210 BC), later recognized as the First Emperor, traveled to Yongcheng from his capital at Xianyang for his inauguration.

Archaeological surveys reveal that Yongcheng's plan included the northern city area, imperial mausoleums to the south, and the commoners' cemetery in the center. Encompassing a total area of 2,600 square acres, the city featured palace halls and ritual temples. From surveys and excavations in the palaces to the city's west and the mausoleums in the south, ritual bronzes, luxury objects, royal musical instruments, architectural elements, and bronze weapons have shed new light on Qin customs and lifestyles. (LJ)

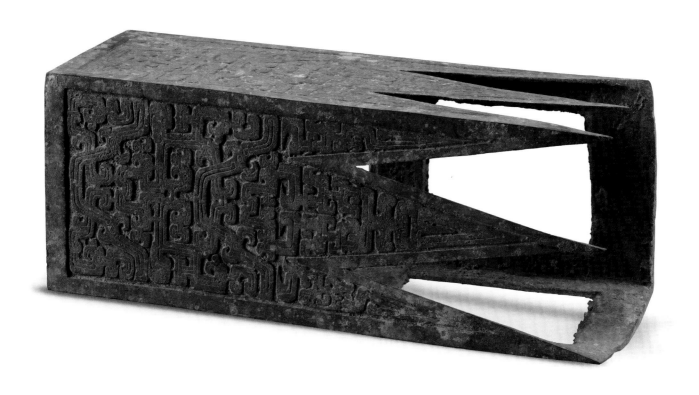

81 春秋 青銅雙齒曲尺形蟠螭紋構件 鳳翔縣姚家崗
Beam Cladding with Serpent Design, 7th century BC
Spring and Autumn period (770–476 BC)
Bronze

L. 43.3 cm (17 in.), W. 16.5 cm (6.5 in.), H. 16.5 cm (6.5 in.)
Excavated from Yaojiagang, Fengxiangxian, 1973
Shaanxi History Museum, 76.017

In 1973 archaeologists excavated a palace complex in western Yongcheng, an important Qin capital from 677 to 350 BC. Three separate hoards at the site yielded sixty-four claddings, out of which archaeologists have identified ten different architectural forms. Prior to the development of the wooden joint technique, metal structures like this example served as architectural components, both functional and decorative, that connected and strengthened wooden beams and columns. Only one to two sides of each piece would be visible when they were installed in the rammed-earth walls of the palaces.

Scholars believe that these claddings belonged to one of Yongcheng's earliest erected structures—most likely the Dazhenggong Palace, a residence of Duke De of Qin (r. 677–676 BC), the second ruler in what was then the new capital. (LJ)

Roof-Tile Ends of the Qin Empire

In classical Chinese architecture, tile ends were used to shield eaves from wind and rain. A tile end was fitted onto a half-cylindrical roof tile. Tile ends can be traced as far back as the Western Zhou dynasty (1046–771 BC). During the Qin dynasty (221–206 BC), artisans altered the shapes of tile ends from semicircular to circular, allowing for many new lively designs.

Archaeologists have unearthed numerous round tile ends from Fengxiang County, formerly named Yongcheng, which served as the Qin capital for more than three hundred years. The city's seemingly endless construction projects of palaces, royal tombs, offices, and workshops created a high demand for tile ends. The most commonly found decorations on

Qin-era tile ends include molded and impressed designs of cloud or water patterns, plants, animals, and four-character Chinese inscriptions. All are represented by the tile ends displayed below and on the pages that follow. (HMS)

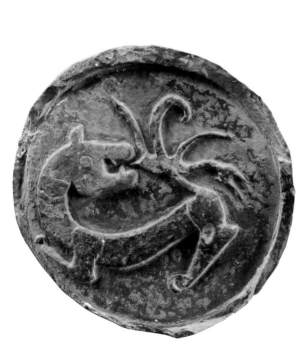

82 戰國 虎食雁紋瓦當 鳳翔縣雍城遺址
Roof-Tile End with Tiger and Goose Design
Warring States period (475–221 BC)
Earthenware

Dia. 15.5 cm (6.1 in.)
Excavated from Yongcheng site, Fengxiangxian, 1982
Shaanxi Provincial Institute of Archaeology, 000929

The dramatic scene on this decorated tile shows a leaping tiger attacking a wild goose. Pressed into the clay with molds, the image captures the wild animal's hunting activities and reflects the Qin people's frequent interactions with neighboring nomadic tribes. (HMS)

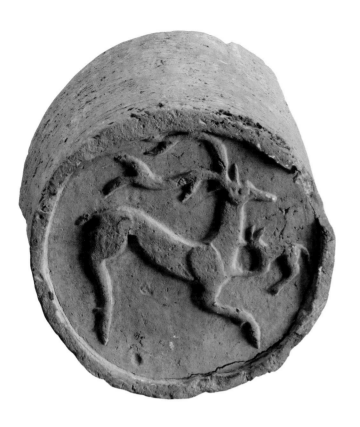

83 秦 母子鹿紋瓦當 鳳翔縣姚家崗
Roof-Tile End with Deer Design
Qin dynasty (221–206 BC)
Earthenware

Dia. 14.7 cm (5.8 in.), D. 12 cm (4.7 in.)
Excavated from Yaojiagang, Fengxiangxian, 2005
Shaanxi Provincial Institute of Archaeology, T1202:42

This tile features the profile of a large stag with exaggerated antlers and a small young deer standing in front of him. The artful design in the limited space captures the spirit of wild animals and reveals the Qin people's affinity with the culture of their nomadic neighbors. (HMS)

84 戰國 橐泉宮當 鳳翔縣孫家南頭
Roof-Tile End from Tuoquan Palace
Warring States period (475–221 BC)
Earthenware

Dia. 14.7 cm (5.8 in.), D. 2.9 cm (1.1 in.)
Unearthed from Sunjianantou, Fengxiangxian, 1996
Shaanxi Provincial Institute of Archaeology, 000663

This roof-tile end bears four characters written in the Qin small seal script: "*Tuoquan gongdang,*" meaning "Tile end of the Tuoquan Palace." Named for a nearby famous spring and commissioned by Duke Xiao (361–338 BC), the Tuoquan Palace was one of the many large palaces at Yongcheng, the Qin capital for three centuries. (HMS)

85 戰國 水紋 (葵紋) 瓦當 鳳翔縣豆腐村
Roof-Tile End with Water Design
Warring States period (475–221 BC)
Earthenware
Dia. 14.6 cm, (5.7 in.), D. 7 cm (2.7 in.)
Excavated from Doufucun, Fengxiangxian, 2006
Shaanxi Provincial Institute of Archaeology, BE000585

Of all the designs found on Qin tile ends, wave patterns are probably the most distinctive Qin creation. This tile was found among palace ruins in present-day Fengxiang County, which was once Yongcheng, a Qin capital. Its craftsman successfully captured the beauty and eternal rhythm of waves using only simple curvilinear patterns.

According to the ancient Chinese cosmology of yin and yang, all events proceed from the Five Phases (or Elements) of metal, wood, water, fire, and earth. The Five Phases, which succeed one another in a cycle, are also associated with seasons, colors, directions, and virtues. Based on this cosmology, ancient dynasties often had their representing virtues: Xia dynasty, the virtue of wood; Shang dynasty, the virtue of metal; and Zhou dynasty, the virtue of fire. The First Emperor believed that the Qin possessed the virtue of water because it conquered Zhou rule, which demonstrated water's power to overcome fire. (HMS)

86 戰國 漩渦紋瓦當 鳳翔縣孫家南頭
Roof-Tile End with Spiral Design
Warring States period (475–221 BC)
Earthenware
Dia. 14.5 cm (5.7 in), D. 9.5 cm (3.7 in)
Excavated from Sunjianantou, Fengxiangxian, 1996
Shaanxi Provincial Institute of Archaeology, BE000655

Numerous tiles decorated with various patterns of animals, flowers, plants, clouds, and waves were found at sites in and around the Qin palaces in Shaanxi Province. Both the large quantity and the rich variety of these tiles indicate the Qin people's fascination with nature. This tile end with a wheel-like circular form at the center surrounded by spirals is not clearly identified. Some have interpreted the design as a stylized floral pattern, others have called it a sun pattern. In either case, it symbolizes the movements and rhythm the Qin people associated with their cosmos. (HMS)

87 戰國 四葉紋瓦當 秦東陵4號園寢殿遺址
Roof-Tile End with Leaf Design
Warring States period (475–221 BC)
Earthenware

Dia. 14–14.4 cm (5.5–5.7 in.)
Excavated from Mausoleum 4, Eastern Qin Mausoleum, 2015
Shaanxi Provincial Institute of Archaeology, QDIVT012119-2

This tile represents a typical Qin design using quadrants. Here the craftsman placed a clearly defined leaf motif in each section and joined them at the center like four petals of a flower. The simple geometric shapes and linear patterns create a dynamic rhythm and demonstrate the unique aesthetic sense of the Qin people. (HMS)

88 戰國 花草紋瓦當 秦東陵4號園寢殿遺址
Roof-Tile End with Floral Design
Warring States period (475–221 BC)
Earthenware

Dia. 14 cm (5.5 in.)
Excavated from Mausoleum 4, Eastern Qin Mausoleum, 2015
Shaanxi Provincial Institute of Archaeology, QDIVT011119-2

This roof-tile end was one of many excavated in 2014 from an imperial Qin mausoleum in Lintong, Shaanxi Province. Scholars believe that the tomb belonged to Queen Dowager Xuan (338–265 BC), great-great-grandmother of the First Emperor of Qin. Most consider the rare decoration on this tile, consisting of four repeating floral designs, simply a graphic element. However, the writer believes that this design was likely a pattern inspired by the unusual last name of the Queen Dowager, written as 芈 (*mi*) in stylized seal script. (HMS)

89 戰國 鳳鳥紋陶模 鳳翔城南豆腐村作坊遺址
Mold of Tile with Phoenix Design
Warring States period (475–221 BC)
Earthenware

Dia. 14.5 cm (5.7 in.), D. 1.3–2 cm (0.5–0.8 in.)
Excavated from Doufucun Workshop, Fengxiangxian, 2005
Shaanxi Provincial Institute of Archaeology, T1102:189

This mold was used to make larger semicircular tiles, also known as half-tiles, for decorating walls. The tile design here features a running phoenix which, together with the dragon, is one of China's oldest mythical animals. Tiles decorated with more well-defined phoenix designs became increasingly popular in the Qin state during the first half of the Warring States period. This mold and many wall tiles made from it were excavated in Fengxiang County in 2005. (HMS)

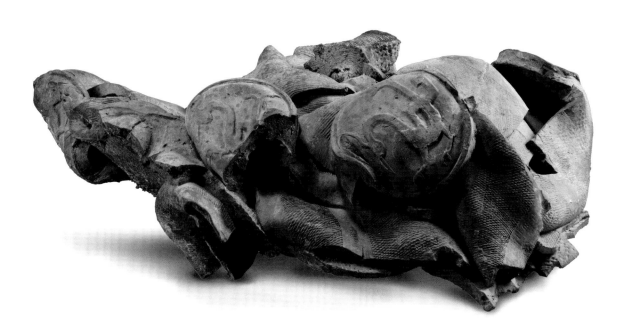

90 戰國 瓦當與筒瓦燒结塊 鳳翔縣豆腐村作坊遺址
Piled Roof Tiles
Warring States period (475–221 BC)
Earthenware

L. 70 cm (27.6 in.), W. 50 cm (19.7 in.), H. 28 cm (11 in.)
Excavated from Doufucun Workshop, Fengxiangxian, 2006
Shaanxi Provincial Institute of Archaeology, T1202:106

Archaeologists excavated this misfired pile of roof tiles from the tile workshop located in Doufucun, Fengxiang County. The discovery of this workshop, where numerous round tile ends, sewage pipes, and other decorative elements made of fired clay were unearthed, identifies the site as a significant supplier of ceramic building materials. Fengxiang County is located in an area formerly known as Yongcheng, the Qin capital for more than three hundred years. (HMS)

Tomb mound of Emperor Qin Shihuang

Section III Quest for Immortality

Li Jian

Named a World Heritage Site by UNESCO in 1987, the mausoleum complex of the First Emperor, a necropolis for the emperor's afterlife, stands at the foot of Mount Li, thirty miles northeast of Xi'an. Construction of the complex began in 246 BC when the future First Emperor, then known as King Ying Zheng, ruled over the Qin state. The tomb was completed thirty-eight years later in 208 BC, two years after his death. The mausoleum complex occupies an area of 13,900 acres. Enclosed within its double walls are a tomb mound, an underground palace, ritual and residential buildings, and accompanying tombs and pits for sacrificial humans, horses, treasured animals, and bronze pottery figurines. The tomb mound, which sits within the complex's inner wall, now measures 167 feet high with a circumference of one mile. None of the above-ground structures survives today.

After he unified the country, the First Emperor sought advice from scholars of yin-and-yang studies in cosmology to ensure the new empire's success. He made five imperial tours across the seven former states between 220 and 210 BC, each trip ranging from three months to nearly a year. He frequently traveled east to Shandong Province to visit Mount Tai and shrines in various locations, where he worshipped heaven, nature, and Qin ancestral rulers. He also traveled to the Bohai Sea, the innermost gulf of the Yellow Sea, in search of the elixir for immortality thought to be in the mythical land of Penglai. The emperor became ill on his last tour and died in 210 BC at the Shaqiu Palace in present-day Xingtai, Hebei Province. He was laid to rest in his tomb at Mount Li.

The tomb of the First Emperor is believed to be undisturbed. The layout of its burial chamber and its contents have remained a mystery for more than two thousand years. The earliest supposed description of the tomb and its contents is found in Sima Qian's *Records of the Grand Historian (Shiji)*, completed ca. 91 BC:

> The tomb was filled with irreplaceable goods and priceless treasures. Crossbows with arrows have been installed for shooting anyone who intends to enter the tomb. The ground is filled with mercury to emulate the rivers and the sea. The ceiling is painted with stars and zodiac constellations, the ground covered by geographic features. The candle lights burn eternally in the tomb.

Little was known about the extent of the First Emperor's necropolis until 1974, when farmers digging a well in a village one mile east of the mausoleum walls uncovered a terracotta head, shards of clay, weapons, and floor tiles. After the initial discovery, archaeologists undertook surveys and excavations, determining that an estimated eight thousand life-size terracotta figures lay buried in three separate pits. Of that estimated total, only approximately 20 percent have been excavated. Other significant discoveries in the following decades include a set of two bronze horse-drawn chariots, limestone armor and helmets, terracotta stablemen and entertainer figures, and bronze water birds. All these remarkable discoveries provide tangible evidence of the First Emperor's grand vision of the afterlife and his quest for immortality.

Plan of the First Emperor's Mausoleum Complex

Outer wall

Inner wall

Stone workshop
at Zhengzhuang

Tomb mound

Bronze birds and
terracotta musicians pit
K0007

Yuchi si

Shangjiaocun

Stable pits

Dike

Linma Road

Pit 3 Pit 4

Pit 2

Pit 1

Terracotta warriors
and horses pits

Inner City

1 Tomb mound
2 Ritual complex remains
3 Accompanying tombs
4 Bronze chariots pit
5 Civil officials pit K0006

Outer City

6 Stone armor pit K9801
7 Entertainers pit K9901
8 Horse stable pits
9 Office and residential remains

Beyond Outer City

10 Stable pits
11 Shangjiaocun tombs
12 Terracotta warriors and horses pits
13 Yuchi site
14 Bronze birds and terracotta
 musicians pit K0007
15 Stone workshop

N

0 1 km

The Terracotta Army

In 1974, outside the city of Xi'an, a group of farmers digging a well stumbled upon one of the greatest archaeological sites of the 20th century. There, one mile east of the mausoleum's outer city wall, archaeologists discovered the First Emperor's subterranean army of an estimated eight thousand terracotta figures. The figures were buried in three pits constructed with rammed earth, bricks, and wooden beams. The First Emperor had been preparing for the afterlife since ascending the throne as king of Qin at age thirteen.

The terracotta army is a life-size depiction of Qin military structure, and each figure in the pit bears a rank. Their astounding level of detail and realism was unprecedented in ancient Chinese sculpture and funerary artwork. Over time, fires, moisture, and deterioration of the ceilings caused significant damage to the pits and their contents, but since 1974, archaeologists have excavated, restored, and reconstructed more than a thousand terracotta figures. The discovery of the terracotta pits has since provided invaluable information regarding the imperial funerary practices and military organization of the Qin dynasty.

Pit 1, the largest of the three pits, spans over 152,000 square feet and houses an estimated 6,000 figures, 200 horses, and 50 chariots. Earthen walls divide the rectangular plan into eleven passages containing terracotta representations of infantrymen, officers, chariots, horses, charioteers, and generals. Scholars believe that the arrangement of figures in Pit 1 simulates a traditional Qin battle formation. Pit 2, which is L-shaped and covers more than 65,000 square feet, hosts nearly 1,000 figures, 450 horses, and 89 chariots. The majority of the figures found in Pit 2, regarded as the army barracks, are cavalrymen, horses, and archers, in addition to charioteers, infantrymen, and officers. Pit 3, the smallest of the three, acts as the army's "command headquarters." This U-shaped pit contains just four horses, one chariot, and sixty-eight figures, mostly infantry and high-ranking officers. In archaeological surveys conducted between Pits 2 and 3, a partially built fourth pit was found, apparently abandoned during construction.

Craftsmen in off-site workshops assembled each terracotta figure by starting with the legs and waist, followed by the upper torso, arms, and head. Using mass-produced, molded parts to form the bodies, they later added detailed components, such as hands and additional garments, individualizing each figure's appearance. The heads, which featured a number of different hairstyles and facial characteristics, were molded and fired separately.

Further archaeological evidence suggests that the figures were fired in the kiln and then coated in dark lacquer and polychromatic pigment. Certain excavated figures retain traces of this pigment, indicating that a number of colors, both natural and artificial, were used. Figures' skin tones were often a pinkish-white, whereas their robes and armor are speculated to have featured deep purples, reds, greens, and blues. Since 2013 ongoing excavations, lab work, and scientific analysis in Pit 1 have focused on protecting the delicate figures' pigmented surfaces from exposure to the elements. The preservation process is meticulous and time sensitive, but it allows for closer speculation on the original, intended appearance of the terracotta army. (WN)

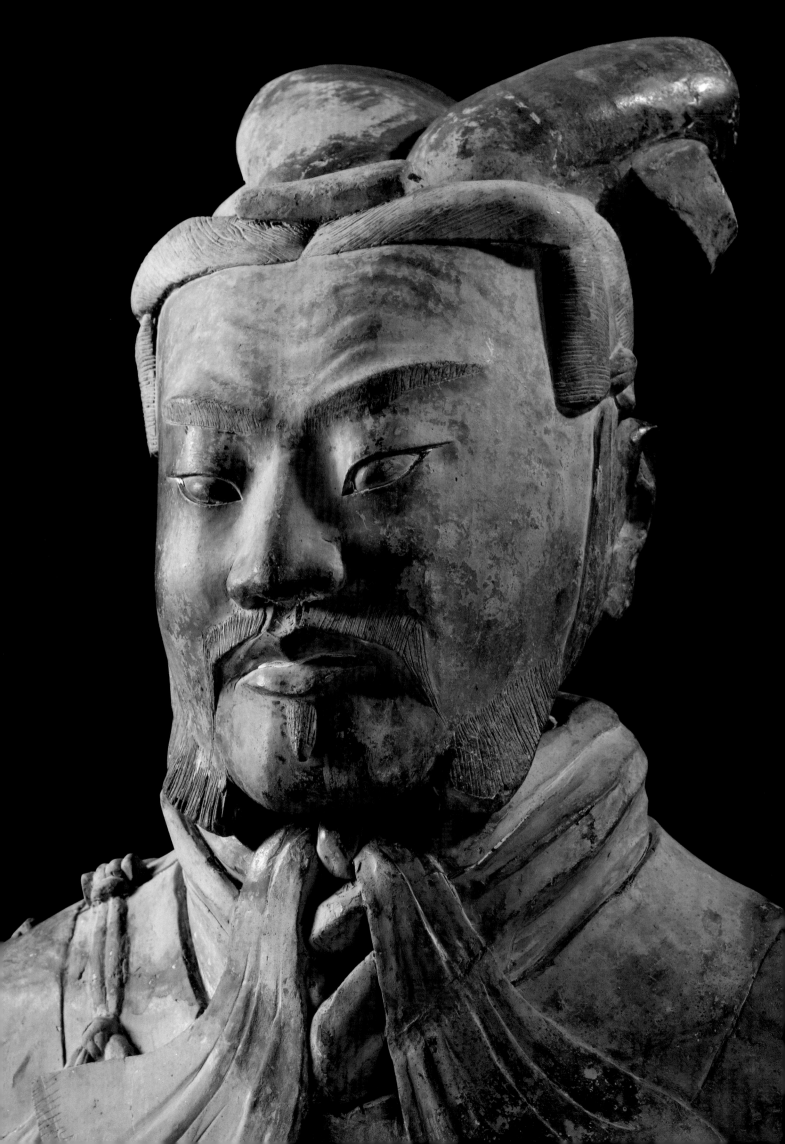

91 秦 將軍俑 秦始皇帝陵兵馬俑1號坑
Armored General
Qin dynasty (221–206 BC)
Earthenware

H. 196 cm (77.2 in.), W. 57 cm (22.4 in.)
Excavated from Pit 1, Qin Shihuang's Mausoleum, 1977
Emperor Qin Shihuang's Mausoleum Site Museum, 002523

The armored general in Pit 1 is both the tallest and highest-ranking figure excavated from all three terracotta army pits. Depicted on this figure is the protective leather apron that would have covered a warrior's entire torso, with an overlay of plated armor on the abdomen and lower back. The detailed design suggests that he wears a thick, double-layered robe, and padded trousers. His elaborate cap would once have featured feathers imitating the twin tails of a pheasant. Ribbons decorate his shoulders, back, and collar to signify high rank and prestige. His overlapping hands hover where they once rested on the hilt of a now-missing sword. As indicated by an outstretched index finger, the general commanded troops in battle, where he would have been accompanied by an infantryman and a charioteer. Only nine terracotta generals have been discovered in total, found mostly near chariot remains, drums, and bells. (WN)

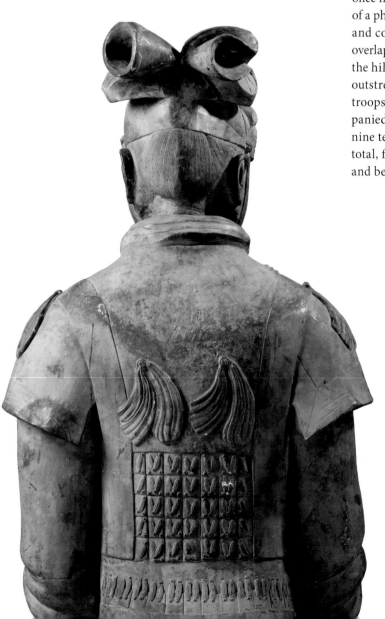

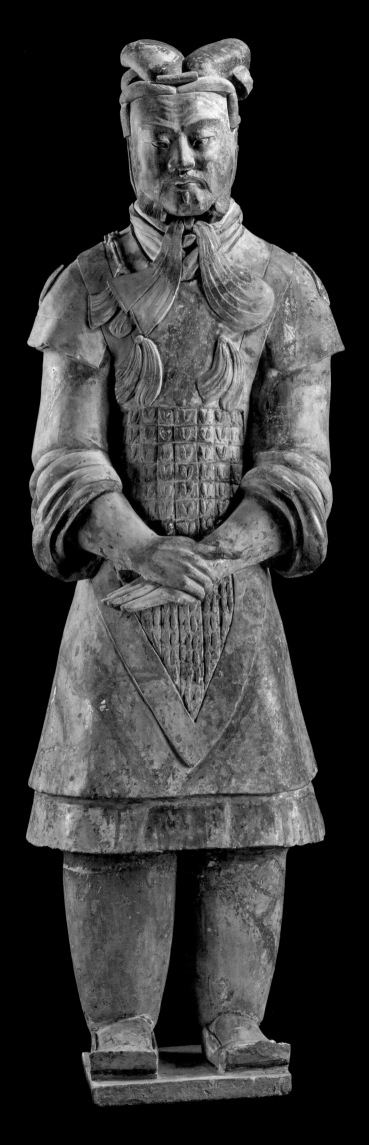

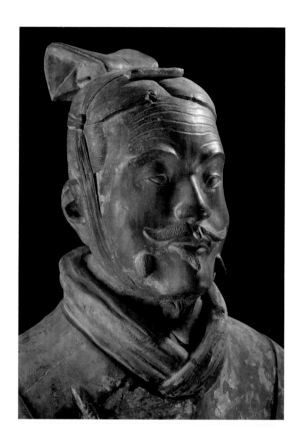

92 秦 鎧甲軍吏俑 秦始皇帝陵兵馬俑1號坑
Middle-Ranking Officer
Qin dynasty (221–206 BC)
Earthenware

H. 189 cm (74.4 in.), W. 71 cm (28 in.)
Excavated from Pit 1, Qin Shihuang's Mausoleum, 1976
Emperor Qin Shihuang's Mausoleum Site Museum, 000849

This tall and stoic figure ranks somewhere between general and infantryman, indicated not only by his height but also by his flattened cap, long robe, curved-toed boots, and extensive armor, all rendered in great detail. Covering his abdomen, back, arms, and shoulders is a sculpted leather garment with layered, plated armor providing added protection. He slightly raises one arm as if wielding a tall spear or lance. His other arm rests calmly at his side, where it once held a short bronze sword. The depiction of rolled-up sleeves and a tightened grip suggests anticipation and preparedness. (WN)

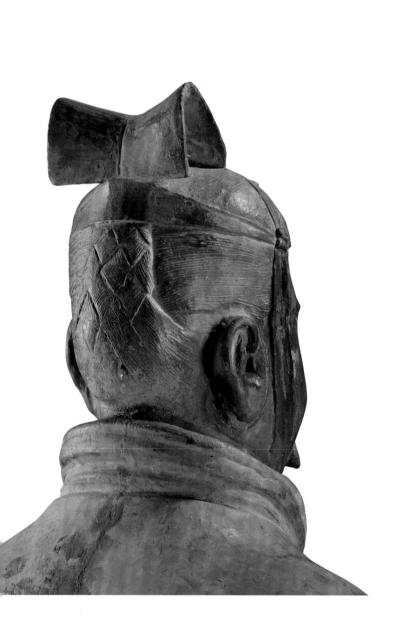

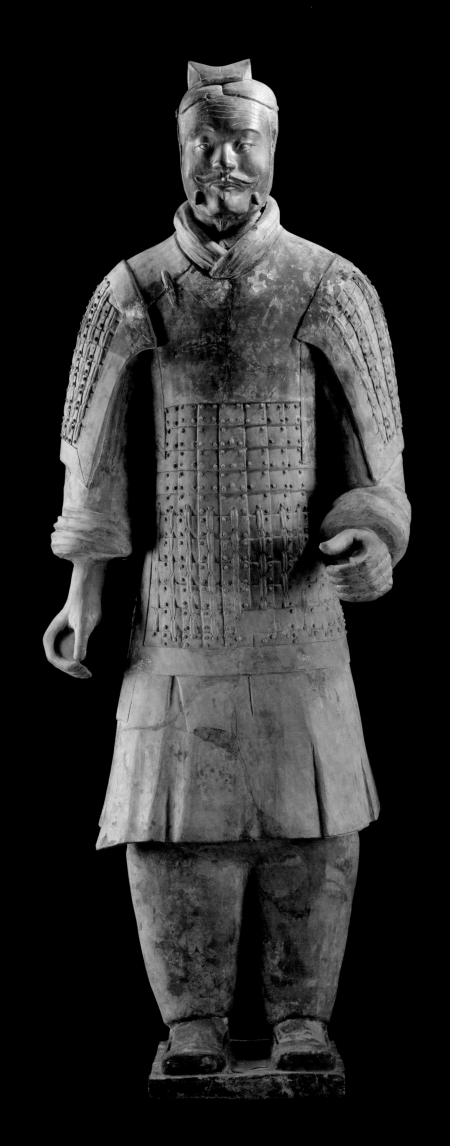

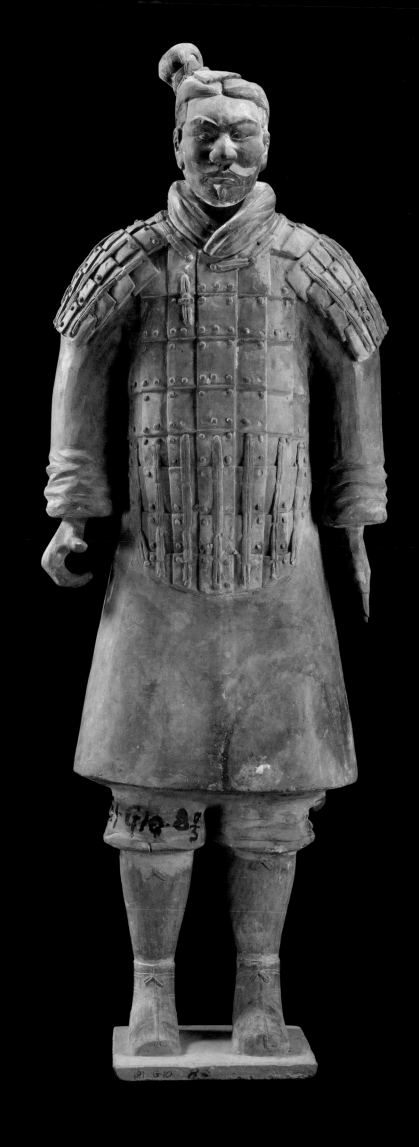

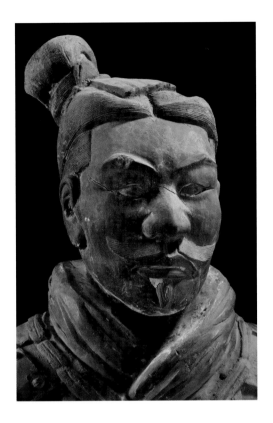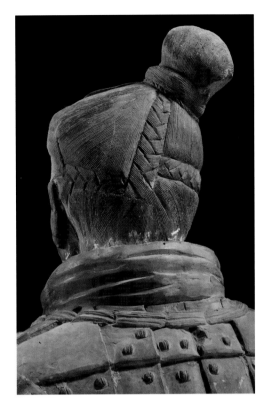

93 秦 鎧甲武士俑 秦始皇帝陵兵馬俑1號坑
Armored Infantryman
Qin dynasty (221–206 BC)
Earthenware

H. 185 cm (72.8 in.), W. 65 cm (25.6 in.)
Excavated from Pit 1, Qin Shihuang's Mausoleum, 1992
Emperor Qin Shihuang's Mausoleum Site Museum, 002753

Vital to the success of the Qin military was the infantry, which is the best-represented rank in the terracotta army pits. This armored infantryman from Pit 1 stands attentively with both arms at his side and an austere expression on his face. His detailed terracotta rendering includes hair tied tightly in a topknot, a robe with a neck-guard, short trousers, boots, and plated armor covering his torso and shoulders. Some terracotta infantrymen brandished spears and halberds, while others, such as this example, were equipped with only a crossbow and positioned behind defensive lines of unarmored infantry and chariot groups. Hundreds of infantrymen figures, both armored and unarmored, have been excavated from all three pits. (WN)

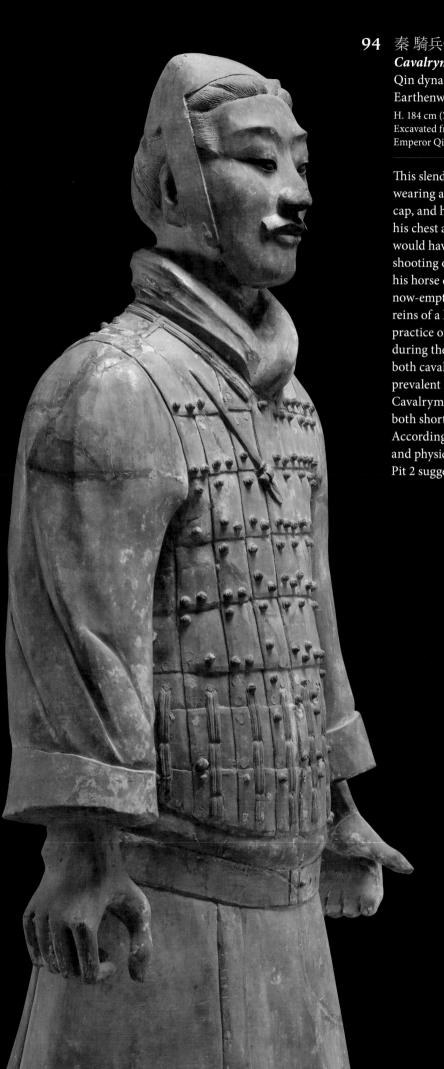

94 秦 騎兵俑 秦始皇帝陵兵馬俑2號坑

Cavalryman (detail)

Qin dynasty (221–206 BC)

Earthenware

H. 184 cm (72.4 in.)
Excavated from Pit 2, Qin Shihuang's Mausoleum, 1977
Emperor Qin Shihuang's Mausoleum Site Museum, 002763

This slender cavalryman figure is portrayed as wearing a short pleated robe, trousers, a hide skull cap, and high-waisted, sleeveless armor protecting his chest and back. The robe and armor depicted would have allowed him to pivot his torso when shooting on horseback and to mount or dismount his horse quickly. With his arms at his sides, his now-empty hands once held a crossbow and the reins of a horse (cat. no. 95). The Qin inherited the practice of horseback riding from nomadic peoples during the Warring States period (475–221 BC), and both cavalry and infantry gradually became more prevalent in the military under the First Emperor. Cavalrymen were tasked with reconnaissance and both short- and long-range combat on horseback. Accordingly, the attire, poses, facial expressions, and physical build of the terracotta cavalrymen in Pit 2 suggest readiness and versatility. (WN)

95 秦 鞍馬俑 秦始皇帝陵兵馬俑2號坑

Cavalry Horse

Qin dynasty (221–206 BC)

Earthenware

H. 172 cm (67.7 in.), L. 210 cm (82.7 in.)
Excavated from Pit 2, Qin Shihuang's Mausoleum, 1977
Emperor Qin Shihuang's Mausoleum Site Museum, 003160

Less than half of the terracotta horses excavated from the mausoleum pits are identified as cavalry horses. Unlike the barebacked horses in groups of four, which draw chariots, cavalry horses are each saddled and individually paired with an armored cavalryman (cat. no. 94). This example's expressive face, alert ears, and plaited tail convey prestige and might. The horse's meticulously detailed saddle includes tacks, tassels, girth straps, buckles, and a blanket, and its bridle components, bits, and reins were detachable pieces made of bronze or carved stone. The large hole in the abdomen of this terracotta horse provided ventilation while the model was fired in a massive kiln in one of the imperial workshops. Terracotta horses were assembled in increments from the bottom up, beginning with the legs. (WN)

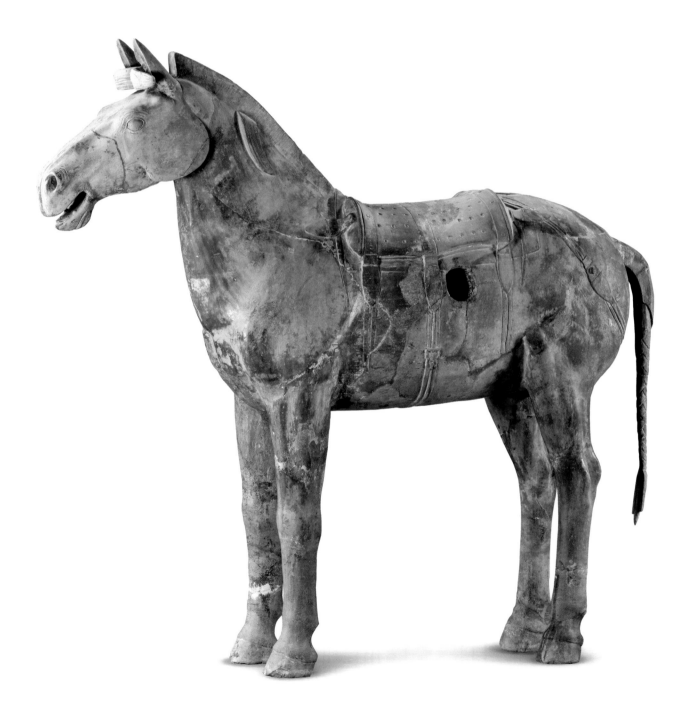

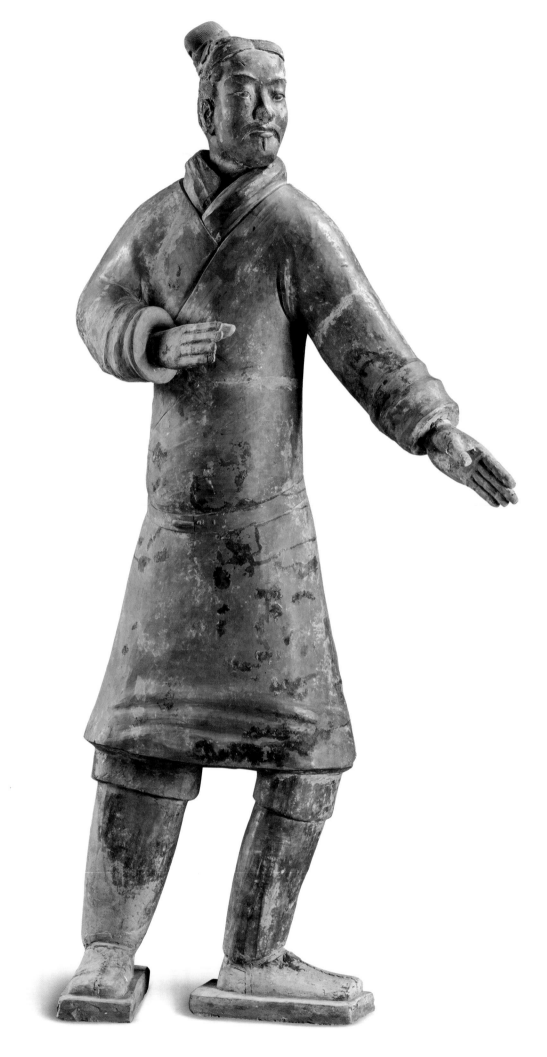

96 秦 立射俑 秦始皇帝陵兵馬俑2號坑

Standing Archer

Qin dynasty (221–206 BC)

Earthenware

H. 182 cm (71.6 in.), W. 96 cm (37.8 in.)
Excavated from Pit 2, Qin Shihuang's Mausoleum, 1997
Emperor Qin Shihuang's Mausoleum Site Museum, 002818

97 秦 跪射俑 秦始皇帝陵兵馬俑2號坑

Kneeling Archer

Qin dynasty (221–206 BC)

Earthenware

H. 122 cm (48 in.), W. 62 cm (24.4 in.)
Excavated from Pit 2, Qin Shihuang's Mausoleum, 1977
Emperor Qin Shihuang's Mausoleum Site Museum, 002744

The some three hundred terracotta archers excavated from Pit 2 either stand or kneel in dynamic poses exhibiting pivoting torsos, bending knees, and craning necks. Qin military strategy required one group of archers to stand and provide cover fire, while the others knelt and loaded bolts into their crossbows. The archer figures were discovered at the entrance to Pit 2, where they take formation. The standing figures, dressed in padded field robes, encircle the kneeling ones, who are depicted wearing short robes with chest and shoulder armor. The hairstyles of both figures include topknots and braids, and each archer once wielded a large wooden crossbow (*nu*). The standing archer, with one foot turned outward, aims down as he draws back the bow. The kneeling archer keeps the crossbow at his hip, aiming it up and away from the ranks. (WN)

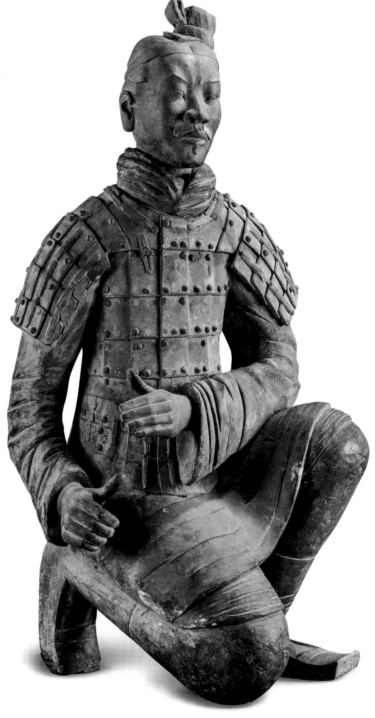

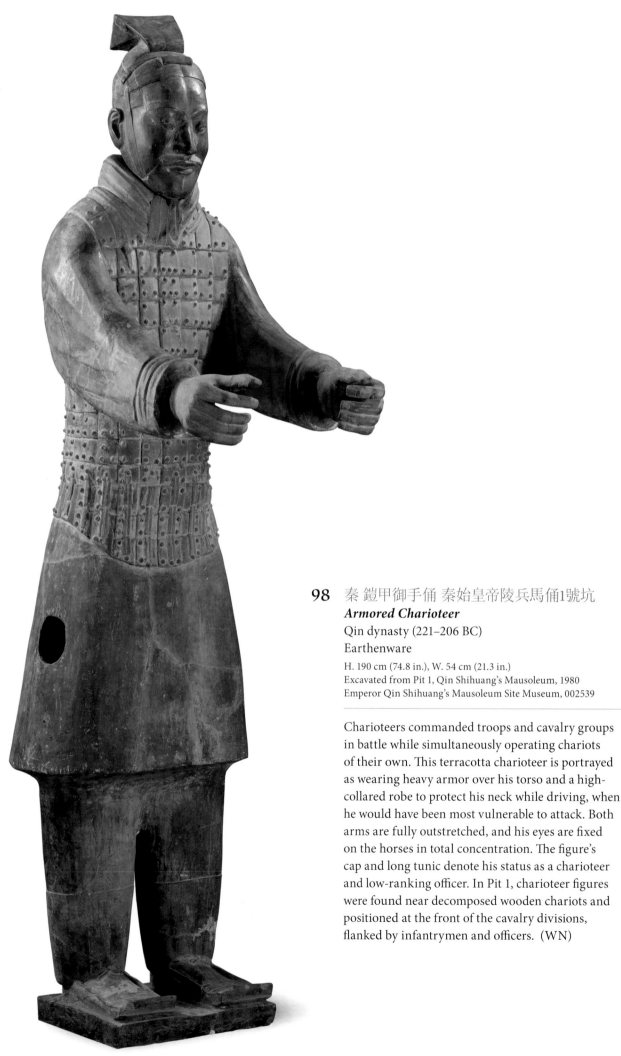

98 秦 鎧甲御手俑 秦始皇帝陵兵馬俑1號坑

Armored Charioteer

Qin dynasty (221–206 BC)
Earthenware

H. 190 cm (74.8 in.), W. 54 cm (21.3 in.)
Excavated from Pit 1, Qin Shihuang's Mausoleum, 1980
Emperor Qin Shihuang's Mausoleum Site Museum, 002539

Charioteers commanded troops and cavalry groups
in battle while simultaneously operating chariots
of their own. This terracotta charioteer is portrayed
as wearing heavy armor over his torso and a high-
collared robe to protect his neck while driving, when
he would have been most vulnerable to attack. Both
arms are fully outstretched, and his eyes are fixed
on the horses in total concentration. The figure's
cap and long tunic denote his status as a charioteer
and low-ranking officer. In Pit 1, charioteer figures
were found near decomposed wooden chariots and
positioned at the front of the cavalry divisions,
flanked by infantrymen and officers. (WN)

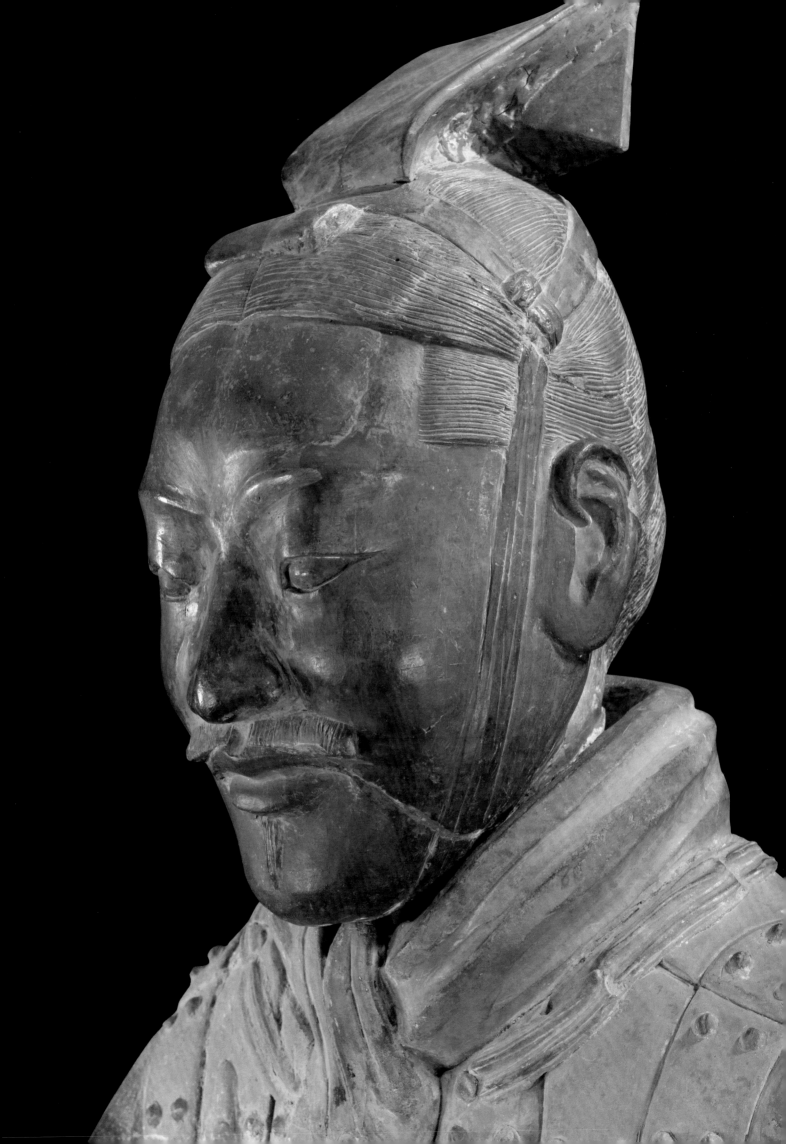

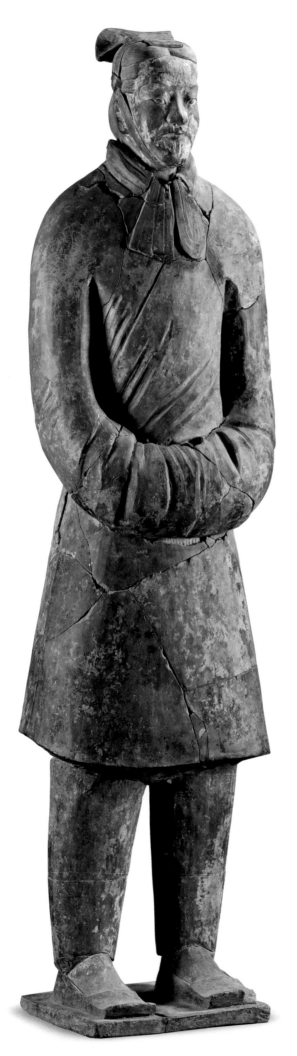

99 秦 文官俑 秦始皇帝陵K0006陪葬坑
Civil Official
Qin dynasty (221–206 BC)
Earthenware

H. 188 cm (74 in.)
Excavated from Pit K0006, Qin Shihuang's Mausoleum, 1999
Emperor Qin Shihuang's Mausoleum Site Museum, 001173

In a solitary pit inside the inner city and southwest of the central burial mound, archaeologists discovered a dozen terracotta figures that represent civil officials and bureaucrats of the First Emperor's court. This civil official wears a curving bonnet and a long robe with large, loose-fitting sleeves that conceal his clasped hands. His reserved facial expression and body language suggest he stands in waiting—a patient and devoted official. A small paring knife and pouch containing a stone sharpener, early court tools for writing on bamboo, discreetly hang from his right side. A small hole carved beneath his left arm was perhaps used for storing such documents. Similar figures excavated from a nearby pit between the inner and outer city were found alongside sacrificial horse remains, leading scholars to suggest they were lower-ranking officers who served as the emperor's horse breeders. (WN)

100 秦 跽坐俑 秦始皇帝陵上焦村跽坐俑坑

Stable Attendant

Qin dynasty (221–206 BC)

Earthenware

H. 68 cm (26.8 in.)

Excavated from Kneeling Figures Pit, Shangjiaocun, Qin Shihuang's Mausoleum, 1985

Emperor Qin Shihuang's Mausoleum Site Museum, 003170

Significantly smaller than the other figures, this terracotta stable attendant was found inside a small coffin alongside earthenware vessels and the skeletal remains of a horse at Shangjiaocun, a village located almost a quarter mile east of the mausoleum complex. The figure is portrayed as having a modest demeanor, simple attire, and neatly groomed hair, traits that denote his servant status. Archaeologists speculate that the dozens of horse skeletons discovered at Shangjiaocun are from the First Emperor's imperial palace stables, and that some ten attendant figures, including this example, served them in the afterlife. Sitting subserviently, he patiently awaits orders with clenched hands. (WN)

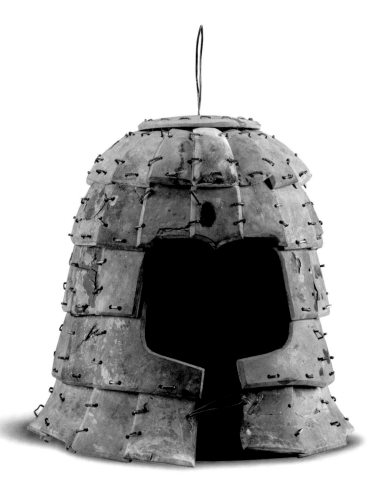

101 秦 石頭盔 秦始皇帝陵K9801陪葬坑
Helmet
Qin dynasty (221–206 BC)

Limestone, copper wire

H. 38 cm (15 in.)
Excavated from Pit K9801, Qin Shihuang's Mausoleum, 1999
Shaanxi Provincial Institute of Archaeology, 007090

102 秦 石鎧甲 秦始皇帝陵K9801陪葬坑
Armor
Qin dynasty (221–206 BC)

Limestone, copper wire

H. 77 cm (30.3 in.), W. 50 cm (19.7 in.)
Excavated from Pit K9801, Qin Shihuang's Mausoleum, 1999
Shaanxi Provincial Institute of Archaeology, 007094

This stone armor and helmet were excavated in fragments from a large pit outside the mausoleum's inner city, southeast of the First Emperor's tomb mound. While the stone armor's form emulates the overlapping, plated leather makeup of real Qin armor, its function was merely symbolic, and neither the armor nor the helmet was actually worn. Archaeologists and scholars estimate that each object—made of hand-cut, polished limestone plates fastened together with copper wire—took between 150 and 350 hours to construct.

Weighing nearly forty pounds and made of about seven hundred limestone plates, the armor was designed to cover the shoulders, torso, and abdomen. The helmet, made of roughly seventy-five limestone plates, covered the entire head, leaving openings for only the eyes, nose, and mouth. Additional materials found in the pit suggest it was once an armory fully stocked with examples like these. (WN)

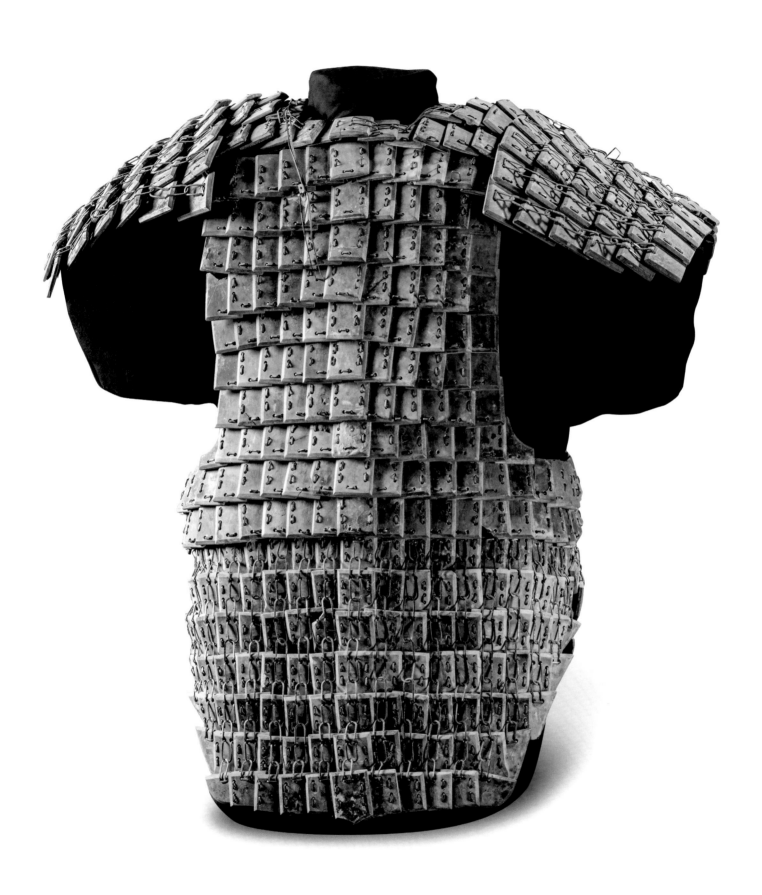

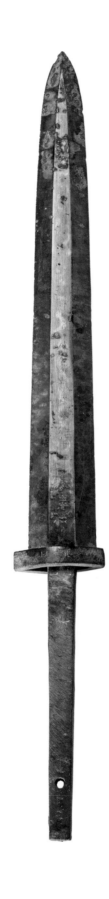

103 秦 青銅鈹 秦始皇帝陵兵馬俑1號坑
Lance Head
Warring States period (475–221 BC)
Bronze

L. 35.6 cm (14 in.)
Excavated from Pit 1, Qin Shihuang's Mausoleum, 1980
Emperor Qin Shihuang's Mausoleum Site Museum, 000858

The blade of this long lance (*pi*) resembles a dagger
or short sword, but its flat stem suggests it was
fastened to a pole with nails and cord and used
offensively. Often reaching ten to twelve feet in
length, lances were used to impale enemies in both
ground and chariot combat. An inscription on an
almost identical example from the same pit dates to
230 BC, the seventeenth year of King Ying Zheng,
prior to Qin unification and his reign as emperor.
Weapons of this variety would have been cast in
court workshops. (WN)

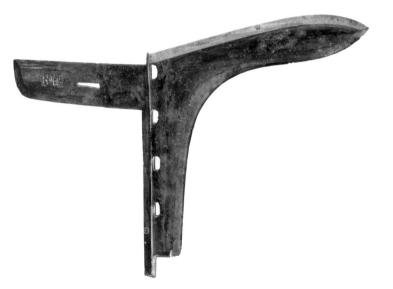

104 秦 "寺工" 青銅矛 秦始皇帝陵兵馬俑1號坑
Spearhead with Inscription
Qin dynasty (221–206 BC)
Bronze

L. 17.5 cm (6.9 in.), W. 3.6 cm (1.4 in.)
Excavated from Pit 1, Qin Shihuang's Mausoleum, 1980
Emperor Qin Shihuang's Mausoleum Site Museum, 000890

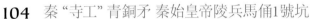

105 秦 "寺工" 青銅戈 秦始皇帝陵兵馬俑1號坑
Dagger-Axe with Inscription
Qin dynasty (221–206 BC)
Bronze

Overall W. 27 cm (10.6 in.)
Excavated from Pit 1, Qin Shihuang's Mausoleum, 2005
Emperor Qin Shihuang's Mausoleum Site Museum, 005803

A variety of pole arms such as spears, lances, and halberds have been excavated from the terracotta army pits. In use since the Shang dynasty (1600–1046 BC), pole arms were offensive weapons measuring up to sixteen feet, comprising bronze heads attached to long, flexible shafts of wood or bamboo. Some terracotta infantrymen and officer figures (cat. nos. 92–93) sculpted with outstretched arms once held long-shaft weapons that have since deteriorated.

Though excavated separately, this spearhead and dagger-axe, when attached to a single shaft, most likely formed a deadly composite weapon capable of both stabbing and slashing. The double-edged spearhead (*mao*) was fixed to the top of the pole by hammering a small nail through its hollow stem. The dagger-axe (*ge*), which features both an anterior and posterior blade, was inserted into the shaft horizontally and fastened with cord through four holes on its back ridge. Both weapons bear inscriptions specifying the official workshop that oversaw their production and distribution. (WN)

Inscription: 寺工 (Craftsman of the court workshop)

106.1–10 秦 青銅鏃 秦始皇帝陵兵馬俑1號坑
Ten Arrowheads
Qin dynasty (221–206 BC)
Bronze

L. 11.3–16.3 cm (4.4–6.4 in.)
Excavated from Pit 1, Qin Shihuang's Mausoleum, 1974
Emperor Qin Shihuang's Mausoleum Site Museum, 001388

107 秦 青銅弩機 秦始皇帝陵兵馬俑1號坑
Crossbow Trigger Mechanism
Qin dynasty (221–206 BC)
Bronze

L. 16.3 cm (6.4 in.), H. 18 cm (7.1 in.)
Excavated from Pit 1, Qin Shihuang's Mausoleum, 1984
Emperor Qin Shihuang's Mausoleum Site Museum, 000945

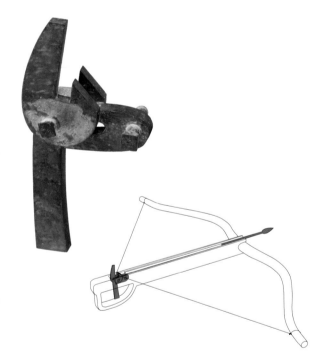

The Qin did not invent the crossbow, but they began utilizing mechanized long-range weaponry as early as the Warring States period (475–221 BC) and reconfigured their military to reflect the new advancements in technology. The trigger mechanism (*nuji*) revolutionized warfare: it had the capacity to fire bronze arrowheads a distance of about half a mile, and it required less strength to shoot than a composite bow. It was positioned at the base of the crossbow's lacquered wooden stock, which measured around two feet in length. The bowstring would be pulled back, held in place by the "tooth" piece, and released once the trigger was pulled. The tooth also served as a sight, allowing a warrior to aim from several hundred feet away. The mechanism itself consists of three parts: aim, trigger, and rest, which were produced separately in a workshop.

The bronze arrowheads feature three blades with curving edges, and long bronze stems that were inserted into thin shafts of painted bamboo or wood before being stored in a woven quiver in bundles of one hundred arrows. Of the roughly 42,000 weapons excavated from the mausoleum pits since 1974, 98 percent are arrowheads. (WN)

108 秦 青銅殳 秦始皇帝陵兵馬俑3號坑

Tubular Mace Head

Qin dynasty (221–206 BC)

Bronze

L. 10.6 cm (4.2 in.), Dia. 2.7 cm (1.1 in.)
Excavated from Pit 3, Qin Shihuang's Mausoleum, 1977
Emperor Qin Shihuang's Mausoleum Site Museum,
001928

The head of this bronze mace (*shu*) once fit atop a tall staff. Its hollow, smooth, and cylindrical body has a tip like a chisel. First used in the Shang dynasty (1600–1046 BC) for bludgeoning and battering in combat, blunt weaponry served mainly ceremonial purposes by the time of the Qin dynasty. About thirty mace heads like this have been excavated from Pit 3, which is often referred to as the "command headquarters" and contains sixty-eight figures thought to be the general's honor guard. There the figures line the narrow halls facing one another, most wielding a long-shafted mace perhaps for usage in military rituals. (WN)

109 西周 青銅鏤空矛 扶風縣法門鎮莊白村

Spearhead with Openwork Design

Western Zhou dynasty (1046–771 BC)

Bronze

L. 14 cm (5.5 in.)
Excavated from Zhuangbaicun, Famenzhen, Fufengxian, 1972
Fufeng County Museum, 0289

110 西周 青銅矛 扶風縣城關鎮物郡西村

Spearhead

Western Zhou dynasty (1046–771 BC)

Bronze

L. 35.2 cm (13.9 in.)
Unearthed from Wujunxicun, Chengguanzhen, Fufengxian, 2006
Fufeng County Museum, 5111

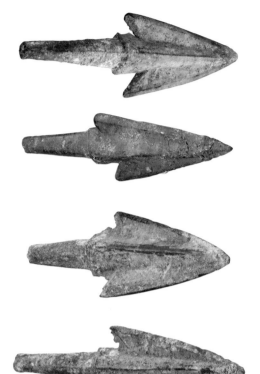

111.1–2, 112.1–2 西周 銅鏃 扶風縣城關鎮益家堡村
Arrowheads
Western Zhou dynasty (1046–771 BC)
Bronze

L. 6 cm (2.4 in.)
Acquired in Yijiabaocun, Chengguanzhen, Fufengxian, 1981
Fufeng County Museum, 1772

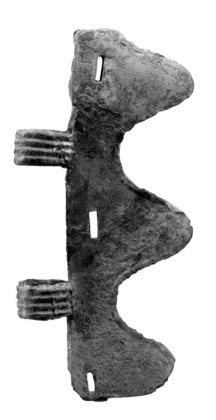

113 西周 青銅我 扶風縣法門鎮莊白村
Wo Weapon
Western Zhou dynasty (1046–771 BC)
Bronze

L. 17.5 cm (6.9 in.)
Acquired in Zhuangbaicun, Famenzhen, Fufengxian, 1977
Fufeng County Museum, 0333

114 西周 青銅戟 扶風縣北呂村144號墓
Halberd
Western Zhou dynasty (1046–771 BC)
Bronze

L. 26.5 cm (10.4 in.), W. 16 cm (6.3 in.)
Excavated from Tomb 144, Beilucun, Fufengxian, 1981
Fufeng County Museum, 4674

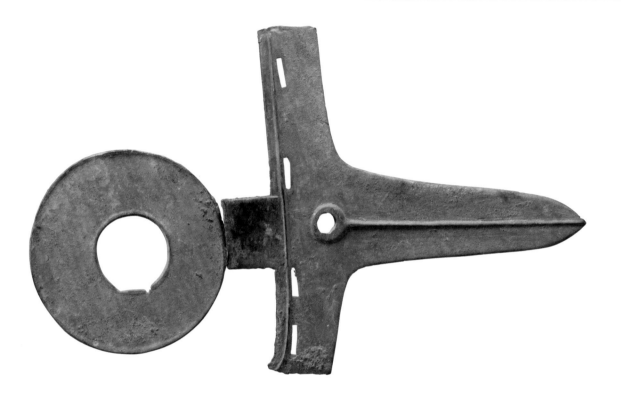

Fufeng County lies in Shaanxi Province, just under a hundred miles west of Fenghao, the capital of the Western Zhou dynasty near present-day Xi'an. Excavations from Fufeng County have yielded ancient bronze weaponry produced and used by forces of the Zhou, Rong, and Qin during the Western Zhou dynasty. The design of certain weapons improved by the time of unification, while others became obsolete.

The five examples here (cat. nos. 109–114) can be classified as either pole arms or projectiles. Both spearheads (cat. nos. 109, 110) are tall and slender, with one unornamented and the other exhibiting

seven rows of symmetrical openwork. The halberd (cat. no. 114) features a front blade and behind it a large disc, perhaps for flying banners in military processions. Four winged and double-bladed arrowheads (cat. nos. 111, 112), while stockier than those excavated from the terracotta pits (cat. no. 106), exemplify the importance of archery to the early Qin military. Last is a rare example of an axe-like weapon known as a *wo* (cat. no. 113), which features three triangular teeth and two large loops for mounting on a wooden shaft. (WN)

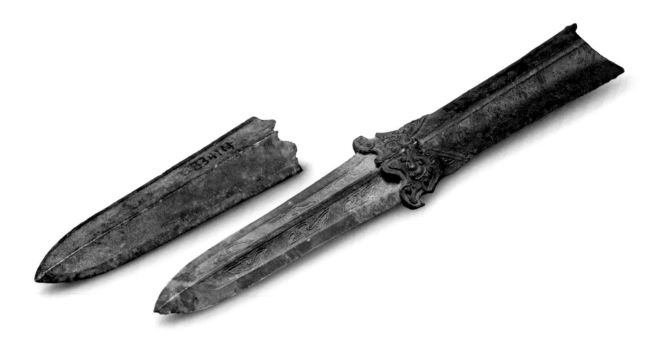

115 戰國 帶鞘青銅鈹 戶縣
Lance Head with Scabbard
Warring States period (475–221 BC)
Bronze

L. 23.5 cm (9.2 in.)
Excavated from Huxian, 1974
Shaanxi History Museum, 08341fu

Archaeologists excavated this bronze lance head and scabbard in Huxian, which lies about thirty miles southwest of Xi'an. Likely belonging to an elite, both pieces were found in excellent condition and exhibit design motifs characteristic of the Central Asian Steppe and the Eastern Zhou dynasty (770–256 BC). The lance head is divided into two components of a blade and a base. Its thin blade has elongated, bird-like shapes incised on either side of the raised central ridge, and its base is flat and hollow for placing overtop a long shaft. The parts conjoin in a highly stylized *taotie* mask, featuring eyes, a nose, and horns. The corresponding scabbard is unornamented and specially cast to fit the animal mask embellishment. (WN)

116 秦 青銅鴻雁 秦始皇陵園K0007陪葬坑

Goose
Qin dynasty (221–206 BC)
Bronze

H. 17 cm (6.7 in.), L. 53 cm (20.9 in.), W. 24 cm (9.4 in.)
Excavated from Pit K0007, Qin Shihuang's Mausoleum, 2000
Shaanxi Provincial Institute of Archaeology, K0007T3:54

This bronze goose is one of forty-six life-size bronze water birds discovered at the bottom of burial pit K0007 in the First Emperor's mausoleum. Including six cranes, twenty swans, and twenty wild geese, the water birds were neatly lined up along a carefully constructed riverbank. Each bird looks unique in its appearance, pose, and attitude. Unlike earlier ritual bronzes, these bronze water birds convey a sense of vitality with remarkable realism.

This bronze goose is rendered with such detail that specialists identify it as most likely an *Anser cygnoides*, or swan goose. Native to Mongolia, the large brown and white goose migrates southward to China in the winter. (HMS)

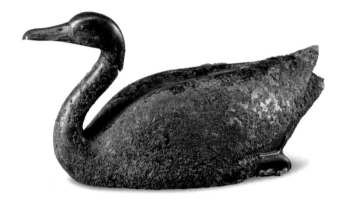

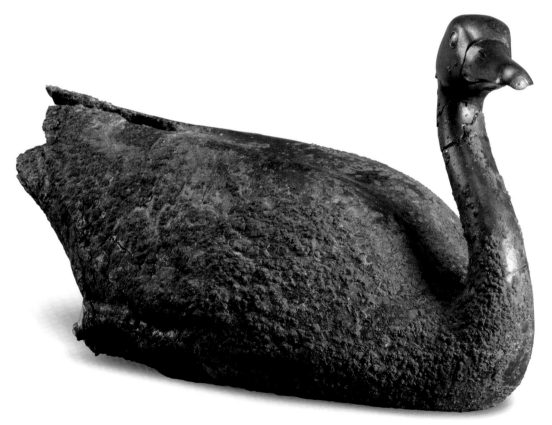

117 秦 夔紋大瓦當 秦始皇陵內城北部西區建築遺址
Large Roof-Tile End with Serpent Design
Qin dynasty (221–206 BC)
Earthenware

H. 39.5 cm (15.6 in.), Dia. 52 cm (20.5 in.)
Excavated from Northwestern Inner City of Qin Shihuang's
Mausoleum, 1977
Emperor Qin Shihuang's Mausoleum Site Museum, 005752

Archaeologists excavated this very large tile end, decorated with a serpentine design in high-relief, from the First Emperor's mausoleum. Identical examples have been found at the other Qin-palace sites in Huangshan Palace at Xingping, Xianyang. Sometimes called the "king of tile," as possibly the largest ever excavated, this tile end was designed and used specifically for the First Emperor's imperial palaces. Related to similar patterns found on late Zhou bronzes, this tile displays a new elegance through its simplified and stylized transformation. (HMS)

118 春秋 陶半圓筒瓦 鳳翔縣雍城遺址
Semi-Cylindrical Roof Tile
Spring and Autumn Period (770–476 BC)
Earthenware

L. 48.5 cm (19.1 in.), Dia. 14.8 cm (5.8 in.)
Excavated from Yongcheng site, Fengxiangxian, and transferred
from Shaanxi Provincial Institute of Archaeology in 1998
Emperor Qin Shihuang's Mausoleum Site Museum, 003103

This semi-cylindrical roofing tile from the Qin capital at Yongcheng has a smooth concave interior and a rigid rope pattern on its convex surface. It was assembled by coiling up clay strips around a circular outer mold with fabric design, which was then split in half before being fired at 900–1100 degrees Fahrenheit (500–600 degrees Celsius). It was laid atop a flat tile with its concave side placed downward.

Similar tiles were excavated along with a group of roof tiles from a large workshop facility found west of the mausoleum complex. The facility, which included a storage space, a workshop, and residential areas, produced architectural materials for the mausoleum's construction, a project that began shortly after the First Emperor took power in 246 BC, and continued through 208 BC after his death. (LJ)

119 秦 陶五方管道 秦始皇帝陵園
Pentagonal Water Pipe
Qin dynasty (221–206 BC)
Earthenware

L. 68 cm (26.8 in.), H. 48 cm (18.9 in.), W. 47 cm (18.5 in.)
Excavated from Qin Shihuang's Mausoleum, 1982
Emperor Qin Shihuang's Mausoleum Site Museum, 002774

120 秦 陶水管道 秦始皇帝陵園魚池遺址
Cylindrical Water Pipe
Qin dynasty (221–206 BC)
Earthenware

L. 57.5 cm (22.6 in.), Dia. 24.5–29.2 cm (9.6–11.5 in.)
Excavated from Yuchi site, Qin Shihuang's Mausoleum, 1987
Emperor Qin Shihuang's Mausoleum Site Museum, 003174

Built after the capital palace at Xianyang, the First Emperor's mausoleum complex included buildings intended for use in the afterlife. Although no above-ground structures remain today, archaeological surveys and excavations have determined that ritual and residential buildings once stood northwest of the burial mound inside the inner walls and that an administrative complex was situated one mile north of the mausoleum walls in the village of Yuchi.

The excavations of these sites yielded two types of ceramic pipes: a round water pipe (cat. no. 120) with different dimensions at each end to fit tightly onto one another, and a pentagonal pipe (cat. no. 119) with a flat base and a triangular top, which bore the pressure of heavy soil when placed deep underground. Stacked components like this might have been used as hollow bricks to clad a wooden column for a palace structure.

The mausoleum complex's drainage system was well planned and constructed according to the area's natural geographic conditions, with higher land in the southeast and lower land in the northwest. Planners, architects, and laborers used hydraulic engineering skills to lay out the sewer system, which not only provided infrastructure to the palace buildings but also protected the underground burial chambers from flooding. (LJ)

Xianyang Palace No. 1

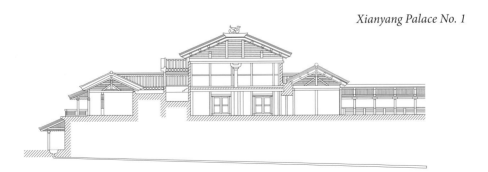

Recent Archaeology and New Thoughts about Qin Shihuang's Mausoleum Complex

Zhang Weixing
Emperor Qin Shihuang's Mausoleum Site Museum

The excavation of the terracotta army in China in the 1970s astonished the world and revealed the grand history and scale of the mausoleum complex belonging to the First Emperor, or Qin Shihuang (r. 221–210 BC). Named Ying Zheng at birth, Qin Shihuang established the Qin Empire and created China's first centralized government and administrative system. Since the discovery of the terracotta army one mile east of the mausoleum walls, excavations in and around the area have uncovered many unique objects, including bronze chariots, stone armor and helmets, entertainer figures, and bronze birds.

First described in the *Records of the Grand Historian (Shiji)* by Sima Qian (d. 86 BC), the story of the First Emperor's quest for immortality continues to unfold before our very eyes. From an archaeological perspective, the primary remains at Qin Shihuang's mausoleum complex, from the tomb at its center to beyond the mausoleum walls, consist of the First Emperor's burial chamber and contents, tomb pathways, above-ground structures, storage pits, accompanying tombs, ritual remains, surrounding walls, entranceways and gate towers, a network of roads, and the mausoleum precinct, as well as other related remains. The mausoleum's layout and contents reveal how construction evolved and what the First Emperor had planned for his afterlife.

Primary Excavations

Qin Shihuang's mausoleum complex encompasses an area of 13,900 acres. The central walled section is only 568 acres. Currently, we have completed surveys of the central area and two-thirds of the mausoleum complex. As for the larger area extending beyond the surrounding pits, we have conducted only investigations.

Our primary excavations have been concentrated in numerous pits inside and beyond the mausoleum walls. Located outside the walled area are the terracotta army pits, a bronze bird pit, real animal pits, and stable pits. Inside the walls, the following pits were discovered: a bronze chariot pit, an entertainers pit, a stone armor pit, a civil officials pit, and animal pits. Recent excavations include the remains of architectural structures, medium- and small-sized tombs, and the roads across the mausoleum. As a large amount of the mausoleum complex remains unexcavated, these finds offer only a glimpse of its entire contents.

Recent Discoveries

Recent discoveries have furthered our understanding of the mausoleum's structure and contents. Since 2010, we have discovered walled sections, measuring 2,067 feet long and 13 feet thick, in the northern inner city, and between the outer and inner city in the southern and northern ends of the complex. Such discoveries have significantly advanced the study of the mausoleum plan and the arrangement of structures within it. Surveys and excavations within the mausoleum's walls have also revealed the remains of a large-scale network of roads surrounding the central mausoleum, suggesting that there were once two types of roads stretching across the mausoleum complex: one shaped like a cross and the other forming two circles. The ruins of nine gateways have also been discovered on the inner and outer mausoleum walls, one on each of the double walls' eight total sides, and the ninth one in the center of the inner city. Additional discoveries include architectural remains of gate towers located between the inner and outer walls on all four sides of the complex.

Gate towers were free-standing structures situated at the entrances to cities, palaces, temples, residences, and tombs. During the Spring and Autumn period (770–476 BC), the gate tower appeared for the first time as a high-ranking form of ritual structure. According to

social status, a gate tower featured between one, two, and three roof eaves. Towers with three-level roofs appear at Qin Shihuang's mausoleum and are the earliest examples of this architectural style discovered to date.

Since the previous excavations in 2010, archaeologists have discovered eight new storage pits located within the mausoleum complex. Also discovered were two large areas of tomb complexes, including ninety-nine neatly aligned medium- to small-sized tombs in the northeastern inner city. Excavation activities here have revealed that the occupants of these tombs were most likely sacrificed members of the First Emperor's family and inner court.

The three large-scale ritual buildings recently discovered within the mausoleum encompass a total area of nearly eighty-seven acres. By examining these structures, we have concluded that ritual ceremonies were systematically performed at the mausoleum, as described in the ancient text, *Duduan*, by Cai Yong (AD 133–192). With the architectural expansion and the development of ritual services in the Qin dynasty, the court established an administrative system intended to protect and manage the mausoleums of Qin rulers. The architectural remains found in Qin Shihuang's mausoleum complex suggest that there must have been a large number of officials and attendants, working at the mausoleum in areas of administration, ritual service, housekeeping, and security.

The latest surveys and excavations have also provided invaluable information regarding the layout of the mausoleum's above-ground facilities and tomb pathways. This informs us of the mausoleum's centralized rectangular layout, while the various tombs and ritual structures reveal imperial burial customs practiced within. The discovery of these sites furthers our comprehension of Qin ceremonies and rituals and provides evidence of changing customs from the late Warring States period (475–221 BC) to the Qin dynasty (221–206 BC).

Continued excavations of the entertainers pit (K9901), the inner city structures and accompanying tombs, road networks, and terracotta army Pits 1 and 2, have provided important information for the study of the mausoleum's process of burial rites, the dates of structures, and the mausoleum's system and layout.

Challenges and Goals

The biggest technical challenge for archaeologists at the mausoleum is how to use modern survey technology, such as the Geographic Information Systems (GIS), to conduct the archaeological surveys and mapping, as well as research and data management. Furthermore, high-resolution 3-D imaging methods should be enhanced at surveys, excavations, and restorations to enable us to create an outline of a burial figure or a structure, and to determine its size, shape, and depth. Another challenge is how to protect artwork and artifacts from deterioration once they are unearthed. In addition, archaeologists are also faced with challenges to recreate various cultural sites and artifacts using ancient techniques, natural materials, and primitive tools.

Through these excavations, we have achieved a better understanding of how the First Emperor's mausoleum and the exterior of his burial chamber were constructed, but we cannot yet identify the actual contents of the First Emperor's burial chamber, which is the core of the mausoleum. Our goal is to study the archaeological data obtained and to enlist scholars from various scientific fields to conduct in-depth research in specific areas. We firmly believe that with comprehensive study of these cultural materials, we will deepen our understanding of Qin Shihuang's mausoleum.

Hierarchy of Qin Imperial Government

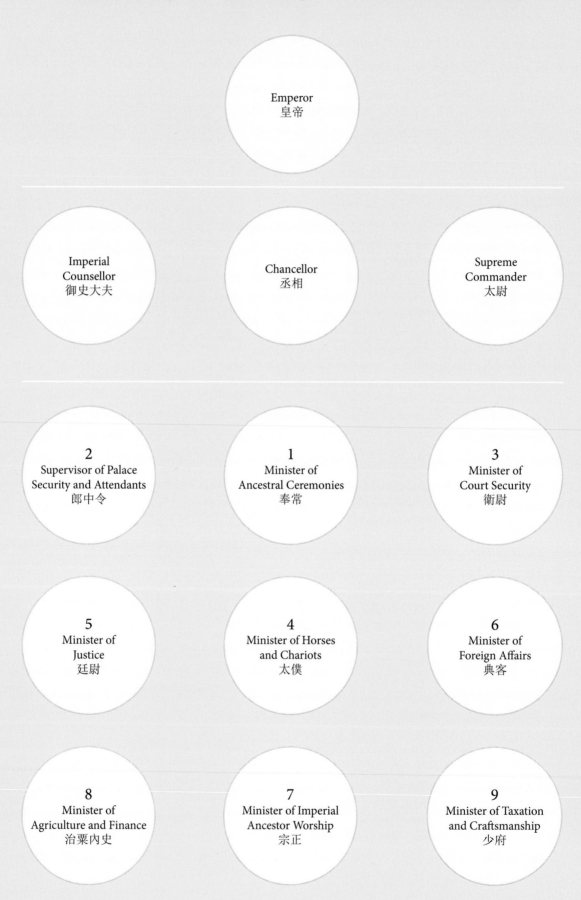

Emperor
皇帝

Imperial
Counsellor
御史大夫

Chancellor
丞相

Supreme
Commander
太尉

2
Supervisor of Palace
Security and Attendants
郎中令

1
Minister of
Ancestral Ceremonies
奉常

3
Minister of
Court Security
衛尉

5
Minister of
Justice
廷尉

4
Minister of Horses
and Chariots
太僕

6
Minister of
Foreign Affairs
典客

8
Minister of
Agriculture and Finance
治粟內史

7
Minister of Imperial
Ancestor Worship
宗正

9
Minister of Taxation
and Craftsmanship
少府

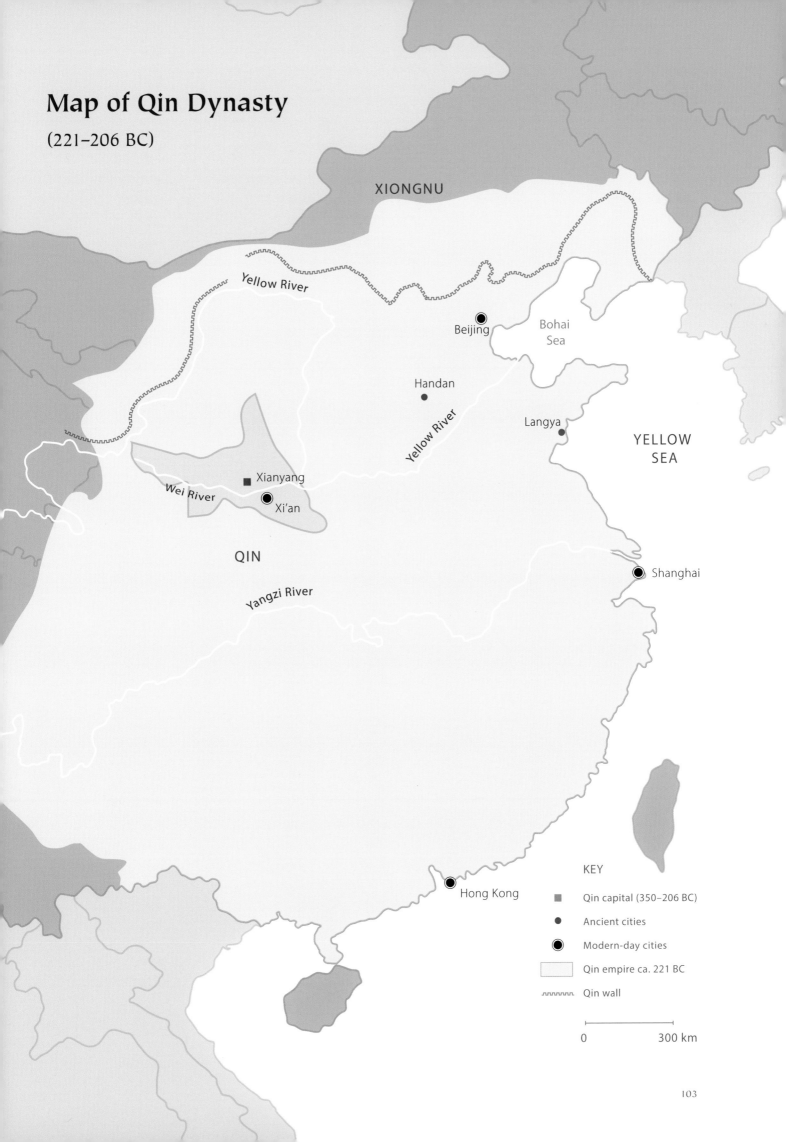

Map of Qin Dynasty
(221–206 BC)

XIONGNU

Yellow River

Beijing

Bohai Sea

Handan

Langya

YELLOW SEA

Xianyang

Wei River

Xi'an

QIN

Yangzi River

Shanghai

Hong Kong

KEY

■ Qin capital (350–206 BC)

● Ancient cities

◉ Modern-day cities

Qin empire ca. 221 BC

꘏꘏꘏ Qin wall

0 300 km

Qin Rulers

Throne Name	Chinese	Reign	Capital	Chinese
Qin Feizi	秦非子	897–858 BC	Qinyi	秦邑
Marquis of Qin	秦候	857–848 BC	Qinyi	秦邑
Qin Gongbo	秦公伯	847–845 BC	Qinyi	秦邑
Qin Zhong	秦仲	844–822 BC	Qinyi	秦邑
Duke Zhuang	秦庄公	821–778 BC	Xiquanqiu	西犬丘
Duke Xiang	秦襄公	777–766 BC	Qian	汧
Duke Wen	秦文公	765–716 BC	Qianweizhihui	汧渭之會
Duke Xian	秦憲公	715–704 BC	Pingyang	平陽
Qin Chuzi	秦出子	703–698 BC	Pingyang	平陽
Duke Wu	秦武公	697–678 BC	Pingyang	平陽
Duke De	秦德公	677–676 BC	Yongcheng	雍城
Duke Xuan	秦宣公	675–664 BC	Yongcheng	雍城
Duke Cheng	秦成公	663–660 BC	Yongcheng	雍城
Duke Mu	秦穆公	659–621 BC	Yongcheng	雍城
Duke Kang	秦康公	620–609 BC	Yongcheng	雍城
Duke Gong	秦共公	608–604 BC	Yongcheng	雍城
Duke Huan	秦桓公	603–577 BC	Yongcheng	雍城
Duke Jing	秦景公	576–537 BC	Yongcheng	雍城
Duke Ai	秦哀公	536–501 BC	Yongcheng	雍城
Duke Hui	秦惠公	500–492 BC	Yongcheng	雍城
Duke Dao	秦悼公	491–477 BC	Yongcheng	雍城
Duke Ligong	秦厲共公	476–443 BC	Yongcheng	雍城
Duke Sao	秦躁公	442–429 BC	Yongcheng	雍城
Duke Huai	秦懷公	428–425 BC	Yongcheng	雍城
Duke Ling	秦靈公	424–415 BC	Yongcheng	雍城
Duke Jian	秦簡公	414–400 BC	Yongcheng	雍城
Duke Hui	秦惠公	399–387 BC	Yongcheng	雍城
Duke Chu	秦出公	386–385 BC	Yongcheng	雍城
Duke Xian	秦獻公	384–362 BC	Yongcheng	雍城
Duke Xiao	秦孝公	361–338 BC	Xianyang	咸陽
King Huiwen	秦惠文王	337–311 BC	Xianyang	咸陽
King Wu	秦武王	310–307 BC	Xianyang	咸陽
King Zhaoxiang	秦昭襄王	306–251 BC	Xianyang	咸陽
King Xiaowen	秦孝文王	250 BC	Xianyang	咸陽
King Zhuangxiang	秦莊襄王	249–247 BC	Xianyang	咸陽
King Ying Zheng	秦嬴政王	246–221 BC	Xianyang	咸陽
Qin Shihuang, or First Emperor	秦始皇帝	221–210 BC		
Qin Ershi (Huhai)	秦二世 胡亥	209–207 BC	Xianyang	咸陽
Qin Sanshi (Ziying)	秦三世 子嬰	207 BC	Xianyang	咸陽

Biographies of Historical Figures

Duke Huan of Rui 芮桓公 (r. ca. 740–710 BC) ruled Rui, a small state established by the king of the Western Zhou dynasty during the 11th century BC. After four hundred years, Rui was defeated by Qin in 640 BC. Following Duke Huan's death, power was transferred to his son Bowan, and later to his wife, Rui Jiang, after she expelled her son from the state in 708 BC. Duke Huan and his wife are buried next to each other at the Rui cemetery along with their luxurious collections of gold, jade, and bronze, which were excavated at Liangdaicun, Hancheng, in 2008.

Duke Jing of Qin 秦景公 (r. 576–537 BC), the son of Duke Huan of Qin (r. 603–577 BC), ascended the throne at Yongcheng, the Qin capital for three centuries. In his forty-year reign during the mid–Spring and Autumn period, he significantly expanded the state's territorial holdings. Located in today's Fengxiang County, Shaanxi Province, his tomb at the Qin mausoleum in Yongcheng is the largest vertical earthen tomb ever excavated in China. The wooden structure of his burial chamber exceeded standard burial rites for a duke of a vassal state of the Zhou dynasty.

Duke Mu of Qin 秦穆公 (r. 659–621 BC) was one of the most powerful state rulers of the Spring and Autumn period. During his reign, the Qin capital was transferred from Pingyang to Yongcheng. Duke Mu filled his court with intelligent politicians, military commanders, and scholars. He assisted the kings of the Zhou dynasty in defense against Rong and Di nomads, expanding westward into Gansu and north into Ningxia. He was buried at the Qin mausoleum in Yongcheng in 621 BC, alongside 177 sacrificed men and women, a group that included three heroic brothers Yanxi, Chongxing, and Zhenhu.

Duke Wu of Qin 秦武公 (r. 697–678 BC) was a ruler of the Qin state during the early Spring and Autumn period. He was the eldest of three sons of Duke Xian (r. 715–704 BC) to rule Qin and was succeeded by his younger brother Duke De (r. 677–676 BC). At this time, Qin's primary enemy was the Rong to the northwest in present-day Gansu Province. Duke Wu ruled from the short-lived Qin capital of Pingyang, and he was buried there in a large tomb alongside sixty-six human sacrifices.

Duke Xiao of Qin 秦孝公 (r. 361–338 BC) ascended the throne of Qin state in 361 BC at the age of twenty-one, succeeding his father, Duke Xian of Qin. He was best known for carrying out a series of groundbreaking political, military, and economic reforms in Qin with the help of Shang Yang, a scholar of the Legalist School. Duke Xiao's reforms transformed Qin into a dominant superpower among the seven states and laid the foundation for the eventual unification of China under his descendant, Ying Zheng, who became the First Emperor, or Qin Shihuang, in 221 BC.

Feizi 非子 (r. 897–858 BC) was the founder of the Qin state and considered to be a descendent of Huangdi, the mythical Yellow Emperor (r. 2698–2598 BC). During the Western Zhou dynasty, King Xiao of Zhou (r. 891–886 BC) appointed Feizi as royal horse breeder in an area between the Qian and Wei Rivers. He later attempted to arrange for Feizi to succeed him on the Zhou throne but was warned of the political ramifications. The king instead awarded him a fiefdom known as Qinyi.

Feng Quji 馮去疾 (d. 208 BC) was a descendent of Feng Ting, a Zhao state commander who died at the Battle of Changping in 260 BC. After unification under Qin, Feng Quji was appointed by the First Emperor as chancellor, while Li Si acted as associate chancellor. The following year, the First Emperor's son, Huhai, succeeded his father on the throne. When Feng Quji advised Huhai to reduce commoners' taxes and to halt the construction of imperial palaces, Huhai ordered the jailing of Feng and his son, Grand General Feng Jie. Facing imprisonment and humiliation, the father and son committed suicide.

Huhai 胡亥 (r. 209–207 BC), also known as Qin Ershi or the Second Emperor of Qin, was the youngest son of the First Emperor. He conspired with Chancellor Li Si and court official Zhao Gao (d. 207 BC) to ensure his succession by driving his older brother and rightful heir, Fusu (d. 210 BC), to commit suicide. Huhai then seized power, inheriting a volatile and rapidly fragmenting empire. With Zhao Gao appointed as chief official, Huhai eliminated all political competition, reinforced laws by installing harsher penalties, and squandered royal funds. In 207 BC, Zhao Gao and his loyal officials surrounded the imperial palace and forced Huhai to commit suicide. Ziying (d. 206 BC), Huhai's nephew and the final ruler of the Qin dynasty, had Zhao Gao killed within months of succession.

King Huiwen of Qin 秦惠文王 (r. 337–311 BC) was a ruler of the Qin state during the mid–Warring States period. His father, Duke Xiao, alongside Shang Yang,

reformed the state significantly by moving the capital to Xianyang and implementing Legalism. As a boy, Huiwen committed a petty crime for which the notoriously harsh Shang Yang attempted to punish him despite his royal status. Influenced by the old forces and Shang's rebellion, Huiwen had Shang Yang executed when he ascended the throne in 338 BC. Huiwen's military forces weakened Qin's neighboring states, Wei and Chu, and he substantially annexed territory eastward to the Yellow River and Central China. He reigned as Duke from 337 to 324 BC and as King until his death in 311 BC.

King Xiao of Zhou 周孝王 (ca. 891–886 BC) was a ruler of the Western Zhou dynasty, reigning from the capital at Haojing, near modern-day Xi'an, Shaanxi Province. He sought to revive the glorious traditions of the early Western Zhou dynasty. King Xiao's court advised him to employ Feizi, a Qin horse breeder and trainer from an area between the Qian and Wei Rivers in western Shaanxi. Satisfied with Feizi's achievements, the king rewarded him with property named Qinyi. The Qin would expand that territory over the following centuries.

King Zhaoxiang of Qin 秦昭襄王 (r. 306–251 BC), also known as Ying Ji, was the son of Duke Huiwen and Lady Mi Yue, who was later known as Queen Dowager Xuan. In 307 BC, his half-brother, King Wu of Qin, died after attempting to raise a large bronze ding vessel, and Ying Ji was exiled to the state of Yan. He was then secretly transferred from Yan to Zhao before finally reaching Qin, where he ascended the throne. As one of his many accomplishments, Ying Ji led the Qin army in victory over Zhao forces at the Battle of Changping in 260 BC, ending the five-hundred-year rule of the Eastern Zhou dynasty in 256 BC and paving the way for unification in 221 BC under his great-grandson, Ying Zheng, who declared himself First Emperor.

Li Si 李斯 (280–208 BC) served as chancellor to the first and second emperors of the Qin dynasty and played an instrumental role in the implementation of Legalist reforms. Born in Chu, he began serving as a retainer to Chancellor Lu Buwei (290–236 BC) just as Ying Zheng was ascending the Qin throne. He maintained a powerful position in the court, strongly advocating legal reforms, standardization, redistribution of land, and military campaigns against the other states. When the First Emperor unexpectedly died while on tour in 210 BC, Li Si and court official Zhao Gao (d. 207 BC) secretly arranged for his successor. Fusu (d. 210 BC), the oldest son and rightful heir, was tricked into committing suicide, and Huhai, the youngest son, became emperor. During Huhai's brief reign, Li Si was imprisoned and executed after being wrongly accused by Zhao Gao.

Queen Dowager Xia 夏太后 (d. 240) BC) was the mother of King Zhuangxiang of Qin and grandmother of the First Emperor. In 247 BC, after ruling only three years, King Zhuangxiang died and his son Ying Zheng, the future First Emperor, ascended the throne at age thirteen. As a young man, Zheng despised the illicit love affairs of his mother, Queen Dowager Zhao, with both Lao Ai and Lu Buwei. Lao Ai staged a coup against Zheng and was later executed. Zheng and his grandmother, Dowager Xia, shared a close relationship. She lived until 240 BC, seven years after Zheng became the king of Qin, and her guidance may have been the most crucial factor to his future success.

Queen Dowager Xuan 宣太后 (338–265 BC), also known as Lady Mi Bazi or Lady Mi Yue, was the great-great-grandmother of the First Emperor. Originally from the Chu state, she first became a concubine of King Huiwen of Qin. In 306 BC, when her young son, Ying Ji, ascended the throne as King Zhaoxiang, Lady Mi served as regent and became Queen Dowager Xuan. Dowager Xuan was a shrewd politician who, together with her son, strategically increased Qin's military strength and dominance over the other states and laid the foundation for the First Emperor's unification of China decades later. The 2015 popular TV drama in China, *The Legend of Mi Yue*, sparked renewed interest in this legendary stateswoman who played a significant role in Qin history.

Rui Jiang 芮姜 (ca. 750–700 BC) was the daughter of a Qi ruler and the wife of Duke Huan of Rui. After her husband's death, her son Bowan succeeded the throne. In 709 BC, she expelled him from the Rui state and established a new ruler. Following this turmoil, Qin launched an attack on Rui but was surprisingly defeated by Rui's defensive forces led by Rui Jiang. Order finally resumed in 702 BC when Bowan was escorted by the Qin back to Rui. It is unclear when Rui Jiang died, but her tomb, excavated at Liangdaicun, Hancheng, in 2008, reveals her lavish lifestyle and affinity for jade jewelry.

Shang Yang 商鞅 (390–338 BC) was chancellor and lawmaker of the Qin state under Duke Xiao (r. 361–338 BC). Shang Yang introduced Legalism, a series of rigorous reforms of Qin's sociopolitical institutions beginning in 356 BC. Reforms included privatization of land to replace feudalism, adoption of a merit-based military ranking system, stricter laws and punishments, and reorganization of the agricultural and manufacturing industries. In addition, he influenced decisions that raised taxes, began standardization, divided villages into districts and households, introduced universal military conscription, and moved the capital to Xianyang. Despite the effectiveness of Shang Yang's reforms, the Qin nobility resented him for lessening their power and wealth. Upon

ascending the throne, King Huiwen accused him of treason and sentenced him to death.

Sima Qian 司馬遷 (ca. 145–86 BC) was a court historian during the reign of Emperor Wu of Han (r. 141–87 BC) and the author of *Records of the Grand Historian (Shiji)*, an official state history covering over 2,500 years of events in China and its neighboring civilizations. For this ambitious project, he collected information from dozens of ancient texts, oral accounts, state records, and other sources. The book, which was completed around 91 BC, comprised 130 chapters in over 525,000 Chinese characters. Original volumes were vertically inscribed on between fifteen thousand and twenty thousand bamboo slips. Its contents ranged from detailed biographies to treatises and annual historical records. When the book was published nearly two decades after Sima Qian's death, its influence on Chinese literature, history, and politics was unprecedented. Many passages detail Qin history and the First Emperor's reign and mausoleum.

Wang Wan 王綰 (act. 240–208 BC) was a chancellor of the Qin court. Wang accompanied the First Emperor on his first tour east in 219 BC, and also assisted him in standardizing weights and units of measurement. He promoted the governing system of the Zhou dynasty, in which vassal properties were awarded to the emperor's brothers, sons, and most-trusted officials to ensure regional stability. Alternatively, Chancellor Li Si suggested the emperor appoint and demote local officials, as the vassal system would only bring chaos as seen under the Eastern Zhou dynasty. The First Emperor heeded Li Si's advice and established a centralized government.

Wei Zhuang 隗狀 (act. 221–208 BC) was chancellor of the Qin court and accompanied the First Emperor on his very first tour of unified China in 219 BC. The trip is documented on a rock at Mount Tai where the names of Wei and other accompanying officials are carved. After the death of the First Emperor, Wei continued to serve as chancellor under the Second Emperor, Huhai. An edict issued in 210 BC mentions Wei as one of two chancellors who assisted the First Emperor in implementation of policies. This edict was inscribed on all standardized weights and units of measurement, as required by the state.

Xu Fu 徐福 (act. ca. 220–210 BC), native of the Qi state, was a popular Daoist master (*fangshi*), who lived at Langya, Shandong Province, on the East Coast of China. In 219 BC, the First Emperor tasked him with finding the fabled Penglai Island and its elixir of immortality. Unsuccessful in his search, Xu returned a few years later. In 210 BC, the emperor ordered Xu to travel again in search of the elixir, taking with him more than three thousand boys and girls, and hundreds of craftsmen carrying grain seeds, food, clothing, and farming tools. Scholars believe the party, which never returned after departing from the port of Langya, may have landed in Japan, where statues, tombs, and tablets housed in temples and shrines honor Xu Fu.

Ying Zheng 嬴政 (259–210 BC) ascended the throne of the Qin state in 246 BC at age thirteen. Following unification, he declared himself the First Emperor of Qin, or Qin Shihuang. Chancellor Lu Buwei acted as his adviser for the first nine years before being replaced by Chancellor Li Si when Ying Zheng was officially inaugurated. Between 230 and 221 BC, he would lead Qin in victory over the other six states of Han, Zhao, Wei, Chu, Yan, and Qi. Influenced by the Legalist reforms of Shang Yang, he and Li Si completely reconfigured the government, economy, military, and legal systems of Qin. Reforms entailed standardization of state script, currency, and measurement units, construction of the Great Wall, a nationwide network of roads and canals, rejection of the feudal system, and reallocation of land. They increased the severity of laws and penalties and divided the ruling government into "Three Lords and Nine Ministers." The First Emperor undertook ambitious building programs like his mausoleum complex and palaces, which recruited and relocated hundreds of thousands of laborers. He also sought immortality, sending search parties on long and costly voyages to mythological locations. During his reign, he completed four tours of the unified empire and died suddenly in 210 BC while on what would be his final tour.

Bibliography

Frequently Consulted Periodicals

Kaogu yu wenwu [Archaeology and cultural relics]. Xi'an: Shaanxi Provincial Institute of Archaeology, 1980–present. 陝西省考古研究所: 考古與文物.

Kaogu xuebao [Archaeological journal]. Beijing: Institute of Archaeology of Chinese Academy of Social Sciences (CASS), 1953–present. 中國社會科學院考古研究所: 考古學報.

Wenwu [Cultural relics]. Beijing: Wenwu chubanshe, 1950–present. 文物出版社: 文物.

General Reading

Chang, Kwang-chih. *The Archaeology of Ancient China*. 4th rev. ed. New Haven: Yale University Press, 1986.

Li Feng. *Early China: A Social and Cultural History*. Cambridge: Cambridge University Press, 2013.

Pines, Yuri, Gideon Shelach, Lothar von Falkenhausen, and Robin D. S. Yates, eds. *Birth of an Empire: The State of Qin Revisited*. Berkeley: University of California Press, 2013.

Rawson, Jessica, ed. *Mysteries of Ancient China: New Discoveries from the Early Dynasties*. New York: George Braziller, 1996.

Shaanxi Provincial Compilation Committee of Regional Chronicles. Shaanxi sheng zhi [Chronicles of Shaanxi province]. Vol. 66, *Wenwu zhi* [Chronicle of cultural relics]. Xi'an: Sanqin chubanshe, 1995. 陝西省地方誌編輯委員會: 陝西省文物誌, 三秦出版社.

Sima Qian. "Qin Shihuang benji" [Annals of Qin Shihuang]. In *Shiji* [Records of the Grand Historian]. Beijing: Zhonghua Shuju, 2011. 司馬遷: 史記·秦始皇本紀, 中華書局.

———. *Records of the Grand Historian* (Shiji). Translated by Burton Watson. 3 vols. New York: Columbia University Press, 1993.

Teng Mingyu. "Qin wenhua de kaoguxue faxian yu yanjiu" [Archaeological discovery and study of Qin culture]. *Huaxia kaogu* [Chinese archaeology], no. 4 (1998):63–72. 滕銘予: 秦文化的考古學發現與研究, 華夏考古.

———. *Qin wenhua cong fengguo dao diguo de kaoguxue guancha* [Qin culture in archaeological perspective: from a feudal state to great empire]. Beijing: Xueyuan chubanshe, 2002. 滕銘予: 秦文化: 從封國到帝國的考古學觀察, 學苑出版社.

Wu Hung. *Monumentality in Early Chinese Art and Architecture*. Stanford: Stanford University Press, 1995.

Section I

Han Chang'an Archaeological Team of the Institute of Archaeology, Chinese Academy of Social Sciences (CASS). "Xi'an xiangjiaxiang yizhi qin fengni de fajue" [Excavation of sealing clays from Xiangjiaxiang, Xi'an]. *Kaogu xuebao*, no. 4 (2001): 509–44. 中國社會科學院考古研究所漢長安城考古隊: 西安相家巷遺址秦封泥的發掘, 考古學報.

Han Jianwu. "Jijian you ming Qin Han tongqi de kaoshi" (Study of some inscribed Qin-Han bronze vessels). *Kaogu yu wenwu*, no. 6 (2007): 72–74, 102. 韓建武: 幾件有銘秦漢銅器的考釋, 考古與文物.

Han Wei and Yongcheng Archaeological Team of Shaanxi Province. "Fengxiang Qin gong lingyuan zuantan yu shijue jianbao" [Investigation and primary excavation of Qin mausoleum at Yongcheng, Fengxiang]. *Wenwu*, no. 7 (1983): 30–37. 韓偉, 陝西省雍城考古隊: 鳳翔秦宮陵園鑽探與試掘簡報, 文物.

Hansen, Valerie. *The Silk Road: A New History*. London: Oxford University Press, 2012.

Liu Yonghua. *Zhongguo gudai cheyu maju* [Chariots and horse ornaments of ancient China]. Shanghai: Shanghai cishu chubanshe, 2002. 劉永華: 中國古代車輿馬具, 上海辭書出版社.

People's Bank of China and China Historical Currency Compilation Committee. *Zhongguo lidai huobi* [Currencies of Chinese dynasties]. Beijing: Xinhua chubanshe, 1982. 中國人民銀行, 中國歷代貨幣編輯組: 中國歷代貨幣, 新華出版社.

Shi Lei and Qi Xiu. *Da Qin qiangu zhimi* [Thousands of years of mystery of the Great Qin]. Xi'an: Xi'an luyou chubanshe, 2011. 石磊, 齊秀: 大秦千古之謎, 陝西旅遊出版社.

Sun Ji. *Handai wuzhi wenhua ziliao tushuo* [Illustrated commentary on the material culture of the Han dynasty]. Beijing: Wenwu chubanshe, 1991. 孫機: 漢代物質文化資料圖說, 文物出版社.

Sun Zhonghui. *Gu qian* [Ancient currencies]. Shanghai: Shanghai guji chubanshe, 1990. 孫仲匯: 古錢, 上海古籍出版社.

Wu Lina. "Qinmu chutu taoqun moxing yanjiu" [Study of the models of granaries from Qin tombs]. *Nongye kaogu* [Agricultural archaeology], no. 1 (2010): 217–20. 武麗娜: 秦墓出土陶囷模型研究, 農業考古.

Yang Baocheng. *Yinxu wenhua yanjiu*. [Study of the Yinxu culture]. Wuhan: Wuhan daxue chubanshe, 2012. 楊寶成: 殷墟文化研究, 武漢大學出版社.

Yuan Zhongyi. *Qin Shihuang ling kaogu faxian yu yanjiu* [Archaeological discovery and research of Qin Shihuang's mausoleum]. Xi'an: Shaanxi renmin chubanshe, 2002. 袁仲一: 秦始皇陵考古發現與研究, 陝西人民出版社.

Section II

Baoji Archaeological Work Team. "Baojishi Yimencun erhao Chunqiu mu fajue jianbao" [Brief excavation report of Tomb 2 of the Spring and Autumn period at Yimencun, Baoji]. *Wenwu*, no. 10 (1993): 1–14. 寶雞市考古工作隊: 寶雞市益門村二號春秋墓發掘簡報, 文物.

Baoji Institute of Archaeology. *Diguo baozang: Yimen erhao chunqiu mu tanyi* [Treasures of the empire: investigation of Tomb 2 of the Spring and Autumn period at Yimen, Baoji]. Xi'an: Sanqin chubanshe, 2006. 寶雞市考古研究所: 帝國寶藏: 益門2號春秋墓探疑, 三秦出版社.

Baoji Pre-Qin Mausoleum Museum. *Qingong yihao damu* [Grand tomb 1 of Qin Duke]. Beijing: Zuojia chubanshe, 2010. 寶雞先秦陵園博物館: 秦宮一號大墓, 作家出版社.

Baoji Work Station of Shaanxi Provincial Institute of Archaeology and the Baoji Archaeological Team. "Shaanxi

Longxian Bianjiazhuang wuhao chunqiu mu fajue jianbao" [Brief excavation report of Tomb 5 of Bianjiazhuang in Longxian, Shaanxi province]. *Wenwu*, no. 11 (1988): 14–23. 陝西省考古研究所寶鷄工作站、寶鷄市考古工作隊: 陝西隴縣邊家莊五號春秋墓發掘簡報, 文物.

Bunker, Emma, James Watt, and Sun Zhixin. *Nomadic Art of the Eastern Eurasian Steppes: The Eugene V. Thaw and Other New York Collections*. New York and New Haven: MetPublications, 2002.

Feng Nai'en. *Gu boli jianshang yu shoucang* [Ancient glass connoisseurship and collecting]. Changchun: Jilin kexue jishu chubanshe, 1995. 馮乃恩: 古玻璃鑒賞與收藏, 吉林科學技術出版社.

Fengxiang County Museum and Shaanxi Cultural Administrative Bureau. *Fengxiang Xi'an Qin gongdian shijue jiqi tongzhi jianzhu goujian* [Preliminary excavation of pre-Qin palaces at Fengxiang and bronze architectural components]. *Kaogu*, no. 2 (1976): 121–28. 鳳翔縣文化館、陝西省文管會: 鳳翔先秦宮殿試掘及其銅質建築構件, 考古.

Han Wei and Jiao Nanfeng. "Qindu yongcheng kaogu fujue yanjiu zongshu" [Summary of excavations and study of the Qin capital of yongcheng]. *Kaogu yu wenwu*, nos. 5–6 (1988): 111–12. 韓偉、焦南峰: 秦都雍城考古發掘研究綜述, 考古與文物.

Jiao Nanfeng, Wang Baoping, Zhou Xiaolu, and Lu Dongzhi. "Qin wenzi wadang de queren yu yanjiu" [Identification and study of Qin tiles with characters]. *Kaogu yu wenwu*, no. 3 (2000): 64–71. 焦南鋒、王保平、周曉陸、路東之: 秦文字瓦當的確認與研究, 考古與文物.

Li Jinshan and Li Guangyu. *Zhongguo gudai mianju yanjiu* [Study of ancient Chinese masks]. Jinan: Shandong daxue chubanshe, 1994. 李錦山、李光雨: 中國古代面具研究, 山東大學出版社.

Li Kaiyuan. *Qin mi* [Mysteries of Qin]. Beijing: Beijing United Publishing, 2015. 李開元: 秦謎, 北京聯合出版公司.

Liu Liang and Wang Zhouying. "Qindu yongcheng xin chutu de qinhan wadang" [Recently excavated tiles from Yongcheng]. *Wenbo*, no. 3 (1994): 53. 劉亮、王周應: 秦都雍城新出土的秦漢瓦當, 文博.

Liu Junshe. "Guanyu Baoji Yinmen erhao mu de wenhua guishu wenti" [Commentary on the cultural identity of Tomb 2 at Yimen, Baoji]. *Qinyong Qin wenhua yanjiu* [Study of Qin terracotta figures and Qin culture]. Xi'an: Shaanxi renmin chubanshe, 2000. 劉軍社: 关于寶鷄益門二號墓的文化歸屬問題, 秦俑秦文化研究, 陝西人民出版社.

Liu Yunhui. *Shaanxi chutu Dongzhou yuqi* [Eastern-Zhou jade from Shaanxi]. Beijing: Wenwu chubanshe, 2006. 劉云輝: 陝西出土東周玉器, 文物出版社.

Rawson, Jessica, and Emma Bunker. *Ancient Chinese and Ordos Bronzes*. Hong Kong: Oriental Ceramic Society of Hong Kong. 1990.

Shan Yueying. "Dongzhou qindai zhongguo beifang diqu kaoguxue wenhua geju—jianlun Rong, Di, Hu yu Huaxia zhijian de hudong" [Cultural pattern in the archaeology of Northern China during the Eastern Zhou and Qin dynasty, along with commentary on the interaction among Rong, Di, and Hu ethnic peoples with Central Plain in Huaxia]. *Kaogu xuebao*, no. 3 (2015): 303–44. 單月英: 東周秦代中國北方地區考古學文化格局—兼論戎、狄、胡與華夏之間的互動, 考古學報.

Shaanxi Provincial Cultural Bureau and Shaanxi Provincial Institute of Archaeology. *Liuzhu wenming* [Preserving civilization: general review of the preservation and research of the major archaeological sites in Shaanxi province, 2006–10]. Xi'an: Sanqin chubanshe, 2012. 陝西省文物局, 陝西省考古研究院: 留住文明: 陝西"十一.五"期間大遺址保護及課題考古概覽 (2006–10), 三秦出版社.

Shaanxi Provincial Institute of Archaeology. *Longxian dianzi qinmu* [Qin tombs at Dianzi in Longxian]. Xi'an: Sanqin chubanshe, 1998. 陝西省考古研究所: 隴縣店子秦墓, 三秦出版社.

———. "Shaanxi Hancheng Liangdaicun yizhi M26 fajue jianbao" [Brief excavation report on Tomb 26 at Liangdaicun, Hancheng, Shaanxi province]. *Kaogu yu wenwu*, no. 1 (2008): 4–21. 陝西省考古研究院等: 陝西韓城梁帶村遺址M26發掘簡報, 考古與文物.

———. "Shaanxi Hancheng Liangdaicun yizhi M27 fajue jianbao" [Brief excavation report on Tomb 27 at

Liangdaicun, Hancheng, Shaanxi province]. *Kaogu yu wenwu*, no. 6(2007): 3–22. 陝西省考古研究院等: 陝西韓城梁帶村遺址M27發掘簡報, 考古與文物.

———. *Kaogu nianbao* (2014) [Archaeological Journal 2014]. 陝西省考古研究院: 考古年報: (2014), 年刊.

So, Jenny F., ed. *Music in the Age of Confucius*. Washington, DC: Smithsonian Institution, 2000.

Sun Derun. "You Xianyang qibingyong tandao zhanguo qibing" [From Xianyang cavalrymen figurines to the cavalrymen of the Warring States period]. *Kaogu yu wenwu*, no. 5: 19–22 (1996). 孫德潤, 由咸陽騎俑談到戰國騎兵, 考古與文物.

Teng Mingyu. "Yetan gongxingqi de xingzhi ji xiangguan wenti" [Commentary of forms of the bow-shaped ornaments and related issues]. *Kaogu*, no. 8 (2011): 73–80. 滕銘予: 也談弓形器的形制及相關問題, 考古.

Tian Yaqi. "Qinguo zaoqi de zhujian qiangsheng he dui rongdi de zhanzheng" [Qin's development and the wars with Rong and Di]. *Essays on Qin Culture*, vol. 3. Xi'an: Xibei daxue chubanshe, 1994. 田亞岐: 秦國早期的逐漸強盛和對戎狄的戰爭, 秦文化論叢, 第三輯, 西北大學出版社.

———, Wang Hao, Liu Shuang, Jing Hongwei, Liu Yangyang, and Sun Zongxian. "Shaanxi fengxiang sunjia Nantou chunqiu qinmu fajue jianbao" [Brief excavation report on the Qin tombs of the Spring and Autumn period at Sunjianantou, Fengxiang, Shaanxi]. *Kaogu yu wenwu*, no. 4 (2013): 3–34. 田亞岐, 王顥 劉爽 景宏偉 劉陽陽 孫宗賢: 陝西鳳翔孫家南頭春秋秦墓發掘簡報, 考古與文物.

Wang Renxiang. "Gudai daigou yongtu kaoshi" [Study of ancient garment hooks]. *Wenwu*, no. 10 (1982): 75–81. 王仁湘: 古代帶鉤用途考實, 文物.

Wang Weilin, Yuan Ming, Zhang Wei, and Guo Xiaoning. "Shaanxi Gaoling Yangguanzhai yizhi" [Yangguanzhai site in Gaoling, Shaanxi]. State Administration of Cultural Heritage, ed. *Major Archaeological Discoveries in China in 2008*. Beijing: Wenwu chubanshe, 2009: 38–41. 王煒林, 袁明, 張偉, 郭小寧: 陝西高陵楊官寨遺址. 國家文物局主編: 2008中國重要考古發現.

Xiao Qi. "Shaanxi Longxian Bianjiazhuang chutu chunqiu tongqi" [Bronze vessels of the Spring and Autumn period from Bianjiazhuang, Longxian, Shaanxi province, *Wenbo*, no. 3 (1989): 79–81. 肖琦: 陝西隴縣邊家莊出土春秋銅器, 文博.

Yang Boda. "Xizhou boli de chubu yanjiu" [Primary study of the glass of the Western Zhou dynasty]. *Gugong bowuyuan yuankan*, no. 2 (1980): 14–34. 楊伯達: 西周玻璃的初步研究, 故宮博物院院刊.

Yang Mangmang. "Qindai cuoyin tongdaigou de baohu" [Preservation of the inlaid gold and silver garment hooks of the Qin]. *Kaogu yu wenwu*, no. 1 (1996): 84–86. 楊忙忙: 秦代錯銀銅帶鉤的保護, 考古與文物.

Yin Shengping and Zhang Tian'en. "Shaanxi Longxian bianjiazhuang yihao chunqiu qinmu" [Qin Tomb 1 of the Spring and Autumn periods in Longxian, Shaanxi province]. *Kaogu yu wenwu*, no. 6 (1986): 15–19. 尹盛平、張天恩: 陝西隴縣邊家莊一號春秋秦墓, 考古與文物.

Zhao Bin. "Xianyang Taerpo zhanguo Qinmu chutu qimayong zushu kaobian" [Investigation and commentary on the cultural identity of the horse riders from the Qin tomb at Taerpo]. *Kaogu yu wenwu*, no. 4 (2002: 40–44). 趙斌: 咸陽塔爾坡戰國秦墓出土騎馬俑族屬考辯, 考古與文物.

Section III

Archaeological Team of the First Emperor's Mausoleum. "Qin Shihuang lingyuan K9801 peizangkeng diyici shijue jianbao" [Brief report on the first primary excavation of Pit K9801 at Qin Shihuang's Mausoleum]. *Kaogu yu wenwu*, no. 1 (2001): 3–34. 秦始皇陵考古隊: 秦始皇陵園K9801陪葬坑第一次試掘簡報, 考古與文物.

———. "Qin Shihuang lingyuan K0006 peizangkeng diyici fajue jianbao" [Brief report on the first excavation of Pit K0006 at Qin Shihuang's Mausoleum]. *Wenwu*, no. 3 (2002): 4–31. 秦始皇陵考古隊: 秦始皇陵園K0006陪葬坑第一次發掘簡報, 文物.

Dai Wusan. *Kaogong ji tushuo* [Illustrated craftsmanship]. Jinan: Shandong huabao chubanshe, 2003. 戴吾三編著: 考工記圖說, 山東畫報出版社.

Dien, Albert. "A Study of Early Chinese Armor." *Artibus Asiae* 43, nos. 1–2 (1981–82): 5–67.

Ma Chengyuan, ed. *Zhongguo qingtongqi* [Chinese bronzes]. Shanghai: Shanghai guji chubanshe, 1988. 馬承源: 中國青銅器, 上海古籍出版社.

Qi Jiafu. *Qinling yu bingmayong* [The mausoleum of Qin Shihuang and terracotta warriors]. Hefei: Huangshan shushe, 2013. 戚家富: 秦陵與兵馬俑, 黃山書社.

Shaanxi Province Institute of Archaeology and Museum of Qin Shihuang Terracotta Army. "Qin Shihuang lingyuan K0007 peizangkeng fajue jianbao" [A brief report on the excavation of Pit K0007 at Qin Shihuang's Mausoleum]. *Wenwu* 6 (2005): 16–38. 陝西省考古所, 秦始皇陵考古隊: 秦始皇陵園K0007陪葬坑發掘簡報, 文物.

Wang Xueli, ed. *Qin wuzhi wenhua shi* [The history of Qin dynasty material culture]. Xi'an: Sanqin chubanshe, 1994. 王學理主編: 秦物質文化史, 三秦出版社.

———. *Qin yong zuanti yanjiu* [Special studies on Qin terracotta figures]. Xi'an: Sanqin chubanshe, 1994. 王學理: 秦俑專題研究, 三秦出版社.

———. *Qinling caihui tongchema* [Painted bronze chariots from the Qin Mausoleum]. Xi'an: Shaanxi renmin chubanshe, 1988. 王學理: 秦陵彩繪銅車馬, 陝西人民出版社.

Wu Yongqi and Tian Jing. *Qin Shihuang ling he bingmayong* [Qin Shihuang's mausoleum and terracotta warriors], 4th ed. Xi'an: Sanqin chubanshe, 2009. 吳永琪, 田靜: 秦始皇陵和兵馬俑, 三秦出版社.

Exhibition Catalogues

Cai Qing-liang and Zhang Chi-gwong, ed. *Ying qin suyuan* [Tracing the roots of Ying Qin: Qin culture exhibition]. In Chinese and English. Taipei: National Palace Museum, 2016. 蔡慶良、張志光主編: 贏秦溯源: 秦文化特展, 國立故宮博物院.

———. *Qinye liufeng* [Reverberations of Qin heritage: Qin culture exhibition]. In Chinese and English. Taipei: National Palace Museum, 2016. 蔡慶良、張志光主編: 秦業流風: 秦文化特展, 國立故宮博物院.

Hong Kong Museum of History. *The Majesty of All under Heaven: The Eternal Realm of China's First Emperor* [一統天下: 秦始皇帝的永恆國度]. In Chinese and English. Hong Kong: Leisure and Cultural Services Department, 2012. 香港歷史博物館: 一統天下: 秦始皇帝的永恆國度.

Khayutina, Maria, ed. *Qin: The Eternal Emperor and His Terracotta Warriors*. Zurich: Bernisches Historisches Museum and Neue Zürcher Zeitung Publishing, 2013.

Michaelson, Carol, ed. *The Terracotta Army and Treasures of the First Emperor of China*. Tampere: Tampere Museums Publications, 2013.

Li Jian, ed. *Eternal China: Splendors from the First Dynasties*. Dayton, Ohio: Dayton Art Institute, 1998.

Liu Yang. *China's Terracotta Warriors: The First Emperor's Legacy*. Minneapolis: Minneapolis Institute of Arts, 2012.

Portal, Jane, ed. *The First Emperor: China's Terracotta Army*. London: British Museum Press, 2007.

Tokyo National Museum. *Shikotei to dai heibayo* [The great terracotta army of China's first emperor]. Tokyo: Tokyo National Museum. NHK, NHK Puromōshon, Asahi Shinbunsha, 2015. 東京國立博物館: 始皇帝と大兵馬俑, NHK.

Shen Chen. *The Warrior Emperor and China's Terracotta Army*. Ontario: Royal Ontario Museum, 2010.

Zhixin Jason Sun. *Age of Empires: Art of the Qin and Han Dynasties*. New York: Metropolitan Museum of Art, 2017.

Index

Note: Page references in italics denote illustrations, principally drawings; page references for illustrations of catalogued objects that run with the catalogue entry are not given separately.

221 BC); First Emperor of Qin (Qin
Shihuang) (r. 221–210 BC), xvi, 1, *2*, 3,
20, 29, 61, 65, 104, 105, 106, 107
conquests of, xvi, 3, 19, 107
immortality as quest for, 1, 69, 100, 107
mausoleum. *See* Qin Shihuang's Mausoleum
reforms of, 1, 3, 17, 18, 23, 106, 107
travels of, 69, 107
see also China, unification of
Yongcheng
as capital, xvi, 3, 29, *29* (map), 34, 61–67,
104, 105
mausoleum at. *See* Jing, Duke, tomb of
Yuandingshan cemetery, object from, 45

Z

Zhao, Queen Dowager, 106

Zhao Gao (d. 207 BC), 105, 106

Zhao (state), xvi, *xvii* (map), 3, 24, *24*, 45, 53,
95, 107

Zhaoxiang, King (Ying Ji) (r. 306–251 BC), 17,
19, 45, 53, 58, 104, 106

Zhenhu (d. 206 BC), 105

Zhou dynasty (1046–256 BC), xvi, 1, 3, 11, 27,
29, 49, 65, 95, 105, 106, 107
Eastern Zhou dynasty (770–256 BC), xvi,
20, 96, 106, 107
objects dating to, 22
Spring and Autumn period (770–476 BC),
xvi, 8, 29, 45, 47, 98, 100, 105
objects dating to, 10, 12–14, 26, 30–31,
33, 35–43, 45, 50, 62
Warring States period (475–221 BC),
xvii (map), 3, 9, 15, 29, 53, 92, 101, 105
objects dating to, 19, 22–26, 31–32,
45–47, 49–52, *54*–55, 57–61, 63–67,
90, 96
Western Zhou dynasty (1046–771 BC), xvi,
9, 11, 15, 16, 51, 95, 105, 106
objects dating to, 16, 42, 44, 63, 93–95

Zhuang, Duke (r. 821–778 BC), 104

Zhuang Wei, 17

Zhuangxiang, King (r. 249–247 BC), 104, 106

Ziying (r. 207 BC), Third Emperor (Qin
Sanshi), xvi, 104, 105